Kellie McGarrh's
Hangin' In Tough

History of Schools and Schooling

Alan R. Sadovnik and Susan F. Semel
General Editors

Vol. 3

PETER LANG
New York • Washington, D.C./Baltimore • Boston • Bern
Frankfurt am Main • Berlin • Brussels • Vienna • Oxford

Kellie McGarrh's
Hangin' In Tough

Mildred E. Doyle,
School Superintendent

Edited by
Clinton B. Allison

PETER LANG
New York • Washington, D.C./Baltimore • Boston • Bern
Frankfurt am Main • Berlin • Brussels • Vienna • Oxford

Library of Congress Cataloging-in-Publication Data

McGarrh, Kellie.
Kellie McGarrh's hangin' in tough:
Mildred E. Doyle, school superintendent / edited by Clinton B. Allison.
p. cm. — (History of schools and schooling; vol. 3)
Author's doctoral dissertation, revised and edited after her death.
Includes bibliographical references and index.
1. Doyle, Mildred E. (Mildred Eloise), 1904–1989. 2. School superintendents—
Tennessee—Biography. 3. Women school superintendents—Tennessee—
Biography. 4. Feminism and education. I. Title: Hangin' in tough. II. Allison,
Clinton B. III. Title. IV. History of schools and schooling; v. 3.
LA2317.D6185M34 99-047661
ISBN 0-8204-3744-1
ISSN 1089-0678

Die Deutsche Bibliothek-CIP-Einheitsaufnahme

McGarrh, Kellie.
Kellie McGarrh's hangin' in tough:
Mildred E. Doyle, school superintendent / ed. by: Clinton B. Allison.
–New York; Washington, D.C./Baltimore; Boston; Bern;
Frankfurt am Main; Berlin; Brussels; Vienna; Oxford: Lang.
(History of schools and schooling; Vol. 3)
ISBN 0-8204-3744-1

Cover design by Nona Reuter
Front cover photograph by Gordon Hodge

The paper in this book meets the guidelines for permanence and durability
of the Committee on Production Guidelines for Book Longevity
of the Council of Library Resources.

Printed in the United States of America

Kellie McGarrh wished to acknowledge the contributions and support of Jackie M. Blount, Diane Cudahy Creitz, Joy DeSensi, Denise Harvey, Mildred M. Patterson, Joan Paul, and Melba Wilkins.

Contents

Foreword by *Clinton B. Allison* ix

Chapter 1 Introduction: Mildred Doyle, a Big Presence 1

Chapter 2 Negotiating Gender Constructs:
Student, Athlete, Teacher, Principal 17

Chapter 3 Negotiating Gender Constructs in a
Good Old Boys' World 33

Chapter 4 An Eclectic Progressive:
"What's Best for the Boys and Girls" 49

Chapter 5 Superintendent Doyle's Curriculum Leadership
during the Progressive Era 69

Chapter 6 Old Habits Die Hard: Life after the
Superintendency 91

Chapter 7 Conclusion: Mildred Doyle in Perspective 111

Appendix A: Tennessee State Senate Joint Resolution No. 66 127

Appendix B: Mildred Doyle's Eulogy 129

Selected Bibliography 131

Index 137

Foreword

Clinton B. Allison

Kellie McGarrh and Mildred Doyle were two extraordinary women whom I admired and cared about very much. Doyle was eighty-four years old in 1989 when she died at home, comforted by her loving companion of many years. She had been the most powerful and best-known female politician and educator in Tennessee. Her life's work behind her, she died full of honors bestowed by a grateful community and state.

McGarrh was thirty-four years old and full of promise with her first university teaching post when she was killed by her longtime companion in her new home in 1995. She had just received her doctorate from the University of Tennessee, and the college of education community was outraged and heartbroken by the tragedy; and, in a crowded memorial service in the college, graduate students, professors, and administrators alike met to talk of their memories of her competency, scholarship, and humor. She was deeply involved in the sweeping reorganization of the College of Education; she administered the New College office, a job that would normally be reserved for a senior staff member rather than a graduate student. In a faculty and administration forum that was called to review the New College planning document, her stature and respect were such that when she argued for the inclusion of an antibias statement on sexual differences in the recruitment of students and faculty, there was no public opposition.

I was Kellie's professor in several classes, a member of her dissertation committee, a research partner, and a friend. Despite differences in age and gender, we enjoyed working together. She possessed a mischievous (but never mean-spirited) sense of humor, and she enjoyed teasing me about being an old, white, heterosexual guy—hopeless, she supposed—but there didn't seem to be anything that I could do about it. Biography

particularly interested her and, when she was looking for a dissertation topic, I suggested a study of Mildred Doyle. A few weeks before her death, she received a book contract from Peter Lang Publishing to revise her doctoral dissertation on Doyle. Full of excitement, she asked me to write an introduction to her book. Shortly after her death, I agreed to edit her dissertation for publication, with royalties going to the Kellie McGarrh Graduate Student Travel Fund that had been established as a memorial to her.

From the 1950s through the 1980s, nearly everyone in East Tennessee thought they knew Mildred Doyle; as McGarrh points out, she was a "big presence." All Knoxvillians seemed to have a Doyle story based, they often said, on their own experience or on the experience of someone they personally knew. The stories were usually of two types: her outrageous public behavior (often involving challenges to reluctant public officials to do the right thing) or her personal, private, even secret acts of kindness. From 1946 to 1976, she was Knox County superintendent of schools. (Or, according to the knowledgeable, including some of her disciples and admirers, she was Benevolent Dictator of Schools). As an education professor, I watched, sometimes with amusement and sometimes with consternation, Doyle's unique style of country humor and hardball politics on behalf of children, particularly poor children. My wife was a public school librarian, and when one of our children became seriously ill, we experienced directly the thoughtfulness of the "tough guy" superintendent—a story told later in this book. Because I was a south Knox County neighbor (the working-class side of the river) and had built our house close to her "home place," on land that had been part of her family's Revolutionary War land grant, she seemed to feel a kinship. After her retirement, I conducted a several-hour videotaped interview with her; it was edited into a shorter video-biography, "Mildred Doyle at Eighty."

Kellie quickly embraced the idea of constructing a biography of Doyle. It was a good subject for her because, in part, it would be fun to research and write. It may be that "any life is interesting when looked at close up," but Doyle's life *was* extraordinary; in the tradition of successful southern politicians, she was a great character—courageous, mischievous, and contradictory. Kellie helps the reader to understand how complex this seemingly simple Appalachian woman was, and her study exemplifies the admonition that "human beings only seem simple when we do not really know them."[1]

In Doyle's life, we can find major issues that concern educational historians and feminist scholars: meanings and variety of "progressive" educa-

tion for practitioners (as opposed to theorists), leadership by progressive southern administrators in the racial desegregation of schools, women's struggles to attain educational administrative positions and differences in the ways men and women supervise and lead, the impact of homophobia on those who are not stereotypically "masculine" or "feminine," and better understanding of women-committed relationships.

Biographers disagree about whether they need to like their subjects. Reflecting on her recent study of Virginia Woolf, Hermione Lee insisted that "you have to have emotional feeling to do the work," and she was bereaved when she finished her work and had to return Woolf to the rest of the world: "I felt she had been mine."[2] Not surprisingly, as her research progressed, McGarrh became emotionally attached to Doyle, and, after interviews with Mildred Patterson, Doyle's longtime companion, McGarrh and the eighty-six-year-old Patterson became strong friends. One evening after we had a couple of drinks, McGarrh told me that as she was leaving the house that Doyle and Patterson shared for many years, Patterson had told her that "she was supposed to" write Mildred Doyle's story. McGarrh had replied that she hoped that Doyle would have wanted her to be the one to write her biography; just then, a small bell in a nearby cup had tinkled as she and Patterson had looked at each other in silence. The hair rose on the back of the neck of this old agnostic about things supernatural as McGarrh told of the incident.

McGarrh's biography is appreciative of the life and work of Mildred Doyle without being worshipful. In her review of Lee's *Virginia Woolf*, Daphne Merkin praises Lee for not putting Woolf on the couch and making "more sense of her than she can make of herself." We may appreciate McGarrh for the same reason; she is particularly successful in helping readers see ambiguities and contradictions as Doyle both defied and embraced conformity. And, although there was a temptation to engage in reductionist speculation about Doyle's sexuality, McGarrh refused and instead constructed a balanced, respectful account of the Doyle and Patterson relationship.[3]

School personnel are gender polarized: women teach and men administer, and the ratio of women to men administrators has fallen for much of the twentieth century. In her recent history of women and school superintendencies, *Destined to Rule the Schools*, Jackie M. Blount calls for more biographies of women "who have challenged the bounds of a traditionally male domain." Their stories will help us better understand the processes that keep men in control of a profession consisting largely of women.[4] Biographies may serve as case studies, providing specific ex-

amples from which generalizations can be constructed or confirmed, but perhaps as important, biographies may also offer stubborn witnesses against the generalizations, providing exceptions or anomalies who shade, in subtle or glaring ways, what we think we know about complex phenomena. McGarrh's Mildred Doyle was characterized by ambiguity, contradictions, and paradox, and her life serves both to confirm and to confound generalizations about women leaders. McGarrh stresses the humanness of Doyle, who did not even appear to recognize, much less reflect on the contradictions in her life—she was much too busy trying to improve the world. If McGarrh's treatment of Doyle's life serves as a model for other women, it is to act as if gender constructs do not exist and to trust and follow their instincts.

In many ways Doyle was male identified. In the tradition of many, perhaps most, southern school superintendents of the time, she was a former athlete, a jock, a "good old boy" politician in a tailored suit (although, according to Patterson, she, unlike most we suppose, wore frilly underwear under hers). Yet, despite the gruff, tough-talking, glad-handing exterior, she nurtured students and teachers and practiced the kind of inclusive, democratic decision-making more often associated with women administrators.

Doyle's educational philosophy was also self-contradictory. Aware of national educational trends, Doyle wanted her East Tennessee school system to reflect the best practices, and she seemed unaware of contradictions or conflicts between various policies and practices in vogue from time to time. Like many of her male counterparts, she was what David Tyack called an administrative progressive, one who placed great store on efficiency and scientific management, standardized testing, ability grouping, and differentiated curricula—seemingly unaware of possible social class and racial bias—and when it became fashionable, she tried to institute a basic skills curriculum. Yet, through much of her superintendency, without regard for theoretical niceties, she supported educational practices associated with pedagogical progressivism: a child-centered pedagogy with a strong activity-based component and curricular enrichments for students in music and the arts. Although usually a forceful leader, like many other southern progressives she was cautious rather than bold in developing school desegregation policies after the 1954 *Brown v. Board of Education* decision. On the other hand, she, ever the master politician, carefully pushed the margins of voter tolerance in an evolving desegregation strategy.[5]

McGarrh constructed a story of a woman who was conventional in many respects, one who did not venture far beyond the boundaries of her

southern Appalachian culture and Methodist religion. Her tastes were middle-brow: pop music and Broadway show tunes, *Little House on the Prairie* and baseball games on television. Swearing or foul language offended her (although she was an accomplished and creative user of expletives when angered). Yet, in other ways, she was the antithesis of what was thought "normal" in her time and place. She was both beloved and considered odd, but women who break gender barriers are often considered odd, perhaps more so in the mid-twentieth century South than elsewhere in the nation. And she often lived as if gender barriers had never been constructed, not only in her successful rough and tumble political career but also in her long-term professional and personal relationship with her assistant and companion, Mildred Patterson. But even in this unconventional relationship, Doyle played mid-century conventional roles: mowing the lawn, gardening, driving the car, and eating the meat-and-potatoes meals that Patterson cooked for her. She would have given her famous Tennessee "hoot" (equivalent to a Bronx cheer) if she had been asked if she was a feminist. In an observation that perhaps only southerners can completely understand, had Doyle been a man, she would not have been a redneck—she would have been a good old boy.

I was unprepared for the difficulty of editing and rewriting someone else's work for publication. My notes for the editing of her dissertation begin with the admonition, "Be true to Kelley." From time to time in the editing process, I caught myself talking to her: "Kellie, would it make more sense if I moved this section to another chapter?" Fortunately for my sanity, I did not hear her answers, although I know she would have argued vehemently with some changes and additions (she was always polite but never timid in asserting her opinions); unfortunately, I can't know which changes would cause her disapproval.

But I was careful not to win posthumously debates that we had when McGarrh was writing her dissertation. For example, she used "instinct," "instinctive," or "instinctiveness" to explain Doyle's disregard for social constructions and her courage in escaping the limitations of the women's sphere. To me, these terms usually indicate qualities that are inborn and unalterable and, thus, reflect beliefs that are at odds with modern psychology and, certainly, with cultural studies. Occasionally, this does seem to be McGarrh's usage, as when she writes of "Mildred's instinctive self-confidence." Generally, however, by "instinctive," McGarrh means Doyle's actions that reflected authentically and unself-consciously who she was (by whatever combination of nature and nurture) without fear or even consideration of artificial social criteria.[6] I was also uncomfortable with her referring to the superintendent as Mildred rather than as Doyle. I

argued that a gender bias is often reflected when men are called by their last names, whereas women are called by their first—it may trivialize women. I pointed out that she referred to Mildred Patterson as Patterson, and, in an unscrupulous appeal, I remarked that had Mildred Doyle's younger brother been superintendent, she would not have called him Pinky. She agreed to all I said but remained adamant, insisting that she was comfortable referring to the superintendent as Mildred or Miss Doyle, as she was called in her lifetime, but just couldn't bring herself to call her Doyle. Her preference is respected throughout the revised text.

In addition to copyediting and reorganizing (I constructed seven chapters from the original five in the dissertation), I added more historical context on some issues. As do most doctoral students, McGarrh wrote primarily for a local audience of four professors, and she emphasized Doyle's life and work in East Tennessee. As she would have done for a national audience, I linked her biography of Doyle more fully to the literature on gender and administration, educational reform at mid-century, and women-committed relationships. Three sources were particularly helpful to me in placing McGarrh's Mildred Doyle in these broader contexts. The first is Jackie M. Blount's *Destined to Rule the Schools*. Immediately after seeing a publisher's notice of its publication, I ordered a copy of this history of women school superintendents; it appeared to be exactly what I was looking for to help me compare Doyle with other female superintendents of her time. When the book came, I was amazed to find that it was dedicated to Kellie McGarrh (and two other persons). McGarrh and Blount had met at an academic conference as they were finishing their dissertations. In the acknowledgments of her book, Blount writes of their meeting: "Kellie and I had been working on similar, though separate projects; but when we discovered each other's research interests, bystanders could not pull us apart as we skipped sessions, compared notes, and frantically discussed our work for hours at a stretch. We exchanged dissertations after the conference and committed to working together on historical projects about women school leaders."

Had she lived to revise her manuscript for publication, McGarrh would have been informed, as I was, by Blount's book. As the text will reveal, I learned much from Blount about the reasons for declines in the number of women administrators and the ways that the superintendency became male identified and male controlled. Her work was also particularly helpful in better understanding the relationship among sexual stereotyping, homophobia, and women's aspirations for school leadership. Jackie Blount is, in turn, listed among those to whom I think Kellie would have wanted to dedicate her book.

Two group biographies of women were also particularly helpful. *Composing a Life*, Mary Catherine Bateson's essays on five extraordinary women, including two college administrators, added to my understanding of the centrality (and sacrifices) of nurturing in the lives of women leaders. I was somewhat doubtful that it would be useful when Susan Semel, one of the general editors of the History of Schools and Schooling series, suggested that for context I read Patricia Ann Palmieri's *In Adamless Eden: The Community of Women Faculty at Wellesley College*. After all, Mildred Doyle, a "tomboy" raised on a hardscrabble Appalachian farm, and upper-class New England intellectuals lived in worlds too far apart to share much about being twentieth-century women. I was wrong; Palmieri's scholarly study was helpful at many points and, particularly, in better understanding the nature of "romantic friendships."[7]

In addition, I acknowledge with gratitude and affection the cochairs of McGarrh's dissertation committee, Joy DeSensi and Joan Paul. They nurtured Kellie and, as my colleagues (and department heads), they have nurtured me. I appreciate the contribution of photographer Gordon Hodge, who searched his files for the portrait of Mildred Doyle that is found on the cover. And, as always, I express my love to my wife, Claudia.

I cannot imagine Mildred Doyle writing an autobiography. She was egotistical enough, but she was a person of action, not self-reflection. She would have been pleased (as was Mildred Patterson) that Kellie McGarrh accepted the task. Had McGarrh lived to edit this work, I don't know how much more adventuresome or daring her interpretations might have been, but I am delighted that she will be able to share her research with a wider audience.

Notes

1. Brenda Maddox, "Biography: A Love Affair or a Job?" Bookend, *New York Times Book Review*, 9 May 1999, 47; Linda McMurry, "George Washington Carver and the Challenges of Biography," *Vitae Scholasticae* 2 (spring 1983): 9.

2. Maddox, "Biography," 47.

3. Daphne Merkin, review of Hermione Lee's *Virginia Woolf*, *New York Times Book Review*, June 1997.

4. Jackie M. Blount, *Destined to Rule the Schools: Women and the Superintendency, 1873–1995* (Albany: State University of New York Press: 1998), 6.

5. For an analysis of the "wings" approach to understanding progressive education, see David B. Tyack, *The One Best System: A History of American Urban Education* (Cambridge, MA: Harvard University Press, 1974).

6. McGarrh's meaning is similar to one expressed by Katharine Butler Hathaway: "It is only by following your deepest instinct that you can lead a rich life and if you let your fear of consequences prevent you from following your deepest instinct then your life will be safe, expedient and thin," University of Tennessee *Context*, 16 (March 1999).

7. Blount, *Destined to Rule the Schools:*; Mary Catherine Bateson, *Composing a Life* (New York: Plume/Penguin, 1990); Patricia Ann Palmieri, *In Adamless Eden: The Community of Women Faculty at Wellesley* (New Haven: Yale University Press, 1995).

Chapter 1

Introduction:
Mildred Doyle, a Big Presence

On Tuesday, May 9, 1989, Knoxville, Tennessee, was in mourning for a legend: famed athlete, longtime school superintendent, "Granny" to many teachers, and, in an area that has always had more than its share of political characters, one of its most colorful politicians, Miss Mildred Doyle had died. Hundreds of friends and admirers gathered at Berry Funeral Home for the 11:00 A.M. service to pay their last respects to Miss Doyle. Knoxville mayor Victor Ashe ordered three official days of mourning as flags over city and county government buildings were flown at half-mast to honor the influence that Miss Doyle had on the lives of 750,000 students, spanning nearly three generations in the Knox County schools.[1]

She died surrounded by the love and care of the other Mildred—Mildred Patterson, her longtime partner, companion, housemate, and associate in running the county school system. Although the unyielding Miss Doyle had fought bone cancer into a state of remission for several years, Patterson said that near the end, "She got *real* bad *real* fast." During her last six weeks, she spent most of the time in the hospital in and out of a coma, when conscious, she experienced excruciating pain. Patterson stayed with her during most days and she had sitters at night for Mildred Doyle never liked to be alone. In her lucid moments she struggled to return to the humor that had been a principal political asset and that had endeared her to generations of East Tennesseans. She called Patterson to her side, asked her to turn around, and then used the patterns on the back of her partner's sweater to map out her grave plot so that she would be sure to be buried next to a "preferred" rather than a disliked family member. On another occasion, Patterson was in the hospital room talking to the nurse about the logistics of getting Mildred home and providing proper care for her. She was eliciting the nurse's opinion on various possibilities, when

Mildred Doyle came out of her delirium and spoke, "Don't pay any attention to Patterson. She never could make up her mind about anything!" As they laughed, Mildred lapsed back into semiconsciousness.[2]

Despite pain and overwhelming odds against her, Mildred Doyle remained the fighter who had taken on all opponents in sports and politics, and she refused to die easily. The Reverend Robert Temple frequently visited Mildred who was still, at some level, determined to overcome her sickness. Although in obvious pain, she regularly assured him, "I'm hangin' in *tough*." When Temple asked if she wanted him to offer a prayer, she responded, "If you think that *you* need it." About a week before she died, when all the family had come to say good-bye, Patterson leaned gently over Mildred's bed and whispered to her that everyone loved her and that her loved ones were waiting for her in heaven and that maybe it was time for her to let go. Patterson remembered, "She looked at me and said, 'Well, I guess that's really what I ought to do. I need to go there and find out what's there and get things ready for you because you won't know what to do when you get there.'"[3]

Mildred Doyle's one wish at the end of her life was that she could leave the hospital and die at home. She adamantly told Patterson that if, for some reason, she died in the hospital before she could get home, she wanted her obituary to read that she died at home regardless. Mildred Doyle's determination enabled her to return to their longtime home on Maplewood Drive. Patterson placed a hospital bed in her room at the back of their house facing the lawn that Mildred Doyle lovingly tended for twenty-eight years. Flowering dogwoods and azaleas, the return of a canopy of green trees, and sweet, warm air make even the old who have experienced it every year of their lives savor springtime in Knoxville and view it with awe. As Mildred drifted in and out of consciousness, Patterson whispered to her, "You're home now. Can you see out the window at how pretty everything looks?" Mildred Doyle smiled back at her companion. Two days later she died.[4]

As the legendary character lived an unorthodox life, so she planned for herself an unorthodox funeral. While the cancer was in remission Mildred Doyle refused to discuss her will or plan her funeral because she refused to accept the reality of her illness enough to talk about her death. Patterson had to finesse the stubborn Mildred in order to discover her wishes. Patterson casually mentioned what *she* would want to happen if she were to die first, provoking Mildred Doyle to talk about her own funeral service. The former superintendent wanted absolutely no part of morbid dirges played at the service. As a final illustration of her mix of conventional

(even hackneyed) and unconventional attitudes, the "avid consumer of music" wanted those present to hear her favorite popular songs—ones of happiness, hope, and joy with a little humor thrown in. Sitting on their sunporch one evening, she told Patterson that she wanted two of their New York musician friends to sing her favorites—"Somewhere over the Rainbow" from *The Wizard of Oz* and "Climb Every Mountain" from *The Sound of Music*. Finally, the humorist and former athlete requested that the organist play "Take Me Out to the Ballgame" as the pallbearers took her casket from the chapel. Patterson complied with all the musical wishes—except the last one. Unfortunately, the organist lacked Mildred Doyle's free spirit and sense of humor and refused to play the postlude. However, Patterson knew her companion well enough to make an alternate selection that Mildred would have appreciated. Mildred Doyle was carried from the church to the tune of the "The Battle Hymn of the Republic."[5]

An Unsuitable Job for a Woman

In 1946, when Mildred Eloise Doyle became Knox County superintendent of schools, thousands of American women faced layoffs from jobs obtained during World War II. Servicemen returning from active duty expected their prewar jobs to be waiting. The importance of "Rosie the Riveter" to the nation's economy faded after the turmoil of war had eased. Many women who welcomed the wartime work commonly reserved for men were told by employers that their place was no longer in American industry but back in the home—in the bedroom and the nursery. With a surplus of employable males, this story was repeated for women across the country, especially for those working in business and industry at jobs considered nontraditional for their gender.

Women, on the other hand, had dominated the teaching profession, at least in numbers, since the late nineteenth century. Early in the twentieth century, before the creation of school bureaucracies and increased pay and prestige for school administrators, women superintendents were also common. Their numbers began to drop after World War I, but, as late as 1930, women accounted for over a quarter of county superintendents and 11 percent of all American school superintendents. After World War II, according to Jackie Blount, school boards deliberately attempted to induce men into education "with promises of rapid advancement even at the expense of the women who had previously served as principals." The percentage of women superintendents continued to drop: 9 percent in

1950, 1 percent in 1972, and about .5 percent in 1980. When Mildred Doyle was elected, the "golden age" of women administrators was over; they had gone the way of the buffalo. Women teachers managed children and men administrators managed women, and, in the conservative South with its chivalry myths of weak women (as long as they were white) and strong, manly men (also as long as they were white) protecting them, the number of women school administrators was small. Including Mildred Dole, there were four (out of ninety-five) women Tennessee county superintendents in 1950; by 1970 the number had dropped to three.[6]

Yet, despite the postwar availability of men for administrative positions, Mildred Doyle proved an exception to the traditional pattern by winning election to the highest position in educational administration at the local level. On July 11, 1946, "Miss Doyle" was sworn in at age forty-two as the first female superintendent of schools in Knox County, Tennessee—a post she retained for thirty years.

Tough and determined, the gritty Miss Doyle prepared to meet the challenge of her lifetime as she took on the "big, two-fisted man's job" of bringing a badly neglected school system up to twentieth-century standards. Having devoted twenty years to working her way up the ladder from elementary school teacher beginning in 1924 to principal to supervisor of elementary education, Mildred was no stranger to the business of schooling. It was her position of supervisor, however, that took her out into the field where she witnessed with dismay the deplorable conditions that existed in many of the eighty county schools in the mid-1940s. Knox County was always stingy with money for schools, and the war effort absorbed the funds and building materials that were available. At war's end Knox County's physical facilities often resembled nineteenth, rather than mid-twentieth century, schools. Over one-half of the schools lacked indoor plumbing and some operated without electric lights or telephones. And many teachers coasted along with very little schooling themselves, having never been inside a college classroom.[7]

Personally ambitious and sincerely appalled by school conditions, Mildred envisioned 1946 as the perfect time to run for superintendent in hopes of developing a reformer's reputation and improving schools, not only in the physical condition of the system but in curriculum and teaching quality as well. A daughter of one of the region's most prominent political families, she combined her inherited political clout with a visionary determination to attain an exceptional position in an era and place where traditional roles for women were rigorously and religiously demanded. Keeping her initial campaign promises, as superintendent she diligently

closed or renovated old schools and built new ones, championed innova-
tive curricular reform, raised teaching standards, and continued to be a
fervent advocate for children and youth. And before her defeat for super-
intendent in a mean-spirited political campaign in 1976, Mildred Doyle's
powerful presence had reached legendary proportions as she became
arguably Tennessee's most effective figure in twentieth-century public
education with a career that spanned fifty-two years.[8]

Mildred Doyle's Personal Flair

A combination of probity, frankness, and accessibility mixed with a scald-
ing temper and an irrepressible sense of humor made Mildred Doyle a
dynamic and charismatic individual not easily forgotten by those who
crossed her path. She had a "big presence" that left lasting impressions
on educators, students, politicians, and other Tennesseans, and as a re-
sult of her unique personality, she became one of the most well-respected
and powerful public servants in the region.[9]

Characterized by a disarming frankness, especially for a politician with
an ever present constituency to appease, Mildred sustained her belief that
"the one thing you've got to do is to say what's right, not what people
want to hear." She adhered to her values as best a seasoned politician can
with reelection in mind; although she probably lost votes as a result. She
was savvy, knowing not only what to say but when to say it. At the end of
her lengthy career, she attributed her success as superintendent to the
correct combination of "political know-how and knowing what you're
talking about." An amalgam of political expertise and integrity, along
with a thorough knowledge of educational issues, and the placement of
children's welfare first contributed to her continued reelection by the gen-
eral public for over a quarter of a century.[10]

Mildred deeply loved both politics and public service. While she never
downplayed her role as a politician, as superintendent she strove to keep
partisan politics outside the schoolroom, arguing that her business was to
"do what's best for the boys and girls of Knox County." Miss Doyle often
used this phrase in speeches and was able to convince most voters that
the welfare of children—not political advancement—was always her top
priority. For example, in her quest to establish a high-caliber teaching
force, she never allowed a teaching candidate's political affiliation to influ-
ence hiring practices, although such political tests for teaching posts were
still common in Tennessee. Mildred Doyle, with her personal connections
and influence, could easily have furthered her political career by capturing

a higher political office in the state at practically any time during her superintendency. She chose, however, to remain at home in Knox County to oversee the education of some 750,000 students who passed through the school system between 1946 and 1976. When nominated (though not appointed) to the post of U.S. Commissioner of Education in 1956 by Senator Howard Baker, Mildred expressed little desire to further her career by going to Washington. While she garnered formidable political power during her career, Mildred Doyle was not appraised by the public as one who sought such influence solely for personal gain or glory. Much in the tradition of women who sacrifice themselves for the good of others, whether family or community, throughout her career as an educator and politician she remained focused on her particular vision of "the best" for Knox County children and youth.[11]

Essential to the success of Mildred's work was an uncanny ability to communicate with people from different races, ages, social strata, educational levels, and political persuasions. Mildred's secretary, Faye Cox, said she could "talk with any person on their level. She could talk with intellectuals and she could talk with these uneducated parents who came in having problems with their children." She could meet people on whatever level they were which enabled her to bridge potential gaps between her power position as superintendent and that of her constituencies. She "listened with her heart" to the concerns and suggestions of others and labored to ensure that her intentions and policy proposals were understood by all whom they affected, be they school board members, squires on the Knox County Court, or parents of students from working-class communities.[12]

Early in her superintendency, in a particularly crowded meeting room at Carter High School, located in a rural section of the county, Mildred walked a group composed primarily of students' families step by step through the results of a needs assessment conducted by the school system and the University of Tennessee College of Education, "putting the fodder on the ground," as she would say in her characteristic down-to-earth Tennessee manner and firm voice. For her, this meant illuminating the fundamental elements of educational issues in simple, jargon-free language, making them accessible for a public audience. As she explained why one school would receive priority over another, a Mrs. King, who was sitting in the back of the room, stood up in the midst of the discussion and blurted out, "Now, Miss Doyle (in south Appalachian dialect, pronouncing Doyle as "Dial"), I jest don't understand that at all. I want you to broaden me out." Mildred, addressing the woman by her name,

promptly and patiently restated the issues in different, clearer terms in an effort to "broaden her out." When she had finished, the woman replied, "God bless you, Miss 'Dial'! Now I understands it."[13]

Unlike many male school managers of the time, she was an accessible leader, not only verbally but as a highly visible figure at schools and community meetings. Mildred thought nothing of hopping into her car and paying personal visits to county schools. She visited classrooms and walked the halls, frequently chatting with teachers and students. According to Faye Cox, "If the kids were out on the playground, she might pick up a ball bat and hit a few balls with them . . . she was a very personable person, well-liked and respected, too." Miss Doyle not only remembered faces, but names and details about the lives of school personnel as well as Knox County citizens. In her personal files she kept a quote from Norman Vincent Peale (the clichéd and the unorthodox coexisted peacefully in her life) that she practiced: "Learn to remember names. Inefficiency at this point may indicate that your interest is not sufficiently outgoing. A man's name is very important to him." It was important to her, both personally and from a career standpoint, to be able to maintain individual connections and cooperative relationships with all manner of Knox County residents.[14]

Throughout her career, Miss Doyle held meetings at local schools to explain policy and significant decisions to community members. According to Patterson, "She never held anything back from communities." Questions or concerns expressed by a constituent were worthy of the superintendent's attention. She was philosophically opposed to allowing educational events, procedures, and policies to become mystified. She considered the public entitled to understand changes in educational policy, personnel, or curriculum during her administration. In addition to holding public meetings in community schools, she kept extended office hours and often worked on Saturdays. She also had a weekly radio show to keep local citizens in touch with educational issues. Either Mildred or a staff member would go on the air on Sunday mornings, relaying school business to the public. Further, she insisted that her office door always remain open as a signal of constant accessibility to staff, students, and parents. While remaining an accessible leader was assuredly politically expedient for Mildred, to do so was also a fundamental aspect of her personality. This characteristic represented a natural, instinctive mode of operation, contributing to her overall personal style.[15]

While greatly respected by most citizens and even loved by many whose lives she touched closely, the willful, red-haired woman was known for her

potentially scalding temper, and she freely admitted her tendency to "pop off." Central office colleague Sam Bratton explained that "she could have a very sharp tongue, and when somebody made her mad," she would sometimes angrily snap at them. Her partner, Mildred Patterson, described the superintendent during a fit of anger: "Her hair would get redder and her eyes would pop, and she'd raise an eyebrow, and soon be over it." According to Patterson, Miss Doyle, while *certainly* capable, only occasionally held a grudge.[16]

Patterson said that she could count on witnessing an angry episode if Mildred perceived that a child was being wronged in any way. Patterson recalled occasions when Miss Doyle "really let parents have it" when she perceived that they were neglecting their children or "letting them run wild." Miss Doyle remained in the long tradition of opinionated public school officials who overstepped their boundaries in reprimanding parents for failing to adhere to their personal ideas about dealing with children. Miss Doyle did not think that her responsibility ended at the schoolhouse door; she knew that students brought their pain and family problems with them to school, and as a caring educator, she found it difficult not to want to intervene on behalf of children. Superintendent Doyle may not have meant to patronize the child-rearing practices of parents, yet her rather aggressive behavior toward parents could be construed as condescending and paternalistic.[17]

Open and frank herself, the superintendent was indignant when she encountered duplicity in others. Patterson explained that Miss Doyle became especially angry with political exchanges in which someone was being "underhanded" about things—talking one way and doing another. While Patterson referred specifically to Miss Doyle's political dealings, she explained that the superintendent became angered by that kind of behavior in anyone with whom she interacted.[18]

Relations with governing boards provided many opportunities for Miss Doyle's ire, and Knoxville newspaper reporters were delighted with the emotional conflagrations that raged between the superintendent and the Knox County Court, the governing body responsible for approval of the county school budget. Mildred and her staff worked diligently to present what she considered to be reasonable budget figures to the court, thus she justified her anger over resistance on the part of squires to accept her proposals. She was widely respected for never padding a budget and for bringing proposals before the court that called for spending only in ways she considered essential for good schooling, thus, her temper flared when the squires did not see eye to eye with her. Regardless of portrayals by

the press, the aggressive Mildred Doyle, unable to understand "what was so durn sacred about the tax rate," played verbal hardball when fighting to secure school funding. She believed that it was the community's responsibility to support quality public schools for their children, and if tax increases were necessary the community at large should be willing to support them. It should be noted, however, that questioning the sacredness of the tax rate was easier for Mildred Doyle than was it for county court members, as she never had to answer to her constituency regarding the necessity of a tax hike. While there were periods in which virtual war raged between squires and Mildred Doyle, the superintendent's political skills, including her legendary humor, usually resulted in the development of relationships of mutual respect and patterns of reciprocal support between the squires and the superintendent.[19]

Teachers and principals appreciated the aggressive (and paternalistic) Superintendent Doyle's struggles with the taxing bodies. Like many other women superintendents, her political power base was female teachers and their organizations. But she also had the support of male administrators. Principal John McCloud recalled, "[She] fought all our battles for us." And powerful Tennesseans, including former Tennessee governor and U.S. Secretary of Education Lamar Alexander and U.S. Senator Howard Baker, who called her "the very essence of the stern, but understanding educator," praised her ability to play hardball politics to get what she wanted for her school system. While some people felt intimidated by her tendency to fly off the handle, others respected her quick temper, sharp tongue, and dauntless determination for they felt her battles, both politically and educationally, were ultimately fought on behalf of the children in her care.[20]

Those who knew her do not recall Mildred Doyle's temper and toughness, however, without remembering the keen sense of humor that kept local citizens amused for decades. Mildred had a "Rolodex" of jokes and humorous stories inside her head, which is not surprising as she kept a thick folder of such material in her filing cabinet for reference. She used jokes and humorous anecdotes in planned speeches as well as extemporaneously in informal conversations. Copies of speeches made to colleagues, students, and various community groups reveal notes in the margins, signaling appropriate times to add a humorous touch—a joke, an anecdote, or a yarn. As a stand-up comedian, she often transformed otherwise dry speeches into entertainment. She was popular at a podium and was constantly in demand for speaking engagements at civic meetings and social functions.[21]

Her humor had a folksy, homespun, down-to-earth quality; often it was corny. Depending on her audience, she could be somewhat risqué, but never vulgar. She detested vulgarity in any form. Often she seemed blind to gender constructs, and some of the jokes and stories contained in her "humor file" could be considered blatantly sexist as they, for example, portray women as nags or brow-beaters of men, but she seemed unaware that she perpetuated socially constructed stereotypes. Born just after the turn of the century in 1904, her particular sense of humor was shaped largely by her experiences among a southern Appalachian, male-dominated leadership class. Nonetheless, she amused East Tennesseans in varying degrees throughout a half century spent in the public sphere.

People who never knew Mildred Doyle personally often express a fond awareness of her penchant for telling jokes. Rarely does her name arise in a Tennessee conversation without a tandem reference to her notable sense of humor and quick wit. Always seeking comic relief, Mildred spoke in a local newspaper interview in 1986 about the ways in which children have changed over her years as an educator. She talked about a child (someone she supposedly knew) who played the role of the innkeeper in a Christmas program depicting the birth of Jesus Christ. According to Miss Doyle, "Mary and Joseph entered the scene and knocked on the door of the inn. A high little voice answered. 'I am sorry for you, but there is no room in the inn, but would you like to come in for a beer?'" In fundamentalist Tennessee, jokes about drinking were considered roguish humor. In a University of Tennessee College of Education faculty meeting address, the old athlete told of her honor to visit the Big Orange football locker room while the players were getting their physicals: the physician called out from the examination room that he had a case of VD in there. "Good!" said the huge tackle sitting next to her. "I'm getting so tired of Gator Ade."[22]

Mildred's routine use of humor in public interaction endeared her to people and served to narrow the communication gap between a powerful public official and the average citizen. As a school superintendent, Mildred Doyle was deadly serious about her work, and her charisma and sense of humor served her well. People trusted her, and their devotion and cooperation afforded her more power and community influence than is typical for school superintendents.

In addition to her blazing temper and playful sense of humor, Mildred Doyle had a softer, more sentimental side that she preferred to conceal from the general public. The same Mildred who fought heatedly with Knox County Court over school budgets became teary-eyed over televi-

sion episodes of *Little House on the Prairie* or a particularly moving musical performance. If at home, she often left the room because she did not want to be seen crying over a sad movie on television. Paradoxically, the tough, salty superintendent's favorite day of the year was Valentine's Day, and Judy Garland's emotional "Somewhere over the Rainbow" was a song she loved so much that she arranged to have it performed at her funeral service.[23]

Mildred's partner and colleague, Mildred Patterson, remembered her as "a soft-hearted person, but she did not want you to know that. She took care of many, many children—even getting them money and buying them shoes. People did not know that side of her." Mildred Doyle was often moved to tears over children who were mentally or physically disabled. She was used to control and felt helpless because she could not do anything personally to significantly change their situations. Her powerlessness upset her as much as the plight of the children. Superintendent Doyle personally, and without fanfare, paid out-of-state tuition for a troubled girl who had been expelled from a Knox County high school, enabling the student to graduate. When she was principal at Vestal Grammar School, located in a pocket of white Appalachian poverty in south Knoxville, Mildred quietly had a load of coal delivered to a student's family who could not afford to heat their home for the winter. "Her heart was as broad as could be," Patterson concluded. "She would've helped everybody if she could've."[24]

Mildred's niece Sue Hicks told of the time her Aunt Mildred and Patterson took her to New York for a high school graduation present. The superintendent, who "was a maniac behind the wheel," got caught in a speed trap somewhere in New Jersey and was forced to appear before a judge and pay a one hundred dollar fine or go to jail. A distressed young couple who had just gotten married had also been caught in the speed trap. Upon learning that the couple had very little money, Mildred Doyle paid their fine so that they would not have to spend their wedding night in jail. Hicks explained that "she was always doing stuff like that and never telling anybody."[25]

While teachers, parents, and other citizens were generally aware of a kind of overall goodness associated with the superintendent, many of her expressions of tenderness or sympathy were witnessed behind the scenes as she preferred to put forth a more male, tough guy kind of image for the public. She chose to present herself as tough, strong, funny, capable, understanding, and caring, but never soft or sentimental. These qualities, whether common knowledge or not, created an indelible personal flair

that contributed immeasurably to her success as an educator, politician, and powerful community leader.

Until a vicious election, with lesbian charges, in 1976, Mildred Doyle faced little or no opposition in her campaigns for school superintendent. Indeed, she faced only one opponent in the Republican primaries after 1946 and only two Democratic opponents in general elections between 1952 and 1976. Throughout her superintendency she gained the people's confidence and developed a great deal of political savvy and clout. Would-be competitors were daunted by her considerable influence and support by the local Republican Party, and the overwhelming number of Republican voters in Knox County curbed the enthusiasm of Democratic candidates or of Republicans with less community strength. Mildred Doyle also enjoyed the support of both political parties represented on the board of education and the county court, and both local newspapers, the *Knoxville Journal* and the *Knoxville News-Sentinel*, supported her, providing an immense source of political power. In addition, the majority of Knox Countians were reasonably satisfied if not completely happy with Mildred's administrative record as school chief. During a crucial generation of change, including significant increases in county population, she expanded and modernized an antiquated school system to ultimately serve hundreds of thousands of students.[26]

Notes

1. Leon Stafford, "Doyle Helped Others until the End: Former Superintendent Active in Fund Raising for Cancer Van Patients,"*Knoxville News-Sentinel*, 9 May 1989, B1; Kaye Franklin Veal, "Mildred Doyle, a Leader in ET Education Dies," *Knoxville News-Sentinel*, 7 May 1989, A1; "Mildred E. Doyle," *Knoxville News-Sentinel*, 8 May 1989, A6.

2. F. Graham Lee, letter to Mildred Doyle, 30 November 1988, personal files. Faye Cox, Mildred's niece, explained to me that she often accompanied Miss Doyle on errands or to schools, and on occasion she even returned to the office when the superintendent worked on weekends because Miss Doyle did not like to be alone.

3. These anecdotes were taken from the Reverend Temple's remarks as he officiated at Mildred Doyle's funeral ceremony. See "Funeral Service for Mildred E. Doyle," 9 May 1989. A printed copy was given to me by Mildred's sister Ruth Doyle Hilton on 25 February 1994; Mildred Patterson, interview by author, 10 October 1994.

4. Patterson, interview by author, 1 March 1995.

5. Patterson, interviews by author, 10 October 1994 and 1 March 1995; Sue Hicks, Mildred's niece, interview by author, 13 October 1994.

6. Jackie M. Blount, *Destined to Rule the Schools: Women and the Superintendency, 1873–1995* (Albany: State University of New York Press: 1998), 61, 116, 176, 190. This gender pattern in educational administration has been amply documented by researchers. For examples, see Michael Apple, "Teaching and 'Women's Work': A Comparative Historical and Ideological Analysis, *Teachers College Record* 86 (1985): 455–473; Sari Biklen and Marilyn Brannigan, eds., *Women and Educational Leadership* (Lexington, MA: D. C. Heath and Co., 1980); Myra Strober and David Tyack, "Why Do Women Teach and Men Manage? A Report on Research on Schools," *Signs* 5 (1980): 494–503; David Tyack and Elisabeth Hansot, *Managers of Virtue: Public School Leadership in America, 1820–1980* (New York: Basic Books, 1982).

7. Squire H. T. Seymour of the Knox County Court, quoted in Homer Clonts, "More About 'Lost Day,'" *Knoxville News-Sentinel*, 28 February 1960, B8; Mildred Doyle discussed the condition of the school system in Clinton B. Allison, *Mildred Doyle: A Conversation at Eighty* (Knoxville, TN: UTK College of Education Instructional Services Center, 1986), videocassette. The school conditions in 1946 are discussed in Carol E. Baker, "Superintendent Mildred E. Doyle: Educational Leader, Politician, Woman," (Ed.D. diss., University of Tennessee, 1977).

8. Mildred Doyle revealed her campaign intentions in "Aspirants Eye GOP Primary," *Knoxville Journal*, 7 February 1946, A1. Many articles from the *Knoxville Journal* and the *Knoxville News-Sentinel* attest to the legendary status of Miss Doyle.

9. Mildred's niece Sue Hicks used the phrase "big presence" in describing her aunt (interview by author, 13 October 1994).

10. Lois Thomas, "Departing Supt. Doyle Feels Funds Pose Biggest School System Obstacle," *Knoxville News-Sentinel*, 29 August 1976, A1.

11. Her dual devotion to public service and politics was described by Mildred's cousin Gordon Sams (interview by author, 3 March 1994) and by Mildred's Personnel Director and Administrative Assistant Mildred Patterson (interviews by author, 9 March 1994 and 8 June 1994); copies of speeches where Mildred Doyle frequently used the phrase "do what's best for the boys and girls of Knox County" were obtained from her personal files; Patterson, interviews by author, 9 March 1994 and 8 June 1994.

12. Faye Cox, interview by author, 9 March 1994, 8 June 1994, and 5 December 1994; and in Patterson's written introduction of Mildred Doyle for a speaking engagement at the Knoxville Exchange Club, 22 June 1972, personal files.

13. According to central office colleague Samuel Bratton (interview by author, 4 March 1994), Mildred often used the "fodder on the ground" phrase to describe policy explanations to the public. It should be noted here that she also demystified educational issues for the Knox County Court in budget hearings. This factor has been cited as significant in developing a working relationship with court members. See C. Baker, "Superindendent Doyle," 186. The "Mrs. King" story was cited as an example of Mildred's patience and skill at communication by administrative assistant Patterson (interview by author, 8 June 1994). References to the incident were also found in Mildred Doyle's personal files.

14. Faye Cox, interview by author, 5 December 1994.

15. Cox, interview by author, 1 March 1995. The radio show was described in Cynthia Moxley, "Benevolent Dictator: For 30 Years, Mildred Doyle Got Things Done as School Chief," *Knoxville Journal*, 4 July 1985, A1. Moxley also discussed Miss Doyle's "open door" policy concerning office hours, as did Mildred's former secretary, Cox (interview by author, 5 December 1994).

16. Quoted in Georgiana Vines, "Women in Public Life: Miss Doyle Reminisces," *Knoxville News-Sentinel*, 17 June 1973, A6; Bratton, interview by author, 4 March 1994; Patterson, interview by author, 10 October 1994.

17. Patterson, interview by author, 10 October 1994.

18. Ibid.

19. Patterson, interview by author, 8 June 1994; Kaye Franklin Veal, "Mildred Doyle Saluted for Service to Schools," *Knoxville News-Sentinel*, 1 October 1986, A16; Baker, "Superintendent Doyle," 185.

20. On support of female administrators by women's groups and teacher organizations, see Blount, *Destined to Rule the Schools*, 81, 126; Baker, "Superintendent Doyle," 185; Mildred's sister Ruth Doyle Hilton, interview by author, 25

February 1994. Hilton recalled that Mildred would get angry if the county court failed to immediately approve funding for various programs. Moxley, "Benevolent Dictator," A8.

21. Cox, interview by author, 5 December 1995. Miss Doyle's personal files containing humorous material and copies of speeches are located in the home of Patterson.

22. Veal, "Mildred Doyle," A16. The "beer" story was also found in Miss Doyle's personal file of collected jokes and humorous stories to be used at her discretion; Clinton B. Allison, recollection. Recollections of her humor were common when I mentioned Mildred's name in casual conversation with UTK faculty and staff and other Knox County citizens, usually those who had resided in the area at least ten years or more.

23. Patterson, interview by author, 10 October 1994.

24. Hilton, interview by author, 25 February 1994; Patterson, interview by author, 9 March 1994, 10 March 1994, 8 June 1994, and 10 October 1994. The incident concerning payment of a student's tuition was described in Patterson's written introduction of Mildred Doyle for the Knoxville Exchange Club, 22 June 1972, personal files.

25. Hicks, interview by author, 13 October 1994.

26. C. Baker, "Benevolent Dictator," 167; Patterson discussed Charter Doyle's influence and Mildred's personal power acquisition (interview by author, 8 June 1994); Official Knox County Election Return Sheets between the years of 1952 and 1976 confirm infrequent opposition.

Chapter 2

Negotiating Gender Constructs:
Student, Athlete, Teacher, Principal

Since Mildred Doyle often chose to adopt roles considered nontraditional for women of her time, she, consciously or subconsciously, had to negotiate gender constructs. This chapter explores ways in which Mildred experienced her gendered identity, tracing her interaction with gender as a social construct during her life as a young girl, an athlete, a teacher, and a principal.

From Mildred's Appalachian mountain heritage she witnessed women as independent and strong, both emotionally and physically. Despite this independence and strength, however, Appalachian women often lived a commitment to more traditional gender roles as caretakers of their children and homes. Their gender identity centered largely on their homeplace, marriage, and family, while their husbands sought work in the public world of fields, mines, or quarries.[1]

Mildred Doyle fit this model with respect to her independent nature and physical and emotional strength, yet she neither married nor cared for children of her own within the private sphere of the home. Rather, she entered and remained in the public world of paid work, supporting herself for fifty-two years until she faced political defeat as superintendent. Regardless of her life's choice not to follow the traditional pattern of marriage and bearing children, family members and colleagues saw her as a matriarchal figure, not only of the extensive Doyle clan, but of the entire Knox County School system. Throughout her eighty-four years, Mildred Doyle shattered various gender barriers and felt the constraints of others. In still other cases, she seems to have remained largely unconscious of gender as a social construct while simultaneously serving as a role model for women in educational leadership and politics.[2]

Early Life in Rural Knox County

Mildred Doyle and her parents, grandparents, and great grandparents were born in the great valley of the Tennessee River in southern Appalachia, one of the greenest, most beautiful places on earth. Traditions of southern chivalry as well as Victorian attitudes influenced gender beliefs in Knox County when Mildred Eloise was born to Illia and Charter Doyle on 27 December 1904. Gender ideology which emphasized separate spheres for women and men continued to loom large in the minds of many Americans and most southerners. Conventional beliefs about the frailty of women and their place inside the home, however, never rooted deeply in the mind of Mildred Doyle. Her childhood never required it of her.

Mildred's parents, Charter Doyle and Illia Burnett, married on 16 February 1895. The determined young couple braved a driving snowstorm, taking a horse-drawn sleigh to the home of a justice of the peace, Squire Abe Maxey, who performed their wedding ceremony. The marriage lasted fifty-four years, until Charter's death in 1949, followed by Illia's death six months later. Mildred was one of six daughters and five sons born to the Doyles, who lived on a twenty-acre farm off Neubert Springs Road in south Knox County. The land was part of her great-great-grandfather John Doyle's original Revolutionary War land grant of 1800. Around 1912, the family moved to Charter Doyle's childhood home, a larger farm of two hundred acres, still part of the original land grant and located on Martin Mill Pike, closer to the tiny working-class community of Vestal. Some of the farmland and the large, white, two-story frame house, known as "the Homeplace," still remain in Doyle hands as the home of Mildred's younger brother Otto, or "Pinky," although the city limits of Knoxville have long since encompassed it. The Doyle family shared with other Appalachians such traditional values as family solidarity, independence, self-reliance, pride, and devotion to keeping their homeplace in the family. Although Charter Doyle worked as a timber buyer for Vestal Lumber Company for over fifty years, he kept a small farming operation alive on the Homeplace to supply dairy products, meats, and vegetables for his family. The Doyles were financially comfortable, neither wealthy nor poor.[3]

The Doyle children, including the girls, were an active crew who were expected to help with never-ending chores around the farm. Mildred's sister Ruth recalls, "We didn't have a dainty way of life, I'll tell you that, because there was too much to do." In an interview in 1976 Mildred remembered her early life on the farm:

"We had chickens, cows, a horse I nearly rode to death. We lived the life of a regular farm family for the most part . . . it was a good life; I enjoyed it. I milked cows, churned butter, helped take care of the garden, picked blackberries."[4]

When her three older brothers served in the army during World War I, young Mildred helped willingly with strenuous tasks around the farm, jobs that would normally have been assigned to Bert, Eugene, or Thomas. In one particular incident her father had a large alfalfa field that needed cutting before an imminent rain shower. Mildred told him confidently, "If you'll hitch that team of mules to the mowing machine, I'll mow it and we'll rake it and get it into the barn." She beat the rain. The superintendent recalled the physical results of those busy years, "I got to be strong as an ox." An active life on the farm did not leave much time for this free spirit to contemplate rigid gender roles evident in the broader society, nor did her practical Appalachian parents expect it of her. They needed her help in the fields, and Mildred enjoyed the challenge. It was that simple. Consequently, the young and independent Mildred developed an appreciation for hard work, for the outdoors, and an unwavering confidence in her physical capabilities. From this nascent sense of her personal strength sprung the instinctive drive that later propelled her into educational leadership positions in Knox County that were never before held by a woman. First, however, the energetic young girl became captivated by athletics, a love she would possess her entire life.[5]

Athletics

Mildred Doyle was a natural athlete; she felt at home in the sporting world, which has been considered a "male preserve" since ancient times. During Mildred's days as an athlete in the first half of the twentieth century, opportunities for women were severely limited, due both to societal expectations of appropriate behavior for women and lack of financial backing for organized women's athletics. She participated in sports long before the 1970s when women fought for equality with men's athletic programs through such efforts as the passage of Title IX of the Education Amendment Act. Despite obvious inequities, Mildred Doyle appreciated the advances made in girls' athletics that she witnessed in her lifetime. In a newspaper interview six years before her death, she commented on advantages for girls that were absent in her day: "They have the equipment and the facilities and the coaching. We were pretty much on our own. It's good to see people recognizing the fact that girls can be really

outstanding athletes." Any increases in opportunity or changes in social perception seemed significant to her as she had experienced being denied an opportunity for recognition as a female professional athlete. Although Mildred's introduction to sports began in informal family settings, she eventually played basketball in high school and college and, later, basketball and softball in independent leagues in the Knoxville area. Mildred's love for sports ran so deeply that had there been the slightest opening for women, she would have sprinted through the gate to professional athletic competition. To be recognized as a professional athlete was her impossible dream.[6]

The Doyle family "lived and breathed sports, especially baseball." Rather than discourage their daughters from participation in outdoor sports, Charter and Illia Doyle regularly organized baseball games at the Homeplace for the entire family and any neighboring children who happened by. In an interview just after her election to the superintendency in 1946, Mildred told a reporter, "Counting Mama, there were always enough of us at home for a real good ball game." Her maternal grandfather even had his own baseball team bearing his name, "The T. J. Burnetts." Throughout the warm East Tennessee summers the family youngsters challenged others in the community to afternoon ball games in Mr. Burnett's cow pasture. It is likely that during these years of family support, Mildred began to nurture her characteristic aggressive competitive spirit and superb athletic coordination.[7]

As an elementary student at the two-room Moore's School, Mildred, the red-headed "tomboy," as she described herself, chose to hang out with the boys rather than the girls at recess as they tended to be more physically active. Because of her physical strength and skill, her schoolmates often chose her first in team selection. Mildred's competitive drive and prowess extended from the boys' playing field to the marble ring, and according to her sister Ruth, "She could shoot as well as any boy at Moore's School."[8]

Circumstances such as these likely contributed to the subconscious formation of Mildred's unique personality and enabled her as an adult to move comfortably and with great respect in the male-centered world of politics and educational leadership. According to her companion, Mildred Patterson, Mildred Doyle "thought she was as good as any man living," and while she was close to many women, "she had more men friends than she had women friends." Further, Patterson believes that Mildred Doyle "thought like a man" in that she was aggressive when going after things she wanted, a characteristic that Patterson more closely associates with men than with women in American culture.[9]

After completing grades one through six at Moore's School, Mildred attended Young High School as a seventh grader in 1916. She soon developed a novel reputation, not by being the only Doyle child to ride to school on a horse—bareback—but for being a mischievous student and a tough ball player with a temper to match. Mildred made the girls' basketball team as a freshman in 1918, playing guard for four years. The team played on outdoor courts, often dealing with windy weather that affected play. The girls wore bloomers, "the standard uniform in those days." A reporter described Mildred's aggressive play: "Known on the court as a fierce competitor, Red Doyle was not to be reckoned with unfairly by either opponent or referee. Never one to keep her thoughts to herself on the hardwood [or elsewhere], Doyle's spicy language sometimes got her into trouble with the officials." Forever the successful competitor, Mildred Doyle never got used to losing at anything—including her last bid as Knox County superintendent of schools. By her senior year, Mildred's leadership abilities had already begun to emerge as she served as both manager and captain of the girls' team. Mildred recalled high school as a happy time as she gained recognition as an athlete and a leader.[10]

Upon graduation, Mildred's family made plans for her to attend Maryville College, a Presbyterian boarding school in neighboring Blount County. Mildred consented, although she was much less interested in academics than in the fact that Maryville had a women's basketball team. She made the team and played for one season; according to local folklore, rival coaches were known to threaten to forfeit games if the aggressive Red Doyle was not kept under control. Mildred's devotion to the basketball court during the 1922-23 school year showed up on her final grade report. In English, she made a C and a D. Failing mathematics and French, she managed C's in Spanish and biology. Bible class was mandatory and graded on a pass/fail scale—she passed. Not surprisingly, she passed physical education as well. Clearly, academics were not the future educator's top priority as a college freshman. In addition to her marginal grades, she received a total of nine demerits, which were noted but not explained on her records. The present registrar excuses the college's now famous alumna by explaining that demerits were "very easy to get in those days." A student could receive a demerit for being late to chapel or to the dormitory. Smoking cigarettes was a more serious offense. Apparently, women were not allowed to play cards in their dormitory rooms either—a temptation too great for the gamester Mildred to resist. Her sister Ruth remembers Mildred "being campused" for getting caught with a deck in her footlocker; this surely accounts for at least one of the nine demerits. Per-

haps the boisterous freshman received another demerit for the incident in which she jumped on the running board of her visiting family's car and rode with them to the entrance gate of the college before hopping off and running back to her dorm, only to be caught by the dorm mother.[11]

The reasons for Mildred's leaving Maryville College are unclear. Her record for the 1923–24 academic year states simply "Left School Before Exams—January 5, 1924." Mildred's niece Sue Hicks mentioned that she had been expelled, but the record itself is ambiguous. The irony here is that the future school superintendent attended Maryville college only to play basketball, left school with a poor academic history, and in 1965 the College awarded her an honorary doctorate for her outstanding contribution to education and to the community.[12]

For whatever reason, the 1922–23 basketball season was Mildred's last school-related athletic competition. Since no opportunities for women's participation in professional athletics existed in the 1920s, Mildred hit a concrete gender barrier for perhaps the first and only time in her life. She dreamed of recognition as a professional athlete, yet fulfilling the dream was beyond her control, a disappointment that was especially frustrating for a young woman who had seldom experienced gender as a barrier to personal aspirations and who had always enjoyed considerable control over her life. She later mused that she had been born a half century too soon for the realization of her dream of starring in professional sports.[13]

While opportunities to make a living as an athlete eluded Mildred Doyle, she played basketball for approximately twenty years on independent leagues in the Knoxville area. Mildred, along with her sisters Lois and Ruth, played for a women's team sponsored by the Firestone Tire Company. They looked forward to Thursday night games at the YMCA and occasional travels to neighboring communities to compete with other teams. With the aggressive Mildred as captain and manager, their team was among the first in the region to abandon the old bloomers for the newer and less modest uniform style of jerseys and shorts.[14]

Basketball was not the only sport Mildred enjoyed. She also played first base in softball for the Pepsi Cola Bottling Company and on independent leagues from 1938 until the time she announced her candidacy for the superintendent's race. Mildred delighted in telling a story about her later days in softball when she did not move as quickly as before. She hit the ball late, knocking it just over first base rather than hitting it toward the usual center or deep into right field. She said anyone else could have made it safely, but she was thrown out at first base. This happened twice, and the second time, as she headed back to the dugout, she said, "Some

leather-lunged farmer sitting up here in the stands reared back and says, 'Come on Granny, you run like a dry spring!'" After that incident, Knox County teachers affectionately called her "Granny."[15]

Shortly thereafter, Granny hung up her cleats—not because she was ready, but because she was about to run for superintendent and was told that "it wasn't ladylike to play softball and attempt to be superintendent of schools too." However, her natural abilities were not forgotten. In a poll conducted by the *Knoxville Journal*, she was named Tennessee's Outstanding Woman Athlete from 1900 to 1950 and was inducted into the Knoxville Sports Hall of Fame in 1983. Men, of course, usually found participation in athletics to be helpful in attaining administrative positions, one of the ways that women were at a disadvantage. In 1971, as an example, 80 percent of superintendents were former coaches.[16]

It isn't known exactly how Mildred reacted to the gender role constraints implicit in the suggestion that it "wasn't ladylike" to play ball and run for school superintendent. For *some* citizens, it "wasn't ladylike" to run for school superintendent, never mind the ball playing. Mildred chose her battles carefully. She acquiesced in gender conventions by following the advice to give up the "unladylike" softball, yet she ignored caveats from citizens regarding her aspirations that the position of school superintendent was a man's job—despite the fact that overwhelming numbers of superintendents were, and still are, men.[17]

Gender conventions in athletics made themselves real to Mildred Doyle for they largely controlled her destiny. She stated plainly many times that not only did she want more than anything to be a professional ball player, but she "would *never* be an old maid school teacher." However, the gender barrier against professional opportunities for women in sport was insurmountable, and she had no other real choices except to seek a career outside athletics or get married. There is no evidence that she ever considered the later, and she never intended to become a teacher. It was the commonly enforced policy barring married women from teaching school that launched Mildred's unlikely, although lengthy and productive, career as an educator. Ironically, for the unmarried Mildred, this exclusionary type of gender-based policy welcomed her into school teaching following her stint at Maryville College.[18]

Teaching

David Tyack and Elisabeth Hansot explain that early supporters of hiring women teachers "assumed that they would, of course, leave their work

when married and that marriage was the goal of all proper women." Until after World War II, most teachers were unmarried and there existed official policies throughout the nation, including Knox County, prohibiting married women from teaching school.[19]

After leaving Maryville College, the nineteen-year-old Mildred moved back to the Homeplace and continued to help with chores around the farm when not playing basketball and tennis. During the summer of 1924, Mildred's sister Lois, an elementary teacher at Anderson School, married. Because of the Knox County Board of Education's policy concerning the prohibition of married teachers, Lois was forced to quit her job, leaving a vacancy that would have to be filled by the beginning of the fall semester.[20]

By that time her father, Charter Doyle, had amassed enough political clout to land a seat on the Knox County Quarterly Court, the chief governing body of Knox County. The court exercised considerable control over public schools, and it often expanded its control beyond its legal boundaries by hiring school personnel as political favors. Mildred Patterson explained the hiring process, "You had to know a Squire or a member of the Board to get a job, and it helped to be a Republican." The privileged few exercised a significant degree of social control over the schools by awarding coveted teaching jobs. Charter Doyle simply asked Mildred if she would be interested in taking the position vacated by her sister at Anderson School. He then arranged her appointment with the Knox County Schools, and that fall Mildred, who had vowed never to become an "old maid school teacher," accepted her first teaching job on a one-year provisional certificate issued to all high school graduates at the time.[21]

Patriarchal policies and cultural norms for women prohibited Mildred from living the dream of becoming a professional athlete while enabling her to move into the career in which she would devote the next half century of her life. Mildred Doyle soon discovered that she enjoyed teaching, and throughout her career she was passionate about the lifelong benefits of an education.

Following one year at Anderson as a teacher of the third, fourth, and fifth grades, Mildred was reassigned to Vestal Grammar School where she taught fourth and fifth grades. Her provisional teaching certificate expired after one year, renewable only if she continued work on her education. She enrolled at the University of Tennessee where she took night classes and diligently attended summer school every year until she received her bachelor's degree in 1940 with a double major in history and education. She received her master's degree in Educational Administration and Supervision in 1944.[22]

A classmate remembered Mildred during their graduate work at Tennessee:

> In class she was good, always active in discussions; her views were not controversial, nor was she in a rut, wanting to hold on to the old ways . . . she would say if we could find somebody to be a benevolent dictator . . . in education and government . . . somebody who really had the welfare of people and children at heart and would work to that end . . . a "papa figure". . . but then we decided that the benevolence would fade away and he would become a typical dictator.

Mildred's conception of the educational leader as a "papa figure" is noteworthy. Whether she had set her sights on the superintendency at that point is not certain, yet it would seem by that characterization that she, too, accepted at least subconsciously the typical pattern of males holding the vast majority of educational leadership positions. The pattern in Knox County was so persistent that in all likelihood she took it for granted, or perhaps she actually considered herself a kind of "papa figure" as superintendent.[23]

In 1929 she fractured a gender barrier in educational leadership when she became one of the first female principals in a Knox County school. (While women have had the greatest representation in educational administration as elementary principals, percentages of women principals in elementary schools declined from 61.7 to 19.6 percent.) When Mildred decided to seek the principalship at Vestal, only about one-half of the nation's elementary principals were women and in Knox County women principals, even at the elementary level, were extremely rare. Mildred had a head-on collision with gender expectations and East Tennessee morality as her travels upward in the educational hierarchy created a serious community uproar.[24]

The "Flapper Case"

Mildred had taught for three years at Vestal School in south Knox County when the male principal requested a transfer to another school. The ambitious and aggressive twenty-three-year-old teacher considered herself qualified to fill Mr. Weaver's shoes as principal at Vestal, a four-room school with an auditorium and a staff of three female teachers, including herself. She decided, "[I] could do a better job than some others. I felt I could be a pretty good principal. I applied for the job and got it." Then the fireworks began. Apparently, Mildred had not considered that her gender might pose a problem for some residents of the community.[25]

Fifteen members of the Vestal Parent-Teacher Association brought written charges against Mildred Doyle before the Knox County Board of Education on 11 September 1929, two days after the opening of fall semester classes. The PTA had been grumbling about her application for several months prior to submitting their formal charges to the board. A series of articles spanning a two-month period appeared in Knoxville newspapers, keeping citizens informed of developments in the "Flapper Case." The PTA charged that Miss Doyle was "a product of the reckless, thoughtless, don't care flapper age" and requested that "a man of high Christian morals" be appointed to take her place. They further asserted that she kept late hours and "even cussed a little bit," citing that members had witnessed Mildred's use of indecent language in her home three years before. The PTA also expressed concern that Miss Doyle was too young and inexperienced to handle the job and explained to the school board that members of the association would be "willing to transfer her in exchange for the principal of any school of any district in which a member of the school board may reside."[26]

Mildred, too busy at Vestal School to attend the meetings, responded through her attorney with a written motion to dismiss the charges. Although they postponed a hearing for as long as possible, hoping the issue would settle itself, the county school board finally held a special meeting on 30 September to address the charges. Mildred's attorney, John Jennings Jr., argued eloquently that the charges were vague and indefinite while members of the PTA and their attorney looked on. Jennings built a strong case for which he had gathered sworn statements from Mildred's supporters such as former Vestal principal Ebb King, who attested to his belief in her: "She is a young woman of sterling character. Her moral and private life can not be questioned."[27]

Ultimately, board members voted unanimously to dismiss all charges against Mildred. Board member A. W. Mays made a motion to examine the possibility of a transfer for Miss Doyle to another school, a plan he had suggested in a previous meeting. Although the motion received a second, the board never took any further action to transfer her.[28]

Members of the Vestal PTA were unaccustomed to seeing women in positions of educational leadership in Knox County. Generally fundamentalist, provincial, and resistant to change, they were genuinely concerned about a young woman's capabilities for running their community school— particularly a woman whom they considered to be a "flapper." Having expressed these concerns to the school board and the county court prior to Mildred's appointment, members of the PTA were angry because they

felt that Squire Charter Doyle had ignored them and influenced Mildred's appointment despite their concerns.[29]

In all likelihood Mildred's appointment was politically influenced and school board members would probably have voted to dismiss the charges even if they had been more substantial. Charter Doyle was a powerful man, and the board's reticence to hear the case suggests that members desired to avoid political controversy if possible. They resisted being wedged between the power of Charter Doyle and the wishes of a disgruntled Knox County citizens group. However, attendance records on the first day of school at Vestal indicate the confidence that many parents had in the "flapper" principal, despite the Vestal PTA's preference for a male with Christian morals. According to Superintendent W. W. Morris, Vestal School opened with a record enrollment of 257 students with only two families keeping their students out of school due to charges against Miss Doyle. In his testimony at the board hearing on 30 September, the superintendent told of a visit he made to the school the previous week: "Discipline was good and classes were regular. No complaints have come to me since school opened as to Miss Doyle's inability to keep good order." Perhaps the record enrollment figures were the most solid signal that many residents of the Vestal community felt comfortable with Miss Doyle as their new principal. In 1983 Principal Leland Lyon awarded Mildred a certificate of commemoration from Vestal Elementary School for her services as teacher, principal, and superintendent.[30]

When Mildred was asked years later whether she felt discriminated against as a woman, she recalled, "Being as aggressive as I was, it didn't occur to me at the time that I was being discriminated against." During the controversy, she considered the charges "a general indictment of the younger generation" rather than a case of gender discrimination against her personally.[31]

Mildred clearly saw herself as capable of handling the job, and she certainly did not consider herself a flapper. Rather, a "tomboy" is how she retrospectively characterized herself. In all likelihood the tomboy was not conscious of the fact that, as one of the first women principals in Knox County, she inadvertently paved the way for women to follow in leadership positions.[32]

Notes

1. Characterizations of Appalachian women as seen through the eyes of Appalachian women novelists are found in Kathleen Bennett DeMarrais, "Wrenched from the Earth: Appalachian Women in Conflict," in *Curriculum as Social Psychoanalysis: The Significance of Place*, eds. Joe L. Kincheloe and William F. Pinar (Albany, NY: SUNY Press, 1991), 99–120. DeMarrais describes the economic hardship and struggle for survival faced by Appalachian mountain people after industrialization threatened farm life.

2. Mildred's colleague Samuel Bratton, interview by author, 4 March 1994; Sue Hicks, Mildred's niece, interview by author, 13 October 1994; Mildred's sister Ruth Doyle Hilton, interview by author, 25 February 1994; Mildred's partner and colleague, Mildred Patterson, interview by author, 8 June 1994; Mildred's cousin Gordon Sams, interview by author, 3 March 1994. Each either used the term "matriarch" outright or referred to her as the "head" of the family. Miss Doyle was largely responsible for organizing many Doyle family reunions and various get-togethers throughout the years.

3. "Charter E. Doyles Celebrating Fiftieth Wedding Anniversary," the *Knoxville News-Sentinel*, 16 February 1945, photocopy, Doyle Family File, McClung Collection, East Tennesee Historical Society, Knoxville, TN; "Mrs. Charter Doyle Is Dead at 73," the *Knoxville News-Sentinel*, 17 October 1949, photocopy, Doyle Family File, McClung Collection; Clinton B. Allison, *Mildred Doyle: A Conversation at Eighty* (UTK College of Education Instructional Services Center, 1986), videocassette; Ruth Doyle Hilton, interview by author, 25 February 1994; DeMarrais, "Wrenched from the Earth, 102. DeMarrais describes such values as being of utmost importance to Appalachian families along with their desire to maintain a sense of freedom. The Vestal community was not considered part of south Knoxville until after the completion of Chapman Highway in the 1930s when population growth and easy access contributed to development of that portion of Knoxville located "south of the river." Pinky Doyle died as this book was going to press.

4. Hilton, interview by author, 25 February 1994; Carol E. Baker, "Superintendent Mildred E. Doyle: Educational Leader, Politician, Woman" (Ed.D. diss., University of Tennessee, 1977), 100.

5. Hilton, 25 February 1994; Cynthia Moxley, "Benevolent Dictator: For 30 Years Mildred Doyle Got Things Done as School Chief," the *Knoxville Journal*, 4 July 1985, A1.

6. William J. Baker, *Sports in the Western World* (Urbana: University of Illinois Press, 1982), 2, 21–22, 295, 298–303; Nancy Theberge, "Toward a Feminist Alternative to Sport as a Male Preserve," *Quest* 37 (1986): 193–202; Susan Birrell and Diana Richter, "Is a Diamond Forever? Feminist Transformations of

Sport," *Women's Studies International Forum* 10 (1987): 395–409; Ben Byrd, "Byrd's Eye View," *Knoxville Journal*, 24 June 1983, B1. Written into law in 1972, Title IX mandated that sex discrimination be eliminated from programs receiving federal funding of any nature. While the legislation significantly enhanced opportunities for girls' and women's athletic programs in public schools and universities across the country, its implementation has weakened during the last 20 years. Since the 1970s, social attitudes have become somewhat more accepting of female participation in sports, yet a decidedly male bias pervades, as readily exemplified by continued inequalities in the funding of men's and women's programs and in the virtual absence of opportunities for women's athletic participation at the professional level.

7. Byrd, "Byrd's Eye View"; Betsy Morris, "First Woman County Superintendent Has 21-Year Background of Teaching Here," *Knoxville News-Sentinel*, 10 July 1946, B1. According to an autobiographical document (n.d.) entitled "Mildred E. Doyle," located in Mildred's personal files, T. J. Burnett also had a fondness for horse racing and operated a race track on his property.

8. From a speech written by Mildred's sister Ruth Doyle Hilton and delivered by a cousin, James Doyle, to the Exchange Club of Knoxville on 22 June 1972 as part of a tribute to Mildred (personal files). Mildred Doyle often referred to herself as a "tomboy."

9. Patterson, interview by author, 8 June 1994.

10. "Mildred E. Doyle," autobiographical document, personal files, 2.; Patterson, interview by author, 10 October 1994; Hilton, interview by author, 25 February 1994; Miss Doyle, quoted in Byrd, "Byrd's Eye View," B1; George Roberts, "People: Mildred Doyle," *Weekly Review,* 31 December 1985, 6; Mildred Patterson, interview by author, 9 March 1994. Her sister Ruth Doyle Hilton recalled that Mildred refused to go to school unless she could ride the horse. During the school day she kept the horse in a barn located behind Young High School.

11. Martha Hess, Registrar, Maryville College, telephone interview by author, 8 February 1995; Hilton, interview by author, 25 February 1994. Mildred's academic history at Maryville College is recorded in the Office of the Registrar, Maryville College, Maryville, TN.

12. Mildred Doyle's academic history, Office of the Registrar, Maryville College.

13. Byrd, "Byrd's Eye View," B1.

14. "Mildred E. Doyle," autobiographical document, 4. A photograph of the Firestone Tire Co. team in their jerseys and shorts is located in Mildred's personal files. It was photocopied from an unidentified newspaper.

15. Allison, *A Conversation*; Mildred's former colleague Samuel Bratton told of this story in an interview on 4 March 1994; Former teammate Doris Sams cited in a telephone conversation on 16 November 1994 the fact that Mildred played until she practically had to hit a homerun to get to first base.

16. Allison, *A Conversation*; Byrd, "Byrd's Eye View," B1; Frank Bailes, "Elite Eleven Will Be Inducted June 25," *Knoxville News-Sentinel*, 4 June 1983, B1; Thomas O'Toole, "Eleven Knoxville Greats Feted at Banquet," *Knoxville News Sentinel*, 26 June 1983, D3; "Ten New Members to Be Inducted in Knoxville Sports Hall of Fame," *Knoxville Journal*, 4 June 1983, 11; Jackie M. Blount, *Destined to Rule the Schools: Women and the Superintendency, 1873–1995* (Albany: State University of New York Press, 1998), 117.

17. Patterson, interview by author, 9 March 1994. For examples of documentation and discussion of women's underrepresentation in educational administration see Blount, *Destined to Rule the Schools*; Sari K. Biklen and Marilyn B. Branigan, eds., *Women and Educational Leadership* (Lexington, MA: D. C. Heath, 1980); J. B. Saks, "Education Vital Signs," *American School Board Journal* 179, no. 12 (1992): 38; Myra Strober and David Tyack, "Why Do Women Teach and Men Manage? A Report on Research on Schools," *Signs* 5, no. 3 (1980): 494–503; David Tyack and Elisabeth Hansot, *Managers of Virtue: Public School Leadership in America, 1820–1980* (New York: Basic Books, 1982).

18. C. Baker, "Superintendent Doyle," 101; Allison, *A Conversation*. Aside from this instance, Miss Doyle made frequent references to this ironic situation.

19. Tyack and Hansot, *Managers of Virtue*, 191.

20. "Mildred E. Doyle," autobiographical document, 3.

21. C. Baker, "Superintendent Doyle," 97, 101, 160–161.

22. C. Baker, "Superintendent Doyle," 101, 104; "Mildred E. Doyle," autobiographical document 43; Moxley, "Benevolent Dictator," A1; Roberts, "People, 6"; *Permanent Professional Supervisor's Certificate*, Number 89269, State of Tennessee, Department of Education, 21 June 1945; *County Superintendent's Professional Certificate*, Number 860, State of Tennessee, Department of Education, 26 April 1946.

23. The quote was taken from an interview conducted by Carol E. Baker on 10 May 1977 with Iva Anderson Rouser, a longtime associate of Mildred Doyle (cited in C. Baker, "Superintendent Doyle," 104); Patterson, interview by author, 9 March 1994.

24. Tyack and Hansot, *Managers of Virtue*, 183–189; Hilton, interview by author, 25 February 1994.

25. Mildred Doyle, notes on Vestal School found in Mildred Doyle's personal files; C. Baker, "Superintendent Doyle,"102.

26. "Knox School Board Sighs Relief as 'Flapper' Case is Postponed," *Knoxville Journal*, 17 September 1929, photocopy, Doyle Family File, McClung Collection; "Board Decides Miss Doyle Is Downright Good Teacher," *Knoxville Journal*, 1 October 1929, 16; "Board to Consider Miss Doyle's Case at Meeting Today," *Knoxville Journal*, 30 September 1929 photocopy, Doyle Family File, McClung Collection.

27. "Knox School Board Sighs Relief"; Ebb King, affidavit to the Knox County Board of Education, 28 August 1929, Mildred Doyle's personal files.

28. "Board Decides," 16.

29. "Written Charge Demanded in School Affair," *Knoxville News-Sentinel*, 5 Sept. 1929, 2; "Mildred E. Doyle," autobiographical document, 5; C. Baker, "Superintendent Doyle," 102–3.

30. Morris quoted in "Board Decides," 16; "Board Wrangles Hour over Doyle Case: To Meet Again," *Knoxville Journal*, 12 September 1929, 3; "Knox School Board Sighs Relief;" "Board to Consider Miss Doyle's Case"; Vestal Elementary School Certificate of Commemoration awarded to Mildred E. Doyle, 1983, personal files.

31. Allison, *A Conversation*; "Knox School Board Sighs Relief."

32. Allison, *A Conversation*; Moxley, "Benevolent Dictator," A8.

Chapter 3

Negotiating Gender Constructs in a Good Old Boys' World

As in athletics and school administration, women have historically been excluded from politics as its domain falls squarely within "man's sphere" in the gender hierarchy. Mildred Doyle stepped outside cultural norms when she became deeply involved in Knox County Republican politics, beginning with a fascination that developed when she was a young girl and lasted throughout her life. This chapter examines the relationships between Mildred's experience with male political mentors (including members of her powerful family), her own mentoring and support for women teachers and administrators, and her construction of a personal life.

The Doyle Family—Power in County Government

While Doyles and Doyle descendants continue to populate south Knox County in East Tennessee, the name itself is historically synonymous with power and community influence. In 1800 Mildred's great-great-grandfather John Doyle settled in the Tennessee Valley after receiving a Revolutionary War land grant of roughly 460 acres located in the southern portion of Knox County. John Doyle became active in early county government, beginning a family tradition that would perpetuate itself into the late twentieth century.[1]

Based on the ancient system of English county legislative and judicial administration, Knox County was governed by the quarterly county court which consisted of a judge and justices of the peace, or squires, elected from various districts by popular vote. Among many other responsibilities the court exercised much power with regard to school matters. The court was responsible for levying school taxes, adopting the school budget, monitoring actions of the board of education, and issuing bonds at the authorization of voters.

In 1876 at age fifty-one, Mildred's grandfather Jacob Doyle was elected as a justice of the peace on the Knox County Quarterly Court. The staunch Republican, elected for a second six-year term in 1882, died in office on 24 February 1887. Of Jacob Doyle's nine children, his son Charter followed his father's path into local politics. In 1924, at age forty-two, he won election to the county court where he remained a squire for four terms until his death in 1949. With a combination of charisma and a sense of humor, he was known as "a foremost public leader, a man who knew politics, a man who got what he wanted." Mildred's brother Bert followed his father by becoming a third generation squire in 1954.[2]

In addition to positions on the county court and Mildred's long tenure as superintendent, various members of the Doyle family served in such county governmental positions as registrar of deeds, tax assessor, and superintendent of roads. Mildred, however, was most directly influenced by the power accumulated by her grandfather and father as squires on the county court.[3]

Mildred's initial election by the Knox County Quarterly Court in 1946 was influenced by the preeminent position of her father and mentor, Squire Charter E. Doyle, known as a veritable "old time Republican ramrod." His contemporaries considered the formidable Squire Doyle to have been one of the most powerful community leaders of his day. He strongly encouraged other court members to support his daughter for the superintendency, and Mildred's early success stemmed from her father's enormous political strength. While her estimable father's influence might explain her initial election, Charter Doyle died of a stroke before the end of his daughter's second term as superintendent. An amendment to Tennessee law, effective in the 1952 general election, transformed the position of county school superintendent to one elected by popular vote rather than by members of the Knox County Quarterly Court. This action had a diminishing effect on any lingering influence of Squire Doyle on his daughter's career. Nonetheless, Mildred Doyle ran unopposed for her third term as school chief, and she proved capable of carrying her family legacy of political involvement and public service well into the latter decades of the twentieth century.[4]

Charter Doyle served as a role model and mentor for his daughter Mildred. She idolized him and was proud to become known as "a chip off the old block." Mildred and her father shared a close relationship, beginning in her early years on the farm when Mildred helped him in the fields in the absence of her older brothers. She began accompanying him to Republican rallies when she was just "so high," and in 1946 she told a

reporter that given a choice, she would opt for a political meeting over any kind of social affair. Through the years she became her father's companion, eagerly driving him about the wooded East Tennessee hills as he negotiated with landowners while buying timber for Vestal Lumber Company. This exposure to the region enabled Mildred from an early age to study at the grassroots level the Appalachian people and their culture. Understandings gained then were a source not only of her dedication to public service and to the people of East Tennessee but also of her subsequent political effectiveness.[5]

Learning to move comfortably within her father's sphere provided her with personal connections, a folk knowledge, and a political style that would prove invaluable to her career as a public official. Charter Doyle was Mildred's entree into the "good old boy network" of Tennessee politics where she operated with amazing aplomb from early in her career until her death in 1989.

When Mildred, as newly appointed supervisor of elementary education, saw the dismal conditions of the school system in the mid 1940s, Charter Doyle encouraged his daughter to run for superintendent despite the fact that a woman had never before held the post in Knox County. Squire Doyle thought his daughter highly competent and did not consider gender to be a barrier to her career aspirations. It is not clear whether Charter Doyle was as "liberated" with respect to gender conventions generally, or if he was simply confident in the capabilities of his daughter, who possessed a similar kind of charisma, direct sense of humor, and fascination with politics. In any case, his political power clearly ensured her initial election to the superintendency in 1946. His influence on her ideas, mannerisms, and self-esteem contributed to her repeated success in dealing with the male-dominated world of politics at local, state, and national levels across party lines.[6]

During her career, Mildred worked closely with state and national political figures on educational policy issues and was appointed by Tennessee governors to serve on various boards such as the State Textbook Commission and the Tennessee Children's Services Commission, responsibilities she held for years. She was so highly regarded by U.S. Senator Howard Baker Sr. that he nominated her for the position of U.S. Commissioner of Education in 1956. Lamar Alexander, former Tennessee governor and U.S. secretary of education under George Bush, recalled that during his stint in 1967 as a legislative aide to Senator Baker, the senator bluntly interrupted a staff meeting to take an unexpected telephone call from Superintendent Mildred Doyle back home in Tennessee.

After the meeting, the young Alexander wondered aloud to Baker why he had chosen to take the call at that moment instead of returning it after the staff meeting ended. According to Alexander, Baker replied smiling, "Lamar, you'll learn. When Mildred calls, I drop everything." (The politically ambitious Alexander learned his lesson well, and came to be known affectionately by Mildred as her "Base Runner." While Tennessee governor, Alexander told a reporter that he always tried "to do what she wants me to.") A story recently confirmed in a chance encounter with Senator Baker was that the superintendent called Baker when he was President Reagan's chief of staff; White House secretaries were suspicious of the person of indeterminate sex but with a pronounced Tennessee twang. Mildred finally talked her way to Baker's personal secretary: "Do your really know Senator Baker?" the secretary asked. "Know him?" Mildred responded. "When he was a baby, he peed on my leg as I bounced him on my lap." The secretary connected her to Baker.[7]

Mildred Doyle got along well with powerful males, and her personal files bulge with letters of congratulations, appreciation, and thanks from both Democratic and Republican political figures ranging from U.S. Senator James Sasser, former Tennessee governor Ned McWherter, and former White House chief of staff Howard Baker to Fred Flenniken of the Knox County Commission. She carried a great deal of weight when she decided to support a political candidate.[8]

Mildred Doyle rubbed shoulders with Tennessee's good old boy politicians as if she were one of them herself. In many ways she was. She could "talk the talk and walk the walk" in such a way that her gender posed no serious problem with regard to her acceptance into this highly male-dominated network. Mildred Doyle knew how to relate to men by being "one of them" rather than taking a more risky feminist position in her negotiation of gender constructs. She never adopted publicly a critical stance toward the patriarchal power elite. Rather, she joined it herself in order to achieve power as an educator and child advocate. She had her own agenda. At the time of her death in 1989, however, her gender as a political anomaly did not go unnoticed by those with a more obvious feminist consciousness. Mildred Doyle was remembered as being ahead of her time and "as a female political force long before it was accepted in this community."[9]

"She blazed the trail for all women in East Tennessee who aspired to political office," reflected a local newspaper reporter at the time of her death; "And each of those women who now retain high offices in this region owe a part of their political success to the legacy that she raised on

her own and left behind when she retired, following her only election defeat, in 1976."[10]

Although a pioneer in the expansion of roles for southern Appalachia women, it is unclear as to what degree she was aware of gender constraints in this traditionally conservative area. Regardless of her consciousness of her trailblazing role, she did not allow her gender to bar her from entering the male-dominated sphere of the school superintendency and its concomitant political power. According to Mildred's niece Sue Hicks, she "never thought about women's rights. She just went out and did it because she didn't know she wasn't supposed to. She told me that once."[11]

Gender and the Leadership Role as Superintendent

Given the already subordinated status of women in the broader society, men easily dominated available slots in educational administration throughout the twentieth century. Maleness was considered an asset to the "social credit rating" of an institution. While Mildred Doyle fits the typical description of twentieth-century school chiefs as being "characteristically middle-aged, Protestant, upwardly mobile, from favored ethnic groups, native-born, and of rural origins," her gender clearly challenges the pattern that superintendents were "almost always married white males." While it remains difficult to assess the extent to which Mildred's gender awareness influenced her decision making and administrative action, she created unprecedented opportunities for women during the course of her tenure, and she embraced community building and participatory management styles that researchers have considered characteristic of women.[12]

As newly elected superintendent, one of Mildred's first decisions was to equalize the dual salary schedules of elementary and secondary teachers. To remedy this inequity that she abhorred, Mildred proposed to raise the salaries of elementary teachers to those of secondary teachers. She did not believe high school teachers "worked any harder" than elementary teachers, as was commonly argued, and should warrant more pay. Hence, she endorsed equal pay scales for elementary and secondary teachers. In early April of 1947 the Knox County Board of Education approved a single salary schedule that acknowledged years of teaching experience and degrees earned. This controversial policy change intersected with gender ideology because most elementary teachers were women while most secondary teachers were men. Although Mildred did not see the dual salary schedule as discriminatory, per se, her policy change contributed directly to allowing women teachers more take-home pay than before in Knox County.[13]

Due to the scarcity of female central office administrators and high school principals nationally at the time, Mildred's practice of naming women to these positions in East Tennessee was also quite progressive. Although she appointed many women to her staff, she maintained that "every applicant received identical consideration and the best person for the job would be employed." Ostensibly, her appointments were not based on such characteristics as political affiliation or gender. Regardless of whether or not she consciously aimed to provide opportunities for women in administration, she appointed a number of women to her staff throughout the years so that women often outnumbered men in the central office. As previously mentioned, she also placed women in high school principalships during her administration, a practice that "was unheard of" in Knox County and uncommon nationwide as women were usually assigned to administrative positions where their contact was limited to female teachers. With a greater representation of males on high school teaching staffs, principals at that level were usually men. While the superintendent did not necessarily see being female as an asset, she clearly did not view it as a serious barrier to upward mobility in the educational hierarchy or the political arena. Four years before her death, she told a reporter that she had regularly dismissed comments, "almost 'til the last time [she] ran for office," that the superintendency was a man's job.[14]

Mildred Doyle possessed certain characteristics that researchers associate with women's leadership styles, despite evidence suggesting that she identified closely enough with men to become a part of the good old boy political network. As an administrator she appears to have shared both female- and male-identified leadership styles rather than reflecting one exclusively.

In her review of research on gender and educational leadership, Carol Shakeshaft found that men tend toward autocracy while women tend to exhibit a more democratic, participatory style of management, a style that encourages inclusiveness rather than exclusiveness. While Mildred Doyle referred to her administrative style as being "a little bit autocratic," she worked hard to empower others on her staff by listening to opposing views and implementing staff-generated suggestions and curricular reform. Central office colleague Sam Bratton characterized Miss Doyle as "a kind of matriarch, a fixture, and a leader who was pretty much in control of everything." However, Bratton added, "At the same time I never felt like I couldn't talk to her about whatever was on my mind. Nor did I feel like I had to agree with her all the time." According to colleague Patterson, who was in the potentially difficult position of life partner and

professional colleague, "She was always the one in charge. You never forgot that, but she always involved everybody that she could . . . she let us operate." Patterson concluded that morale was always high among staff members during Mildred's tenure as superintendent, a characteristic often associated with staffs of women administrators. In a speech to teachers on relationships among faculty members, Miss Doyle described her ideal: "In a school staff loyalty, security, a sense of growth, shared responsibility, cooperative endeavor, and other similar factors lead to a really effective team."[15]

Another common trait shared by many women administrators is an emphasis on community building and a participatory, democratic management styles. Women tend to involve themselves more directly and maintain more closely knit organizations than do men. This trait was reflected in Mildred's administration in the Knox County Schools. Colleagues have commented on the strong relationships that developed within her administration. According to former principal James Bellamy of Farragut High School, "We felt like one big family, principals, supervisors, and the superintendent. Miss Doyle was Mama." Mildred was known for treating her central office staff as part of her family, sharing gifts and fellowship on holidays and other special occasions.[16]

Despite the physical distance between the superintendent and classroom teachers, a feeling of community existed among them. A former Knox County high school teacher recalled, "I felt if I had a problem, I could go down there [to the central office] and get help from Miss Doyle and Mrs. Patterson." It is likely that the sense of support and accessibility felt by teachers grew from Mildred Doyle's personality as well as her frequent trips to the schools. Using her visibility and physical presence to build community among classroom teachers and central office staff represents an interesting combination of male- and female-identified leadership traits as research shows that men tend to be much more visible than women in administration.[17]

Miss Doyle's efforts at empowerment and community building among school personnel are illustrated by the ways she encouraged teachers to get involved in curriculum development projects and provided creative and innovative in-service and other personnel development programs throughout the years. For example, in 1951 employees at all levels were invited to participate in major in-service projects to write a new, more progressive curriculum for the county. Largely due to such broad participation, the project was a great success. During the 1974–75 school year, Mildred involved school personnel from throughout the county in exten-

sive curriculum planning for a year-round school pilot program. According to Sam Bratton, teachers put "a lot of psychological investment in it. It worked much better than [if it were] top-down."[18]

Despite Mildred Doyle's tendencies toward autocracy, her leadership style more closely resembled that of other female administrators rather than the males in educational leadership studied by researchers. Without necessarily recognizing gender as salient, Mildred used an instinctive style that worked best for her. Patterson seems to think that Mildred Doyle's unique combination of male and female qualities contributed significantly to her success as a leader. Her androgynous predisposition appeared to serve her well.[19]

Gender Constructs and the Personal Life of Mildred Doyle

Mildred Doyle never achieved "the goal of all proper women": She neither married nor had children of her own. Colleagues, however, considered her to be the matriarch of the Knox County Schools, and family members looked to her rather than to her mother as the matriarch of the Doyle family.[20]

In 1961 Mildred moved from "the Homeplace" where she had lived with her brother and his family into the home of her administrative assistant Mildred Patterson following the death of Patterson's husband earlier that year. Mildred had been close friends with the Pattersons for nearly 20 years, and she and "Patterson" were very close coworkers and best friends. "We made a pretty good pair at that," beamed Mrs. Patterson, recalling life with Mildred Doyle.[21]

In contrast to the male-dominated worlds of politics and educational administration, Mildred Doyle lived a woman-centered home life with Patterson for twenty-eight years. The rambling white house rests on a shady corner lot only a few blocks away from the Tennessee River that divides Mildred's beloved south Knoxville from the rest of the city. Thick St. Augustine grass covers the expansive lawn, a home to climbing ivy, birch trees, cedars, and tall pines. Neglected beds of iris and crocus, boxes of fiery salvia, and a trellis of neon purple clematis linger as evidence of Mildred's love of gardening. Monkey grass and ferns line the stone walkway and patio out back. Mildred kept their yard herself, mowing grass and tending her flowers and plants until her bout with bone cancer progressed into more severe stages near the end of her life.

Mildred Patterson, a soft-spoken, articulate woman with bright silver hair and twinkling eyes still lives in their house, and Mildred Doyle's por-

trait still hangs on the wall in the den. The large portrait is a photographic reprint of the one located in Doyle High School, Knox County's first comprehensive high school built in 1966. Looking at the portrait, Patterson spoke of Mildred in the present tense, as if she were only in the yard trimming ivy. She clearly misses her companion's presence in her life and is eager to conjure up memories of times they shared as best friends and close colleagues. For Patterson, Mildred Doyle is "irreplaceable."[22]

Patterson shared Doyle's dedication when it came to running the school system and doing the best for children. Although neither woman had children of her own, both gave the educational welfare of Knox County's kids top priority. Mildred appointed Patterson to her central office staff as supervisor of elementary and secondary music in 1947. In later years Mildred named her director of personnel and then administrative assistant. She retired upon Mildred Doyle's defeat as superintendent in 1976.

They enjoyed their life together as companions. They rarely missed a performance of the Knoxville Symphony Orchestra, and they usually attended operas and any Broadway productions that came to town. Mildred Doyle loved music, although she was the only sibling in her family not to take music lessons for the violin, piano, or guitar. Patterson said that Mildred always wanted to but her "tomboyishness" somehow caused her parents not to push it, and Mildred Doyle was too proud to tell them that she really wanted lessons. Because Mildred loved Broadway shows, Patterson planned frequent trips to New York where they would take in as many theater productions as possible, both matinees and evening performances. They occasionally varied their cultural menu, however, taking time out from Broadway to witness such landmarks as Elvis Presley's controversial performance on the Ed Sullivan Show. "We were there!" said Patterson, grinning, "I never shall forget. Elvis was doing all this stuff and Ed Sullivan was trying his best to keep him down. Oh, it was so much fun!" They also saw Judy Garland at the Palace when Garland surprised her audience by bringing her nine-year-old daughter, Liza Minnelli, on stage to perform.[23]

They loved to travel, to just get in the car and go. Together they traveled the contiguous United States, every province in Canada, and toured Mexico, often accompanied by a friend or two from the central office. They usually planned where they would stay for the first night out and from there they did whatever seemed fun, moving from place to place for weeks at a time. Mildred Doyle once went solo on a Caribbean cruise, remarking on her return that she had now been on two cruises—her first and last. For leisure travel, she much preferred the automobile and she loved to drive fast.

At home Mildred and Patterson shared tasks around the house with Patterson usually doing the cooking while Mildred cared for the yard. Patterson explained that while she loved to experiment with different recipes, Mildred Doyle was "a meat and potatoes person" and preferred it when Patterson avoided adventurous culinary forays. Mildred Doyle did, however, spend ample time in the kitchen with Patterson because every summer they worked together at night and on weekends pickling fresh vegetables from Pinky Doyle's garden at the Homeplace. Each year their labor would yield about a hundred jars of pickles that they would then give away as gifts, saving only a few jars for themselves. In 1973, The Knoxville News-Sentinel featured them in the midst of their summer project. Patterson told the reporter, "For staff parties at Christmas we fix up a poke, an old fashioned gift, a sack tied with red ribbon and filled with jars of jellies, preserves, pickles." The article featured not only their recipes for such traditional canned foods as iceberg tomato pickles, beet relish, lime pickles, and red tomato preserves, but a full-length photo of the superintendent stirring a huge batch of cucumber pickles.[24]

With regard to other household chores, Patterson did most of the indoor cleaning, but when Mildred got the notion she would move every piece of furniture into the middle of the floor, get down on her hands and knees, and scrub madly. For the superintendent, household chores seemed easier to take if she could transform them into big projects that would get big results. Patterson maintains that Mildred was "much more domestic" than people would think.[25]

Besides their house in south Knoxville, the Mildreds kept a small apartment resting beside a mountain stream in Gatlinburg, Tennessee, a resort town on the edge of the Great Smoky Mountains National Park. They spent time there on weekends and would use the place frequently to entertain friends and colleagues. Occasionally, Mildred Doyle would organize a principals' retreat or some related school function to be held in Gatlinburg where she could use the apartment as a home base. Mrs. Patterson, now in her nineties, keeps the apartment where she spends as much time as possible, enjoying the company of Mildred Doyle's niece Sue Hicks, who lives in a unit upstairs. Sue, who was especially fond of her Aunt Mildred, is equally fond of "Aunt P." The two share a close relationship.[26]

Like many couples, Doyle and Patterson parted company over athletic events. Mildred Doyle, the maniacal sports fan, went to ball games as often as possible, attending sporting events at the University of Tennes-

see and at local high schools. At high school events, she could maintain a high level of community visibility as superintendent while simultaneously watching a ball game. Mildred enjoyed exhibition baseball games as well, and Patterson recalled that when Ted Williams came to town to play, Mildred Doyle had tickets on the front row.

Despite the woman-centeredness that her companionship with Patterson represented, Mildred Doyle never gravitated naturally toward the more "feminine" styles of appearance often associated with women in this culture. "The fewer the frills, the better," she told a reporter in 1946. The superintendent tended to wear expensive tailored suits. She confessed to owning one hat about twenty years before but could not recall its fate: "It was a sort of blue felt affair." Patterson explained Mildred's motives, "She wanted you to think of her as a very strong person and wore mannish clothes." She wore "flat shoes and bobbed hair—no permanent, no curl." Patterson claims responsibility for coaxing Mildred into carrying a purse or, as southerners call it, a pocketbook: "She usually carried her money in her shoe so I made her get pocketbooks and carry pocketbooks." She added, "I am the one that made her start using lipstick." Patterson also made the recalcitrant Mildred buy several evening dresses for specific formal events, but only under the condition that Patterson go to a store and select several to take home for her to try. According to Patterson, this pattern persisted so that she would not shop for herself. Mildred's secretary, Faye Cox, bought all her girdles for her at Miller's Department Store. Faye carried a label in her billfold so that she would be sure to get the correct style. Despite Mildred Doyle's penchant for "mannish clothes," Mrs. Patterson confided, "[She] wore the sissiest petticoats I've ever seen in my life!" She appropriately described Mildred Doyle as a paradox.[27]

Doyle and Patterson are remembered by family, friends, and colleagues as an inseparable team. Those who knew them well understand that neither would have functioned as effectively independently of each other. The gentle Patterson provided an emotional balance to Mildred's aggressiveness and hot temper. In fact, colleagues considered Patterson to be the only one to even attempt to calm Miss Doyle down when "she was about to go off." Patterson's competence, innovative spirit, and thorough educational insight lifted a great deal of pressure from the shoulders of the superintendent, who could then concentrate on negotiating the best possible deals for Knox County's children with school board members and the county court.[28]

Conclusion

Mildred Doyle operated on instinct with regard to the negotiation of gender constructs. She lived in the only way that made sense to her, ignoring gender convention for the most part—not because she generally disagreed with socially expected gender roles for women but because she personally had trouble living them.

However, by her actions she did much to further the possibilities of alternatives for women, although she did not publicly consider herself a feminist. According to colleague Sam Bratton, "If you would ask her if she was a women's libber or a feminist, she would have probably hooted at you, but she did the stuff." Indeed, Mildred Doyle served as a role model for women who do not fit traditional gender role expectations. In a southern community, she demonstrated that it is possible to be a successful, respected, and unmarried female school administrator. She also served as a role model for women choosing the male-dominated path of politics. With her power as superintendent, she created opportunities for women to move up in the educational hierarchy, also a male domain. Probably more than anything else, Mildred Doyle's experiences with gender constructs serve to highlight the importance of tapping into one's complete potential, regardless of whether gender norms are violated. She had an agenda as a child advocate, and if she had to join the good old boys to fulfill if, then she considered it part of her mission. Luckily for Mildred, it came naturally. She clearly crossed gender lines without apology, and apparently without self-consciousness. Perhaps such a personal position even enhanced her public success. Her life seems to illuminate contradictions inherent in the social construction of gender, suggesting the importance of recognizing life models built upon instinct, models that surpass gender as a social construct.[29]

Notes

1. Mildred enjoyed history and compiled several documents concerning her family origins. They are located in her personal files in the home of Mildred Patterson.

2. Willard Yarborough, former member of Knox County Court, quoted in C. Baker, "Superintendent Doyle," 99; Mildred Patterson, interview by author, 8 June 1994; C. Baker, "Superintendent Doyle," 96–99; Ted York, "Third Generation of Doyle Family Attains County Court Membership," *Knoxville Journal*, 6 February 1955, photocopy, Doyle Family File, McClung Collection, East Tennessee Historical Society, Knoxville, TN.

3. Gordon Sams, interview by author, 3 March 1994; see Doyle Family File, McClung Collection.

4. Former county court member Willard Yarborough, describing Charter Doyle, is quoted in C. Baker, "Superintendent Doyle," 167; Patterson, interview by author, 8 June 1994. Bipartisan support of Miss Doyle was described by Judge C. Howard Bozeman, interview by author, 30 January 1995. Bozeman, a Democrat and longtime supporter of the Republican Miss Doyle, served as county court judge [county executive] from 1948 to 1966 and from 1974 to 1982. Mildred Doyle admitted to the importance of her father's political power in her first successful election.

5. Squire H. T. Seymour so described Mildred in Homer Clonts, "More About 'Lost Day,'" *Knoxville News-Sentinel*, 28 February 1960, B8; Betsy Morris, "First Woman County Superintendent Has 21-Year Background of Teaching Here," *Knoxville News-Sentinel*, 10 July 1946, B1; Cynthia Moxley, "Benevolent Dictator: For 30 Years Mildred Doyle Got things Done as School Chief," *Knoxville Journal*, 4 July 1985 A8.

6. Patterson, interview by author, 8 June 1994. Patterson considers it "pretty good for a man his age" that Mildred's gender did not enter Charter Doyle's mind when he encouraged her to run.

7. Moxley, "Benevolent Dictator," A1; Patterson suggested that the absence of female cabinet members in 1956 was a likely reason for her not being named U.S. Commissioner of Education; Lamar Alexander, signed photograph, 1982, Mildred Doyle's personal files. Mildred became a supporter of Alexander not solely because he was a fellow Republican over whom she had much influence, but also because of his expressed commitment to education while governor of Tennessee. She spoke of Alexander in a newspaper article endorsing his Better Schools Program: "Never before in the history of Tennessee have we had a governor with the nerve to put education at the top of his list." Throughout his two terms as governor, Lamar Alexander appeared to appreciate her support of his education plans and her work as chair of the Tennessee Children's Services Commission. Upon his departure from office, he wrote to his fellow party member: "Dear Mildred, I am writing to say thank you. For the last eight years, I have enjoyed the

very best job in the USA! Without your friendship and support, that never would have been possible." For relations between Mildred Dole and Alexander, see "Mildred Doyle Endorses Move toward Better Schools in State," newspaper article, source unknown, circa March 1983, Mildred Doyle's personal files; Lamar Alexander, Letter to Mildred Doyle, 24 Februry 1983, Mildred Doyle's personal files. Lamar Alexander, letter to Mildred Doyle, 9 Janury 1987, personal files. Jerome Morton asked Baker about the story during a chance encounter in a Knoxville video rental store in spring 1999.

8. Her files also contain letters from local politicians such as Ray Hill claiming, for example, that he would never have attained the primary nomination for Knox County Commission had she not offered her support to his campaign. Ray Hill, letter to Mildred Doyle, 15 June 1984, personal files.

9. Leon Stafford, "Doyle Helped Others until the End," *Knoxville News-Sentinel*, 9 May 1989, B1.

10. "Mildred Doyle, Political Pioneer for GOP Women," *Knoxville Journal*, 8 May 1989, 6A.

11. Sue Hicks, interview by author, 13 October 1994.

12. Strober and Tyack, "Why Do Women Teach"; Tyack and Hansot, *Managers of Virtue*; David Tyack, *The One Best System: A History of American Urban Education* (Cambridge, MA: Harvard University Press, 1974), 169. See also Blount, *Destined to Rule the Schools: Women and the Superintendency, 1873–1995* (Albany: State University of New York Press, 1998); Flora Ortiz and Catherine Marshall, "Women in Educational Administration," in *The Handbook of Research on Educational Administration*, ed. N. Boyan (New York: Longman, 1988); Charol Shakeshaft, *Women in Educational Administration*, 2nd ed. (Newbury Park, CA: Corwyn Press, 1989); Carol Shakeshaft, "Women in Educational Management in the United States," in *Women in Education Management*, ed. Janet Ouston (Harlow, UK: Longman, 1993).

13. C. Baker, "Superintendent Doyle," 115–116; Patterson, interview by author, 9 March 1994; Sam Bratton, interview by author, 4 March 1994; "Minutes of the Knox County Board of Education," 7 April 1947; Clinton B. Allison, *Mildred Doyle: A Conversation at Eighty* (UTK College of Education Instructional Services Center, 1986), vidocassette.

14. C. Baker, "Superintendent Doyle,"115; Patterson, interview by author, 10 October 1994; Bratton, interview by author, 4 March 1994; "Mildred E. Doyle," autobiographical document, 6; Earl Hoffmeister, interview by author, 1 Februry 1994; Tyack and Hansot, *Managers of Virtue* 183–188; Carmen Carter, "'Elect Woman' Session Includes Mildred Doyle," *Knoxville News-Sentinel*, 26 April, 1985, photocopy, personal files.

15. Shakeshaft, "Women in Educational Management in the United States," 47–63; Shakeshaft, *Women in Educational Administration*; Lois Thomas, "Departing Supt. Doyle Feels Funds Pose Biggest School System Obstacle," *Knoxville News-Sentinel*, 29 August 1976; Bratton, interview by author, 4 March 1994; Patterson,

interview by author, 9 March 1994; Mildred E. Doyle, "Faculty-Faculty Relationships," personal files, n.d., 3. Bratton in his 4 March 1994 interview stated that "there wasn't any doubt in your mind about who was the boss."

16. Ortiz and Marshall, "Women in Educational Administration"; Shakeshaft, *Women in Educational Administration*; Shakeshaft, "Women in Educational Management"; C. Baker, "Superintendent Doyle,"117; Patterson, interview by author, 9 March 1994, also characterized the staff as "a big family"; Roger Ricker, "Former Schools Chief Doyle Remembered as Dedicated, Unselfish," *Knoxville Journal*, 9 May 1989, 4A; Mildred's secretary Faye Cox, interview by author, 5 December 1994.

17. Martha Hess, former teacher at Farragut High, telephone interview by author, 8 February 1995; Shakeshaft, "Women in Educational Management," 52.

18. C. Baker, "Superintendent Doyle," 116–118 and 129–131; Patterson, interviews by author, 9 March 1994 and 8 June 1994; Bratton, interview by author, 4 March 1994.

19. Patterson, interview by author, 9 March 1994.

20. Tyack and Hansot, *Managers of Virtue* 191; Gordon Sams, interview by author, 3 March 1994; Bratton, interviews by author, 4 March 1994; 15 March 1994; "A Tribute To Mildred Eloise Doyle, by a Niece, May 9, 1989," Ruth Doyle Hilton's personal files. This tribute was read at Mildred's funeral service.

21. Paterson, interview by author, 9 March 1994. Mildred Doyle always referred to Mildred Patterson as "Patterson."

22. Except where specifically indicated, information in this section was compiled from interviews with Mildred Patterson conducted by the author on 9 March 1994, 8 June 1994, 10 October 1994, and 1 March 1995. Mildred Patterson died at home on 21 December 1999.

23. C. Baker, "Superintendent Doyle,"101; Patterson, interview by author, 10 October 1994. They saw Presley's 1956 performance before they began living together in 1961.

24. Patterson, interview by author, 10 October 1994; "Packing Pickles for Pokes," *Knoxville News-Sentinel*, 25 July 1973, 24–25.

25. Patterson, interview by author, 10 October 1994.

26. Sue Hicks, interview by author, 13 October 1994; Mildred Patterson, interviews by author, 10 October 1994 and 1 March 1995.

27. Morris, "First Woman County Superintendent," B1; Faye Cox, interview by author, 5 December 1994; Patterson, interview by author, 9 March and 10 October 1994.

28. Bratton, interview by author, 4 March 1994; Others supporting the team-like nature of their relationship were Cox, interview by author, 5 December 1994;

Bozeman, interview by author, 30 January 1995; Ruth Hilton, interview by author, 25 February 1994; and Richard Yoakley, 10 October 1994.

29. Bratton, interview by author, 4 March 1994.

Chapter 4

An Eclectic Progressive:
"What's Best for the Boys and Girls"

Mildred Doyle's educational philosophy, policies, and actions supported her underlying mission as school superintendent: to "do what's best for the boys and girls of Knox County." Whether playing hardball politics with the political establishment or wooing the poorest citizens in isolated communities, this student-centered purpose was her ultimate commitment. This chapter examines Miss Doyle's educational philosophy, her relationship with the school board, and her leadership in a period of social change, including a rapid growth of suburbs in her rural school district and racial desegregation of the schools.

Mildred Doyle's Philosophy of Education

The overarching importance of child advocacy represented the most salient and certainly the most constant element of Miss Doyle's educational platform. It is important to keep this idea in mind as a framework when considering her accomplishments as superintendent. She measured all school business in light of how it "filters down to what happens to the *child*." While she understood and enjoyed the politics involved in her responsibility to negotiate priorities with school board members and squires on the county court, her preoccupation was the quality of experiences for children in school. Central office colleague Sam Bratton recalled of Mildred, "I think she *really* cared about kids. I think that came through to parents, community members, and county court people." He characterized her educational philosophy as one of "putting kids first."[1]

Mildred Doyle felt that public schools should, in large part, be used for the improvement of human life, a general belief shared by many educators who were influenced by the multifaceted progressive education move-

ment. School reform meant a variety of things to progressive educators, including broadening the programs and social function of the school to include health, vocational education, and concern for the quality of family and community life; using the new teaching methods and principles emerging from scientific research in child psychology and the social sciences; matching curriculum and instruction with different interests and abilities of students; and using schools to democratize culture so that all might benefit from knowledge of the fine arts and advances in science.[2]

Superintendent Doyle became familiar with progressive philosophies and reform efforts as she continued her higher education at the University of Tennessee while working as a teacher and principal during the 1920s, '30s and '40s. Although, as a student, she considered aspects of the progressive child-centered methods classes to be "a bit silly," she developed policies congruent with various "wings" of progressive ideology. Throughout her lengthy tenure, she implemented numerous progressive reforms, but she never allied herself completely with the philosophies and practices of any faction of educational progressivism.[3]

Rather, she wove threads of the administrative progressives' social efficiency rhetoric together with the child-centered concerns of pedagogical progressives to form her own platform that acknowledged the importance of an efficiently controlled school system, but only insofar as it ensured her vision of individual child welfare and development. For example, while she consolidated smaller schools and expanded the administrative bureaucracy, she never shied away from testing innovative curricular reforms designed to meet the needs of different students and enhance the everyday experience of children in school. And the colorful superintendent never became so removed from the daily functioning of individual schools that she lost sight of how policy changes affected children.

Mildred Doyle fought private battles with her inner tendencies toward administrative autocracy. Growing up bside her rather autocratic father, a respected member of the old guard political elite, she learned no alternative leadership models. Yet, she settled into her own style, striving to be different by advocating democratic consensus-building and empowering both teachers and principals by eliciting their opinions and acting on their concerns.

The Superintendent in Changing Times

Mildred Doyle was driven to seek the Knox County superintendency out of fierce ambition and genuine dismay over school conditions in 1946.

Upon arrival in the superintendent's office, she promised to work toward "making the Knox County School system the best in the state." Miss Doyle never shied away from a solid challenge or a tough chore, and the job of school chief proved to be both. Like many others in the South at the end of World War II, Knox County's schools resembled the nineteenth century more than the twentieth: fifty of Knox County's eighty schools had no indoor plumbing; wood stoves heated thirty-three schools; and one school used kerosene lamps for lighting. Twenty-five schools were one- or two-teacher facilities. The entire administrative staff in the central office consisted of two supervisors of instruction, a secretary, and a book-keeper. Three workers with one truck were responsible for school maintenance. Knox County employed a total of 562 building level administrators and classroom teachers in 1946, and only 37 percent had college degrees. Total student enrollment numbered 17,204.[4]

In the face of escalating postwar population growth, schools experienced tremendous overcrowding. Over 85,000 babies were born in Tennessee in 1947—all scheduled to reach school age by 1953. Families connected with such local institutions as the University of Tennessee, the Tennessee Valley Authority, and Oak Ridge National Laboratories poured into Knox County, resulting in a higher-schooled, more cosmopolitan, and more demanding population. The explosive influence of these institutions precipitated a surge in commercialism, economic growth, schooling expectations, and in county school enrollments beginning in the 1950s.[5]

Superintendent Doyle, realizing the urgency brought about by the inadequacy of the historically neglected school system coupled with the population boom, expressed her concerns to members of the Knox county court by stressing the need to upgrade the teaching and administrative staff, to formulate a building plan, and to expand hot lunch programs to all county schools. Her first meeting with the county court launched a plan of action that continued to evolve and change as concerns were addressed, problems were solved, and innovations were implemented and modified over the thirty years of her leadership.[6]

The highly political Mildred Doyle worked extraordinarily well with both the Knox county court (despite occasional battles for funding) and the Knox County Board of Education. In fact, she used her political connections to influence the election of many board members whom she considered particularly capable, supportive of her leadership, and interested in the welfare of children. Leadership on the board remained fairly constant during Mildred Doyle's tenure as "Hop" Bailey held the position

of chair for more than twenty years. Board members trusted Miss Doyle and depended on her expertise as an educator to keep them informed, giving her a tremendous amount of power and influence when dealing with them. A shrewd politician, Mildred Doyle always made sure she was never "blind-sided" by a board member in a meeting, hence she labored to understand each member's position on an issue prior to board meetings, which were often attended by the public. Because she worked well with the board and often got her way in school matters, some citizens considered the school board to be "a rubber stamp for whatever she said," and there was some validity to the charge; in relationships with the board of education, she was more powerful than a typical superintendent today.[7]

In an effort to build community among board members, she and Patterson often cooked meals for them in the central office's small kitchen. Miss Doyle would charge into the office early in the morning and tell her secretary Faye Cox, "All right, tonight we're going to feed the board." Patterson recalled that they would prepare full-course meals with an entree, vegetables, and dessert in the tiny kitchen. They would talk school business but leave plenty of time for informal conversation. The superintendent worked hard to maintain warm social relationships as well as effective professional relationships with the board members. Often, she "fed" the entire board, but occasionally she used such time to court certain members' support on specific issues because she felt the informal setting to be more appropriate to talk frankly with members about disputed points or controversial issues. As is common in local school politics, issues often involved disputes or competition among communities for new classrooms or schools, hiring of personnel, firing of coaches, or even changes in bus routes.[8]

While the board usually voted with Mildred Doyle, when citizens' emotions were aroused this was not always the case. For example, in 1969 the elected Knox County Board of Education voted to remove J. D. Salinger's *Catcher in the Rye* from the reading list at the secondary level. Mildred Doyle sided fervently with teachers, citing the value of their professional judgment about what students should be reading. Mildred Patterson recalled that the elected board was pressured by local religious groups in their constituency to ban the book, and, caving in to the angry voices, they voted for its removal. Mildred Doyle opposed their vote as well as the pressure from conservative religious groups for censorship. According to Patterson, the superintendent "just felt that it was terrible to have one segment of the public saying what another group could or could not read."[9]

The fact that only 37 percent of Knox County teachers and administrators had college degrees when she took office disturbed Mildred Doyle. While aware of the historical conditions leading to poorly prepared teachers, she nevertheless gave priority to raising the qualifications of Knox County teachers to meet increasing enrollments, parental demands for a quality education for their children, as well as her personal goal that Knox County stand out for its exemplary school system.

A 1956 Tennessee law required a bachelor's degree for initial teacher certification, and although many nondegreed teachers had taught for years, they had to student teach to earn standard certification. At the superintendent's suggestion, the Knox County school board established a policy requiring all principals and teachers lacking a degree to take nine quarter-hours during a school year, a policy that would lead to eventual completion of a college degree. In 1960, the board declared that a Knox County teacher could not become tenured unless he or she had obtained a degree. Further, those teachers and administrators working in the system who still had not completed a degree would become eligible for a leave of absence for that purpose.[10]

Additional professional development programs for teachers included summer workshops and yearly in-service programs centered on curriculum planning and development, improved instruction, and solving problems unique to teachers. Such workshops provided room for teachers' voices to be heard by the administration. Knox County teachers had never before been invited to participate at the "system-wide level" in school planning and development activities, and Miss Doyle broke new ground by offering a way for teachers to begin to realize that they had the support of the administration in gaining more control over their work. Perhaps recognition of her own need for autonomy and control as well as her style of inclusion, more common to women than to men administrators, led her to realize potential benefits of an enlarged role for teachers in planning curriculum and instruction.[11]

The Knox County Principals' Conference represented the most effective and long-lasting professional development program for administrators during Mildred Doyle's superintendency. She considered quality leadership at the building level to be vital in carrying out the goals of schooling, and she demonstrated a particular sensitivity to the responsibilities of Knox County's principals. A principals' Conference was held every year from 1955 to 1976 with program content based on principals' recommendations gathered from surveys administered during the school year. Themes included "The Principal—Pacemaker for Progress," "Dissent—Decision—Direction," and "Educational Leader or Administrative Robot."

The conferences normally took place over a weekend and former administrators remember them as one of the most positive activities to build community and a sense of family among principals and the central office staff. Further, it contributed significantly to the professional growth of administrators as they were able to seriously focus on issues they deemed important as a group. Again, Mildred demonstrated a democratic style that gave more control to the principals and less to the central office. Throughout her tenure, Mildred continued to focus on ways of enabling a principal to "function as a change agent and an instructional leader." As effective as the principals' conferences were, upon her defeat as superintendent in 1976, the new administration abandoned them.[12]

Building an Empire

Gross inadequacy of physical facilities in the school system captured Mildred Doyle's attention and concern from the beginning of her tenure. The school system had not built new facilities or added to existing buildings since the 1930s, and teachers held classes in hallways, in school kitchens, on auditorium stages, and in "tater holes" or root cellars. Classrooms that were already too small were divided to make more room in schools all over the county. The superintendent explained urgently to the Knox county court that quality instruction under these conditions was impossible. The children of Knox County, she argued, deserved much better than that, and the resolute Mildred Doyle developed an extensive plan to add facilities to twenty-four schools. Among items in her proposal were the addition of cafeterias to seventeen schools, indoor restrooms for seventeen schools, heating systems to fourteen schools, libraries for two schools, two gymnasiums, seven auditoriums, and 101 classrooms.[13]

County Judge [the county executive] Howard Bozeman recalled that raising funds for Miss Doyle's building plan was one of the greatest challenges of his life because of the county's pitiful financial condition when he took office in 1948. Mildred Doyle and the brilliant young judge "worked like Trojans," digging up funds wherever they could find them, mainly by issuing rural school bonds and pledging sales tax revenue for capital outlay. Further, they determined that closing some of the shabbier one- and two-room schools would be inevitable. Mildred Doyle pushed her gift for diplomacy to maximum capacity, traveling to highly traditional rural communities, holding meetings to explain to citizens why their schools were to be closed. These mountain people understood that the loss of their school often meant the loss of traditions and their identity as a commu-

nity. Hence, even the savvy Mildred Doyle had her hands full attempting to clearly articulate the benefits that she thought their children would receive by attending a school with more adequate facilities. Ultimately, her persuasive powers proved successful, but not entirely without resistance and emotional bloodshed.[14]

Money for physical improvements was always scarce, and Miss Dole knew that in the past it had often been spent in the more affluent sections of the county rather than where it was most needed. She worked with her central office staff, the Knox County Court, and the board of education to devise a plan for a building program based on need not political clout. Affluent suburban communities not only had bigger school buildings in better condition, but expanded curricular offerings due to the efforts of very organized and vocal parent-teacher associations combined with substantial support from members of the Knox county court. Superintendent Doyle realized that she must obtain thoroughly credible documentation of the present and future needs of all county schools in order to get the financial support she needed from the county court to improve many of the small rural schools neglected by the politically motivated squires. Neither the board of education nor the county court, according to Patterson, could "see spending a million dollars at Gibbs [High School] which is almost to Union County and not spending more than that at Central High in Fountain City. After all there were voters in Fountain City. . . . Her goal was to make smaller schools equally important."[15]

In the tradition of administrative progressives for whom "scientific" surveys were political ploys used to justify the policies they wanted, Mildred Doyle proposed to the court and the board that the school system conduct a county-wide needs assessment of every school community; the assessment would not only determine the present school conditions, enrollment figures, and curricular needs, but would project population growth patterns and enrollment trends for Knox County over the coming decade. The superintendent could use the results from such an extensive survey to support her suggestions for improvements to be made to schools in particular communities and for the construction of new schools in others. By having what appeared to be "hard data" at her fingertips, Mildred could justify funding requests to county court members, who could, in turn, explain to their constituencies why certain community schools were or were not slated to receive funds. Not only could such data provide leverage with the county court, but they enabled the shrewd superintendent to clarify funding priorities in the minds of her own concerned political constituency.[16]

Upon approval of the board of education, Mildred Doyle contacted the University of Tennessee College of Education to enlist the help of faculty in constructing, administering, and analyzing the survey. College professors coordinated teams of graduate students, members of the county court and the board of education, Knox County school employees, and leaders of various communities in conducting the study. Patterson remembered how extensive the survey was: "They went into every community school. They surveyed every building. They counted houses. They counted noses. They projected enrollment for ten years." Those assisting with the extensive project distributed surveys door-to-door to thousands of Knox County residents.[17]

Upon completion of data analysis, Miss Doyle confidently took survey results to the Knox county court. On 16 July 1951, court members approved its use "as the basis for all subsequent planning for improving the school program through 1960" with regard to building plans and future curriculum development. Following the Court's approval, Mildred and her staff held a series of community meetings at high schools around the county to explain to residents the survey results and what they meant for particular schools. Her gift for effective communication with diverse people served her well during those weeks as she "broadened out" Knox County citizens.[18]

The superintendent talked later about the positive outcomes of those meetings:

> For the first time parents realized that some communities had problems more pressing than their own . . . a spirit of generosity and caring developed in which people on one side of the county worked with folks miles away to help them get the kind of school they needed. . . . It was one of the best things that happened to us in education.[19]

Despite the county court's appropriation of additional funds to improve the antiquated schools, the baby boom soon exploded with furor, driving primary school enrollment to all-time highs and resulting in unconscionably overcrowded classrooms. In 1953 the politically astute Mildred Doyle garnered popular support for a budget increase for the next fiscal year by holding community meetings in which she urged citizens to go on record in favor of more funding for a building program. With overwhelming public approval of her proposed 1954 budget, the superintendent pressured county court to give the people what they wanted for their children. If after that kind of pressure she still felt that she needed assistance persuading the squires to see it her way, she encouraged the citi-

zens present at community meetings to descend in mass upon subse-
quent sessions of the county court. According to Judge Bozeman, who
later admitted to being amused by her effective tactics, the angry but
outfoxed Court members had major difficulty withholding funds for the
school budget while hundreds of voters in the meeting room watched and
listened.[20]

Improvements came only gradually. Throughout the late 1950s and
early 1960s, Judge Bozeman and the county court allocated more money
than most observers would have thought politically possible in attempts
to reduce overcrowding, yet classes still met in hallways, offices, cloak
rooms, and even shower rooms. Miss Doyle reported in 1956 that "toilet
facilities were installed in the last school last year." However, by the end of
the ten-year building plan, considerable progress had been made toward
the construction of a modern school empire. Knox County boasted six-
teen new schools and approximately 600 classrooms were added to exist-
ing facilities, many of which had been significantly renovated. Only a
handful of teachers reported class enrollments of more than forty stu-
dents. By 1962 Superintendent Doyle's successful efforts had transformed
a largely dilapidated rural school system into one in which the modern-
ized physical facilities provided an environment much more conducive to
learning—an outcome she declared that the children of Knox County rightly
deserved.[21]

In 1963 Mildred Doyle was deeply disappointed when the city council
of Knoxville voted to annex approximately fifty square miles of Knox
County around the perimeter of the city. The county lost nearly 70,000
residents in the heavily populated suburban areas encompassed by an-
nexation. Having dedicated a great portion of the previous decade to
transforming a neglected rural school system into a modern educational
empire, the superintendent was shocked at the sudden loss of 18,000
students and twenty-eight schools. Of the twenty-eight annexed schools,
sixteen were newly built, and the remaining twelve had been extensively
renovated over the previous ten years to accommodate the many stu-
dents living in the first county suburbs. Superintendent Doyle despaired
as she recalled the years of hard labor involved in obtaining adequate
funding to develop such a system in a financially deprived area.[22]

Annexation ravaged the county school system. In the summer of 1963,
Mildred reported to the Knox county court that in addition to the loss of
school buildings and students, over 600 teachers and principals, eighty
custodians, and twenty-five members of the clerical staff were transferred
to the Knoxville City Schools. Patterson recalled that "it left us with the

very rural schools and half the enrollment. The comeback that we made, I think, is one of the most remarkable things." A former supervisor recalled the initial response of the central office staff:

> We had to show them we weren't dead, and we did many things to keep before the public . . . science fairs, music festivals, all-county bands and orchestras, anything we could do to provide a P.R. and morale thrust for teachers, parents, and students. It was a new beginning, somewhat akin to the first beginning [in 1946]; but with a large staff, we could move fast.

"Believe it or not," Patterson insisted, "everybody sort of pitched in and thought, 'They are not going to do this to us,' and everybody worked and started another building program."[23]

Annexation shook morale only temporarily, and Knox County's iron-willed, workaholic superintendent, planning her next move, busied herself studying projected enrollment figures based on predictions of county growth. Despite the fact that annexation weakened the tax base, Knox County almost immediately entered another phase of rapid population growth, and the superintendent and her staff realized that their problem was not a loss of students but how to prepare for an explosion of them. As the suburbs affected by annexation became crowded, families began moving farther into the county and enrollment in the schools expanded, and the superintendent was back to doing one of the things that she did best—"getting new buildings built."[24]

Using her inclusive style of managing, Mildred Doyle again elicited the opinions of people throughout the community. Teachers, principals, PTAs, members of the State Department of Education and the University of Tennessee, business leaders, and community organizations met to "brainstorm" possible recommendations for improving the overall program of instruction for Knox County Schools. Their efforts resulted in a comprehensive plan for systemic regeneration of the school system. The plan called for the immediate construction of a new elementary school and the total renovation of a dozen others and the Dante Special Education Center. Four high schools and two elementary schools required additional space to relieve overcrowding. These building projects were slated for completion in less than a year's time—by the beginning of the 1964—65 school year. To meet projected building needs by 1968, the document suggested that six elementary schools, two high schools, and additions to thirteen existing schools be constructed.[25]

In 1966, Mildred Doyle began construction of the county's first comprehensive high school. Located in south Knox County where the Doyles

pioneered in 1800, the school was named Doyle High School in honor of the superintendent and her influential family. Like an anxious parent, the superintendent frequently monitored the building's progress as it neared completion in 1967. Known affectionately in the community as "Doyleland" and "the House That Doyle Built," the high school was formally dedicated to the Doyle family on 12 April 1968 by the Knox County Board of Education. Approximately 1,200 Knox County residents attended the dedication ceremony and dinner at the new high school to show their appreciation for Miss Doyle's work as school chief. Andy Holt, the colorful president of the University of Tennessee and longtime friend of Mildred Doyle, was the keynote speaker; and Hop Bailey, Chair of the Knox County Board of Education, made the formal presentation of the school to Miss Doyle, "our, efficient, progressive and *aggressive* superintendent." In response to the dedication, the superintendent, obviously moved by the ceremony, presented the school back to the community.[26]

The suburban population continued to explode, and by 1967 Mildred Doyle again found herself in the midst of a school crisis. Because the county was forced to use many temporary classrooms, the board of education was anxious that she press county court for additional funding. Superintendent Doyle gathered members of the school board and they accompanied her to a meeting with the Knox county court's Finance Committee where they argued for building funds. Within six years the system had built three new high schools, three new middle schools, a new elementary school, and over a hundred additional classrooms at various area schools. Meanwhile in the 1970s, total school enrollment accelerated at an average of 1,000 students per year. Mildred Doyle's extensive building program culminated with the construction of Farragut High School, completed in 1976, her last year in the superintendent's office. Knox County's massive population growth surprised everyone concerned with schooling. Patterson remains amazed that the once minuscule rural community of Farragut is now connected to the city of Knoxville with mile after mile of upscale suburban development.[27]

While the annexation of suburban neighborhoods surrounding the city of Knoxville disappointed the Knox County Schools superintendent, it did not diminish her resolve to provide sufficient space and hospitable learning environments for local children. During Mildred Doyle's thirty years as superintendent, she battled for funding and supervised the construction of twenty-four elementary schools, four middle schools, eight high schools, and two vocational facilities costing a total of $38.8 million.[28]

Desegregation Leadership

The superintendent revealed her political astuteness as well as the limits of her progressivism during the desegregation struggle. While East Tennessee was less aggressive in denying civil rights to African Americans than its neighbors in the Deep South, the predominantly white population nonetheless harbored racist attitudes that led to institutional practices of racial segregation and sometimes violence. Operating under state law based on the 1896 Supreme Court ruling that established the "separate but equal doctrine" in *Plessy v. Ferguson*, Knox County provided segregated school facilities for black and white students until it began the process of desegregation in 1960.[29]

The approximately 300 black families who lived in Knox County at the time of desegregation sent their children to nine "Negro schools" for the elementary grades, all of which were one- or two-room buildings staffed by African American teachers. Because of the relatively small number of black children in the Knox County Schools compared with enrollments in the Knoxville city system, the county never established a separate high school for African Americans. Rather, the county paid tuition and provided transportation for black secondary students to attend Austin High School, a facility operated by the city system and highly acclaimed as a site of educational excellence.[30]

Following the 1954 Supreme Court ruling, in *Brown v. Board of Education of Topeka*, that separate educational facilities were inherently unequal and the Enforcement Decree requiring the desegregation of schools in 1955, Mildred Dole had to decide how Knox County should respond to the Court's decisions. Disregarding her usual practice of seeking the opinions of all those affected by a policy, in 1955 she met with a group of white administrators, teachers, citizens, school board members, and Knox County Judge Howard Bozeman to elicit their opinions regarding school desegregation. Judge Bozeman suggested that Knox County settle the matter by taking immediate positive action by complying with the Court's decision to desegregate public schools. He proposed that black high school students in Knox County be given the choice of enrolling in the white high school closest to their home or continuing to attend Austin High School in the city system. He suggested that elementary children be given the choice of enrolling in the white school closest to their home or attending one of the black schools that the county would continue to operate. Under Bozeman's proposal Knox County would provide transportation for all black children regardless of their choice of schools. Bozeman told

the group that he would "love to see the headlines in the morning," proclaiming that Knox County, Tennessee, had complied with the High Court's decision. It was not that easy, however. The young judge met with resistance as most people present at the meeting were "totally opposed to doing anything" and others were "just violent" in their opposition to desegregation. As the meeting concluded, the majority agreed that the position of the Knox County Schools on desegregation was to "sort of play it by ear and see how things are going to develop." Bozeman recalled that those present saw "no big reason to rush into anything" and decided the best course of action was to delay. Mildred Doyle, having herself adopted a "wait and see" attitude, did not appear particularly concerned with the possibility that members of the black community might feel more of a sense of urgency to speed up the desegregation process than did the white people invited to voice their opinions at a meeting with the superintendent.[31]

The majority opinion reflected at that meeting mirrored racist attitudes pervading much of the country in 1955. The Supreme Court left procedures to enforce integration to federal district judges, who "were often part of the social fabric of their communities and resisted attempts at speedy desegregation." Hence, integration proceeded very slowly until the 1960s saw the passage of further civil rights legislation. So Knox County continued "business as usual" for the next five years.[32]

There were differences of opinion about school desegregation among African American citizens as well. Desegregation advocate Bozeman described his understanding of the positions on the issue held by black residents. In meetings with leaders of the black community, he found that those who favored integration were aware of the benefits of attending an educational institution in which whites had a stake. Not only were they more likely to receive an equal education, but they felt that their social stature would increase. Further, they projected that future generations would have greater opportunities for participation in white-dominated society. Others in the black community indicated that they saw no probable benefits from attending school with whites because they felt that white society would never accept them regardless of where they went to school. Those opposed to desegregation were also afraid that in white-controlled schools their African American culture would be belittled, and they feared that integration controversies would be a source of trouble between the black and white communities.[33]

Finally, with increased national civil rights activism and pressure from the State Department of Education, Mildred Doyle abandoned her "wait

and see" attitude and began to take specific steps with the board of education to desegregate the county schools, despite her initial attitude toward integration. As did many other white southern "progressive" politicians, Mildred Doyle enjoyed considerable respect from leaders of the black community—at least publicly. In a 1986 interview, she recalled that she "knew practically every black family in Knox County." She regularly attended community functions and, according to Patterson, "They just liked her. There again it was that business of being able to communicate. She would slap them on the back, hug them, carry on with them, you know, just like they were her long lost family." Through a series of meetings in black community schools, Miss Doyle, the central office staff, and school board members explained to parents how the process of desegregation was to work, which schools were to be closed, where their teachers were to be reassigned, and which former white schools their children would attend.[34]

In an effort not to alarm anti-desegregation whites, the superintendent purposefully held these meetings with little publicity or fanfare. In August of 1960, the Knox County Board of Education made its first formal steps toward desegregation by adopting a "grade-a-year" policy similar to the one federally approved for Knoxville City Schools. The initial policy held that black children beginning in the first grade in August 1960 could attend the elementary school nearest their home if they wished. If, however, the black school was closer to a student's home than the white one, they were to attend the black school as long as it remained open. The black community learned of the board's policy through community meetings called by the superintendent, but she did not publicly announce the new policy to the white community until the first day of school.[35]

The superintendent and the school board decided to desegregate primarily for political and legal (rather than moral) reasons. School board chair Hop Bailey explained, "We decided to integrate after the city's plan was approved. Board members agreed it would be better to follow the plan of integration rather than to get involved in a series of law suits." While first graders were officially "welcome" in white schools in Knox County beginning 31 August 1960, for whatever reasons no first graders enrolled. However, the superintendent reported that twelve black students attempted to enroll in higher grades at suburban Bearden Elementary and Bearden High School, but "left quietly" when told by principals of the "one grade at a time" policy.[36]

Desegregation in Knox County occurred incrementally. By June 1963, school board policy on integration included grades one through six, and

by April of 1964, it extended through grade twelve. By the 1964–65 school year, only four black schools with a total enrollment of seventy-six remained open at parents' requests. At the end of the school year these facilities were closed, thus completing the process of legally desegregating Knox County elementary schools. Also that year, the county halted transportation services and the payment of tuition for 100 remaining students to attend Austin High School. These students attended formerly all-white high schools in Knox County in the 1966–67 school year. According to a report filed in the central office, the process of desegregation proceeded smoothly. Further, Mildred Patterson indicated that in the schools themselves there were "no problems" with regard to race relations between students and, suggesting reasons for this, added, "Well, there were so few [African Americans] in each school—there might not have been more than two or three in a school."[37]

The relatively small black population contributed to the perception among central office staff that desegregation in Knox County went off without a hitch. Possibly, the absence of major incidents of overt violence or hostility satisfied Knox County administrators that all went well. Knoxville City Schools, with a much larger enrollment of African American students than Knox County, reported more racial incidents between newly desegregated black and white students. But the voices of African Americans in Knox County are not heard in official records. It is impossible to know how much clandestine intimidation took place and what thoughts passed through the minds of black students catapulted into the overwhelmingly white environment of Knox County Schools. Perhaps racist white students would have felt seriously threatened had there been larger numbers of black students "invading" *their* schools.[38]

The "one grade at a time" policy sent subtle messages to African Americans about the extent of their welcome. Further, the policy stipulation allowing black children to attend white schools only if the white school was closer to their homes contained racist overtones because white policy makers knew that "most of the Negroes live in little pockets in the county where the school they attended last year is closer to their homes than the previously all-white schools."[39]

While Mildred Doyle herself did not immediately embrace the Court's decision in *Brown v. Board of Education* by insisting on integrating Knox County Schools, she did not actively oppose desegregation or minority civil rights. It is likely that her failure to comply initially was a political decision designed to keep peace with opposition on the school board and in the citizenry at large. Mildred Doyle was a rather typical southern

racial moderate, certainly no more racist than other white Tennesseans of her generation—her innate sympathy for "the underdog" likely made her less so. But passive, laissez-faire attitudes such as hers hindered progress of the civil rights movement in America.[40]

Notes

1. Mildred Doyle, untitled speech, personal files, n.d., 2, emphasis hers; Samuel Bratton, interview by author, 4 March 1994.

2. Lawrence Cremin, *The Transformation of the School: Progressivism in American Education, 1876–1957* (New York: Random House, 1961), vii–xi.

3. Clinton B. Allison, *Mildred Doyle: A Conversation With at Eighty* (Knoxville, TN: UTK College of Education Instructional Services Center, 1986), videocassette; Tyack, *The One Best System*, 126–198. Tyack's "wings" explanation of the different factions within educational progressivism is well known. He refers to them as "administrative progressives," "pedagogical progressives," "social reconstructionists," and "libertarians." The superintendent referred to an instance where a methods professor suggested that classroom teachers get down on all-fours to imitate a dog to facilitate young children's understanding. Miss Doyle seemed to think that that particular activity carried the aim of engaging learners into the realm of the absurd.

4. Betsy Morris, "First Woman County School Superintendent Has 21-Year Background of Teaching Here," *Knoxville News-Sentinel*, 10 July 1946, B1; "A Thirty Year Comparative Study," Knox County Schools, 23 August 1976. At this point, I want to acknowledge my gratitude to Carol E. Baker for her work completed in 1977. Her dissertation, "Superintendent Mildred E. Doyle: Educational Leader, Politician, Woman," has proved an invaluable source of information for this chapter, particularly with regard to the selection of significant events which spanned the thirty-year period of Miss Doyle's superintendency.

5. Morris, "First Woman County School Superintendent," *Knoxville News-Sentinel*, 10 July 1946, B1; Lucille Deaderick, ed., *Heart of the Valley: A History of Knoxville, Tennessee* (Knoxville: East Tennessee Historical Society, 1976), 61–65. These institutions along with an increase in local industry continue to represent a vital force in the life of Knox County today.

6. "Superintendent's Report to the Knox County Quarterly Court," Knox County Schools, 7 October 1946.

7. Faye Cox, interview by author, 5 December 1994; Samuel Bratton, interview by author, 4 March 1994.

8. Cox, interview by author, 5 December 1994; Patterson, interview by author, 1 March 1995.

9. Homer Clonts, "Dennis Martin Disappeared 25 Years Ago," *Knoxville News-Sentinel*, 7 June 1994; Patterson, interview by author, 8 June 1994.

10. Clinton B. Allison, *Teachers for the South: Pedagogy and Educationists in the University of Tennessee, 1844–1995* (New York: Peter Lang Publishing, 1998),

199; Patterson, interview by author, 8 June 1994; "Superintendent's Report to the Knox County Quarterly Court," 4 April 1949; *Policies for Operation of Knox County Schools 1960*, Knox County, Tennessee, Number 17, 3.

11. Mildred Doyle, untitled speech to teacher group, personal files, 1949, 3; C. Baker, "Superintendent Doyle," 118.

12. Mildred E. Doyle, "Educational Horizons," personal files, 1976, 2; C. Baker, "Superintendent Doyle," 116–117.

13. "Superintendent's Report to the Knox County Quarterly Court," 6 July 1948 and 7 October 1946; Allison, *A Conversation*. In the videotaped interview with Allison, the superintendent used the term "tater holes" when describing school conditions in 1946.

14. Howard Bozeman, interview by author, 30 January 1995.

15. Patterson, interview by author, 8 June 1994.

16. Patterson, interviews by author, 9 March 1994 and 8 June 1994; C. Baker, "Superintendent Doyle," 124–128.

17. Patterson, interviews by author, 9 March 1994 and 8 June 1994; C. Baker, "Superintendent Doyle," 125.

18. C. Baker, "Superintendent Doyle," 125; Patterson, interview by author, 9 March 1994. It was in one of those meetings in the Carter community described in chapter 1 when the woman in the back of the room who was confused about a particular issue involving her grandson's schooling stood up and said, "Now Miss Doyle . . . I want you to broaden me out."

19. C. Baker, "Superintendent Doyle," 126; Patterson, interviews by author, 9 March 1994 and 8 June 1994.

20. "Superintendent's Report to the Knox County Quarterly Court," 20 July 1953 and 19 October 1953; Bozeman, interview by author, 30 January 1995; Patterson, interview by author, 9 March 1994; C. Baker, "Superintendent Doyle," 126–127.

21. "Miss Doyle Credits Success to 'People,'" *Knoxville Journal*, 26 July 1956, Mildred Doyle's personal files; C. Baker, "Superintendent Doyle," 128.

22. Cynthia Moxley, "Benevolent Dictator: For 30 Years Mildred Doyle Got Things Done as School Chief," *Knoxville Journal*, 4 July 1985, A8.

23. "A Twenty-Year Comparative Study, 1946–1966," Knox County Schools, 17 October 1966; Samuel Bratton, interview by author, 15 March 1994; "Superintendent's Report to the Knox County Quarterly Court," 15 July 1963; former music supervisor J. B. Lyle, quoted in C. Baker, "Superintendent Doyle," 138; Patterson, interview by author, 9 March 1994.

24. Bratton, interview by author, 15 March 1994.

25. "Recommendations for Improving the Educational Opportunities in the Knox County Schools," Knox County Schools, October 1963, 1–7.

26. "Tribute Paid Whole Doyle Family as New High School Dedicated," *Knoxville Journal*, 13 April 1968, photocopy, McClung Collection, East Tennessee Historical Society, Knoxville, TN; "Doyle Dedication," *Knoxville News-Sentinel*, 13 April 1968; "Dedication Portrait," *Knoxville Journal*, 11 April 1968, photocopy, McClung Collection.

27. "Dr. Doyle to Ask for Building Funds," *Knoxville Journal*, 6 April 1967, A1; "Superintendent's Report to the Knox County Quarterly Court," 16 January 1967; "A Thirty Year Comparative Study," Knox County Schools, 23 August 1976; Anne Klebenow, "Mildred Doyle Defends Knox County Schools," *Knoxville Journal*, 19 February 1976, A9; Patterson, interview by author, 9 March 1994. Because Miss Doyle received an honorary doctorate from Maryville College in 1965, she was occasionally referred to as "Dr. Doyle."

28. Moxley, "Benevolent Dictator," A8; "A Thirty Year Comparative Study, 23 August 1976."

29. This is not to say that overtly racist incidents did not take place in East Tennessee. For example, in 1958 Governor Frank Clement was forced to call the National Guard to protect students in neighboring Anderson County from racist attacks when a bomb explosion virtually destroyed Clinton High School after integration. Also in that year several bombings occurred in black residential sections of Clinton. Further, the Ku Klux Klan, which originated in Giles County in Middle Tennessee, is still active, particularly in very rural areas.

30. Mildred Patterson, interviews by author, 10 October 1994 and 1 March 1995.

31. Bozeman, interview by author, 30 January 1995.

32. Joel Spring, *The American School, 1642–1990* (White Plains, NY: Longman, 1990), 336–339.

33. Bozeman, interview by author, 30 January 1995.

34. Allison, *A Conversation*; Patterson, interview by author, 8 June 1994.

35. "Integration in Knox Due Today," *Knoxville Journal*, 30 August 1960, A2; Minutes of the Knox County Board of Education, 26 August 1960.

36. Minutes of the Knox County Board of Education, 26 August 1960; "First Graders in Knox Pass Up Integration," *Knoxville Journal*, 31 August 1960, A1.

37. "Progress of Desegregation in Knox County Schools," Knox County Schools, 1964–65; Patterson, interview by author, 8 June 1994. Miss Doyle also confirmed this interpretation in her interview with Allison in 1986, reporting only "very minor incidents."

38. "Integration Case Appeal Undecided," *Knoxville Journal*, 31 August 1960, A2.

39. "Integration in Knox Due Today," *Knoxville Journal*, 30 August 1960, A2.

40. Numerous colleagues in education and politics spoke of this characteristic in Mildred Doyle. See for example: Patterson, interview by author, 8 June 1994; Richard Yoakley, interview by author, 14 October 1994; Sue Hicks, interview by author, 13 October 1994; Bratton, 15 March 1994; Hal Clements Jr., letter to Mildred Doyle, 8 July 1982, personal files.

Chapter 5

Superintendent Doyle's Curriculum Leadership during the Progressive Era

Mildred Doyle never fit smoothly into commonly accepted categories or expectations in her personal life, gender constructs, or educational philosophy. She shared many beliefs about the purposes of schools and the ways children learn with pedagogical progressives. Yet, as with many administrators of her time, the educational policies that she espoused, particularly toward the end of her career as the country moved to the right, had conservative, social control consequences. The chapter explores her curricular and instructional leadership over the thirty years that she served as superintendent and the circumstances leading to her political defeat in 1976.

Mildred Doyle's Curriculum Ideas

The superintendent demonstrated sensitivity to "individual differences and personality needs" in students and supported an expanded, well-rounded curriculum reaching beyond "the old ideas of the three R's" to include art and music programs, literature, health education, commercial and vocational programs, boys' and girls' physical education, and special education programs. She believed that this type of enriched curriculum would enable students "to get the fullest enjoyment from living." She also recognized the pedagogical importance of making learning more meaningful by emphasizing a connection between curriculum and the life experiences of students. In this respect, Mildred's philosophy intersected with John Dewey's belief that knowledge is not only socially constructed but also socially purposeful. In concert with progressive developmentalist philosophies of child-centered pedagogy, Mildred worked closely with teachers and administrators to write a curriculum with a strong activity-based com-

ponent in which integrated units were based on ability level rather than on grade level. Aware of varying developmental levels in children, Miss Doyle and Knox County curriculum planners argued that such a flexible structure would enable the teacher to determine which activities were appropriate for a particular child's level of readiness in order to give each child the richest possible school experience.[1]

While Mildred's beliefs converged with that of child developmentalists, she nonetheless experimented with curricular changes based on contrary perspectives, such as social efficiency and scientific management, during the late 1950s. She and her staff implemented ability-grouping practices in early grades and offered differentiated curricula to high schoolers. These practices were intended to better meet the needs of students with different interests and abilities, but, in practice, they often resulted in the sorting of students based on social class and race. The school system used standardized testing regularly as a diagnostic tool to place students "in groups where they [would] do their best work."[2]

A traditional citizenship education comprised another aspect of Mildred Doyle's eclectic educational philosophy. Her advocacy of a conservative patriotic curriculum is hardly surprising, given her conventional Republican views and national sentiment following U.S. involvement in World War II. Many American citizens, energized by intense nationalism, enjoyed unprecedented opportunities during the rapid economic growth after the war. The atomic bomb and other threats posed by the cold war, however, created a confusing sense of paranoia amid feelings of contentment and prosperity. Having experienced within her lifetime the Great Depression and World War II, Mildred Doyle understood not only change and uncertainty but also the ways a nation can survive shocking social extremes. It is likely that the superintendent's views on the importance of traditional citizenship education as a curricular component in American public schools stemmed from her personal reaction to national upheaval and subsequent survival.[3]

Leftist philosophies such as the social reconstructionists' wing of progressive education, with its sharp critiques of American capitalism as a dehumanizing force, failed to influence Superintendent Doyle. Her devout patriotic tendencies led her to push the importance of the school's role in "training good citizens" who would show "respect for others, respect for authority, development of good habits, learning of certain rules and regulations and how these ideas are *not* to be violated." According to the superintendent, students should do their part to support their country and its institutions by leaving school as good citizens, "equipped to get a

job and start earning a living." She did not seem to notice conflicts be-
tween advocating developmentalist philosophies that generally espoused
schooling for the present rather than as preparation for adult life and
supporting the preparation of children for their eventual roles in the nation's
workforce.[4]

Mildred Doyle's advocacy of training good citizens to take their "proper"
places in the American labor force through the use of such practices as
curricular tracking and ability grouping would evoke criticism from repro-
duction theorists and revisionist historians as schooling for social control.
Although Mildred Doyle accepted the economic function of schooling in
the production of human capital and "good" citizens, her sense of the
purposes of education was much more complicated than simply sorting
students and training them to be servants of capitalism. She believed that
the essence of democracy was empowering others to participate in deci-
sion making and she supported the schools' role in emphasizing the rights
and ethical treatment of others.

Values such as respect for authority and the necessity of following
rules and regulations that she espoused to students in the early 1950s
represented functionalist rhetoric laced with doctrines of social efficiency,
spoken in response to the question of how future citizens could avoid
chaos and effectively get along with each other. At the end of her super-
intendency, she spoke with a group of teachers about "a need for a re-
birth of idealism and respect for ethics and morality," but not so much in
an authoritarian sense as in recognition of the need for individuals to be
socially responsible for each other. She claimed that such values as "hon-
esty, cleanliness, kindness, trust, respect for the rights of others, and the
dignity of man [sic] are basic ingredients for a full and happy life." The
superintendent assured teachers:

> I am not suggesting that we impose certain traditional standards. Agreement
> regarding values will be found not by submission but by honest discussion of our
> beliefs. We must learn to discuss issues, to meet our opponents face to face, to
> examine competing ideas, and to restudy our own beliefs. Out of such discussion,
> a gradual body of common opinion will emerge. I am urging that we undertake
> the necessary dialogue which will result in more common opinions and agree-
> ment which will give guidance and direction to our lives and our relationships.[5]

Like many practitioners, her educational goals were more discordant
and messy than the categories of theorists. While her functionalist think-
ing about schooling and the possibility of social consensus suggests ele-
ments that advocate social control, she viewed the school's role in citizen-
ship education as more complex than simply value transmission for its

own sake. She envisioned democracy as a way to include a range of voices and to encourage dialogue with the goal of reaching a broad consensus for ethical decision making. She pictured citizenship education as schooling for social responsibility toward other individuals, the local community, and the nation. The stocky superintendent vigorously approached lecterns to implore teachers to "practice democratic procedures in our classrooms" and "to urge our pupils to participate in community activities." She called on teachers to engage in political activity by voting, staying informed, and contacting politicians at all levels of government with their individual and professional concerns. Moreover, she challenged them to model such behavior for their students, and at least on one occasion she publicly admonished the poor voting record of Knox County teachers as an indicator of their failure to act responsibly.[6]

She trusted in the power of education to produce citizens committed to social action in order to energize democratic ideals. She believed that the responsibility of schools in promoting ethical values, civic action, and an ethos of national loyalty was not only "best for the boys and girls of Knox County" but for the country as a whole in order "to build the type of citizenry that will keep America a nation of the people." The superintendent wanted the school experiences of high school graduates not only to help them succeed in the job market but also to assist them in developing lives enriched with personal meaning, a sense of ethics, and dedication to social responsibility. According to Patterson, one of Miss Doyle's "foremost beliefs" was that human beings should be responsible for each other.[7]

Curricular Reform

While Mildred Doyle insisted on modernizing physical facilities in order to create comfortable, functional spaces in which students could learn, she maintained "that the instructional program is the heart of our job." Indeed, an improved instructional program was a significant plank in her initial campaign platform and became a central and ongoing goal under her leadership. The progressive superintendent "did not have a closed mind to any innovative things she thought would help education. She was very, very open."[8]

Much in the way of women administrators, Mildred Doyle sought widespread participation in policy making. She advocated teacher involvement at the county-wide level in curricular planning and development because she recognized the potential for teacher contribution through their collective experience and professional competence. She was also

convinced that teachers would be more likely to enthusiastically imple-
ment a curriculum that they had helped create. In 1949, she established
the Curriculum Planning Committee to focus on developing a program of
improved instruction for Knox County Schools. Volunteer teachers repre-
senting various grade levels and subjects, principals and teachers from
large and small schools, and central office staff composed this group that
continued its work under the guidance of a steering committee into the
early 1950s. The members agreed that one-half of the planning commit-
tee would be replaced each year in order to increase faculty representa-
tion and expand deliberations.[9]

The Curriculum Planning Committee relied primarily on results of the
1951 county-wide needs assessment survey conducted with assistance of
educationists from the University of Tennessee. As previously stated, ele-
ments of the survey pertained to curricular needs and what parents in
various communities wanted for their children. That same year the Ten-
nessee General Assembly granted the state board of education the power
to develop curricula. Prior to that policy change, the general assembly
itself determined courses of study for Tennessee's public schools. Given
its new responsibility, the state board mandated that every school district
focus on curriculum development, and to facilitate work of local districts,
the state board sponsored numerous conferences and curriculum plan-
ning workshops. Because of Mildred Doyle's leadership in establishing
and fostering the local Curriculum Planning Committee, Knox County
was "credited" with leading the state in curriculum planning in the 1950s.[10]

In 1950, the state board sponsored a summer-long curriculum plan-
ning workshop at the University of Tennessee in which nearly 150 Knox
County teachers participated. Patterson remembers being impressed at
the dedication of teachers and their willingness to give much time and
energy to improving the quality of instruction for the total school pro-
gram. Building on the ideas generated in previous workshops and in-
service meetings, this intensive workshop resulted in the creation of a
comprehensive document entitled *Knox County Department of Public
Instruction Tentative Program of Work, Grades 1-12, 1951–1952*. The
bulletin contained progressive curricular suggestions that were used as a
guide for classroom practice; they were developed entirely by Knox County
teachers. In the Foreword, Superintendent Doyle stressed the flexible nature
of the bulletin, stating that it was a collection of "initial suggestions for a
tentative program of work."[11]

An examination of the bulletin reveals the influence of pedagogical
progressives on Knox County curriculum makers. While the curriculum
guide features subject matter and learning activities divided into tradi-

tional content areas, the document stresses the need to integrate disciplinary study by providing suggestions for blending art, music, numbers, science, and health with the study of social studies. The bulletin also emphasizes that learning activities should relate subject content to the everyday life of students. A proposal for an integrated unit on mathematics seems to come directly from John Dewey's laboratory school at the University of Chicago. The bulletin (popularly called the Red Book by teachers) required that Knox County elementary students create and operate a store. Teachers could introduce mathematical concepts involved in storekeeping, such as addition, subtraction, weights, and measurements— all in a social context with which students were somewhat familiar. Students were given such responsibilities as opening the store on time, handling money, and making telephone calls to place orders. Teachers could integrate reading and writing exercises through such activities as making signs for the store and labeling products. Having designed a "program in social arithmetic" for her master's thesis at the University of Tennessee, Mildred Doyle had long been a proponent of "making arithmetic a practical study . . . relating problems to pupils' lives."[12]

Teachers relied on the Red Book as a curriculum guide for several years following its distribution, but they soon began to develop additional materials and plans for various grade levels and subject areas. Eventually these expanded subject area guides were followed by guides for further interdisciplinary activities that more explicitly coordinated, for example, the teaching of music with social studies and language arts in elementary grades.[13]

Superintendent Doyle's career follows the generalization that educational administrators are eager to appear innovative by embracing the newest trends. And by the late 1950s, the national conservative reaction to pedagogical progressivism had found its way to East Tennessee. The 1958–59 school year saw significant program changes implemented in response to the developing perception of parents and teachers that existing program designs were not meeting the needs of all individuals. Reflecting the philosophies of efficiency-minded reformers, Miss Doyle and her staff proposed "revolutionary" curricular and instructional reforms based on ability grouping for primary grades, departmentalization for seventh and eighth grades, and three curricular tracks for high school students. With the proposed instructional program, the administration hoped to be able to "better meet the needs of Knox County's youngsters."[14]

The plan called for lengthening the time spent in primary grades for students who were not working on grade level. A learner could take as

much as four or five years to complete grades one through three. During the first grade, teachers observed and tested learners to determine their individual competencies. At the end of the first-grade year, teachers were supposed to know whether a learner was ready to move into a regular second-grade class or if he or she needed further instruction. Miss Doyle and her staff purposefully kept class sizes small in the primary grades. A student labeled a "slow" learner was placed in a "2B" group for as long as "necessary for him [sic] to catch up with the faster-learning pupils." This "in-between" step applied to third graders as well. Teachers were to confer with parents of "slow" learners so that the final decision to place students in 2B or 3B ability groups would be made collaboratively, contingent only upon approval of parents. While no designated ability groups were endorsed for "the brighter child," Miss Doyle and her staff felt that students in regular second- and third-grade classes would benefit from greater teacher accessibility, resulting from the separation of students into 2B and 3B classes.[15]

Although the intentions of the central office about the expected outcomes of the program revisions were benevolent, the administration's assumptions did not take into account the eventual stigmatization of students in the "slower" groups. Because these groups became associated with failure, and because teachers had difficulty creating an instructional program that differed recognizably from the regular second- and third-grade curricula, the school system dropped the 2B and 3B grades in the early 1960s.[16]

In addition to ability grouping in primary grades, Miss Doyle and her staff endorsed departmentalization of the seventh and eighth grades in schools that employed eight or more teachers. The administration believed that instructional quality for seventh and eighth graders would improve significantly if subject matter specialists rather than a single teacher responsible for instruction in all content areas taught them. Principals and teachers were to structure class times so that curricular enrichments such as dramatics, languages, crafts, homemaking, and industrial arts were added to a student's basic program. Mildred Doyle continued to insist that an enriched curriculum functioned to enable students to get "the fullest enjoyment from living."[17]

Finally, echoes of the now discredited (for its anti-intellectualism and class bias) life-adjustment curriculum can be found in the administration's proposal for a three-track curriculum for grades nine through twelve. Like most advocates of a differentiated curriculum in the period, the superintendent seemed unaware of the potential for exacerbating the inequalities

of students. Superintendent Doyle and her staff supported different curricula in the belief that students would have greater flexibility in choosing a program to fit their individual interests and future plans. She hoped that such a strategy would strengthen the schools' holding power on high school students and prevent dropouts. Although not explicitly acknowledged by the administration, the three-track curriculum could effectively sort students into courses of study that would prepare them for labor-market stratification.[18]

An academic track for college-bound students required eighteen credits for graduation; an applied arts curriculum required seventeen credits for graduation, including electives from commercial and vocational courses; and a general education curriculum required sixteen credits to graduate. In the general curriculum, designed for students who would not attend college, students were grouped according to perceived ability.

In 1958, all eighth graders in the county system were given achievement and competency tests to aid placement in their freshman year of high school. Upon assessing test results and prior school records, teachers and guidance counselors were to hold conferences with parents and students to select a curricular track that fit students' individual interests.

While the community credited the county schools with taking an innovative stance toward curricular reforms that were responsive to the concerns of both educators and parents, the school system eventually abandoned the three-track curriculum in the secondary schools and the 2B and 3B levels in the primary grades. Educators found the plan too rigid, missing the objective of meeting individual interests of students. Although there is no evidence that the superintendent or her staff ever considered the possibility of class or racial bias in such placement, scholars have since warned that guidance counselors (historian Joel Spring called them professional sorters), working with unexamined assumptions, often pressured working-class parents to place their children in lower curriculum tracks.[19]

Since Mildred Doyle's time, educational researchers, minority parents, and social theorists have sharply criticized schools for their common practices of curricular tracking and ability grouping. Such research on tracking and ability grouping indicates that "perceived" ability levels and student placement are often based on social class status or race, gender, and ethnicity rather than on actual student ability. Working-class or minority students, regardless of ability, tend to be placed in lower ability groups or in vocational or commercial rather than college preparatory curricular tracks. And research indicates that once placed in a particular ability group

or track, students tend to remain "stuck" there for their entire school careers. Through such practices, social class inequities mirrored in the broader society are effectively reproduced to serve the interests of the dominant classes. Knowledge of the detrimental reproductive effects of tracking and ability grouping, however, was not widespread among Knox County teachers and administrators when they implemented the practices, rather they considered tracking and ability grouping innovative and beneficial to children. Mildred Doyle never consciously intended to facilitate the denial of opportunity to any student, yet she did accept biased conventional wisdom about why some children are "slower" than others and why some are "college material." As was common among many educators of her time, she was a true believer of the rhetoric about opportunities afforded by public schooling, apparently failing to see a need to question the system with regard to unequal treatment and outcomes that might actually limit rather than enhance a student's life chances. She and her staff wanted to provide the widest possible variety of curricular and instructional offerings while matching students with perceived ability level and individual interests.[20]

In the 1980s significant research emerged indicating that teacher *expectations*, often based on race, class, or gender, of ability rather than *actual* academic ability played a major role in the success or failure of students. Given her strong stance as a child advocate and her characteristic willingness to embrace new knowledge of educational theory and practice, it appears likely that if Mildred Doyle were school superintendent today, she would oppose ability grouping and push for an end to the practice.[21]

Introduction of Middle Schools

Throughout the 1960s, school systems reorganized elementary and junior high schools into middle schools; by 1969 over 1,000 middle schools operated in districts across the country. This organizational trend reflected an awareness of and sensitivity to the developmental range unique to students in the liminal state between childhood and adolescence.[22]

Always aware of educational trends, Mildred Doyle pioneered establishment of middle schools in East Tennessee. Aside from addressing an awareness of the unique developmental stages of middle-school-aged children, she used this organizational plan to relieve overcrowding in the elementary schools. The large numbers of elementary-aged children entering Knox County schools throughout the 1960s surprised administra-

tors, causing them to radically rethink their projected building plans. Classroom teachers and principals expressed concern to Miss Doyle and the central office staff that the inadequacy of building facilities was negatively affecting instruction.

In her usual inclusive style, the superintendent scheduled inservice meetings in which principals, teachers, and supervisors of instruction "brainstormed" possible solutions. As expected, they soon reached the conclusion that the county should abandon the decades old organizational pattern in which elementary school comprised grades one through eight and high schools included the ninth through twelfth grades. Under the proposed plan, elementary schools would house grades one through five; new middle schools would include grades six, seven, and eight; and grades nine through twelve would continue in high schools.[23]

Patterson and Director of Instruction Beecher Clapp traveled to schools in Indiana and Colorado where the middle school concept had been successfully implemented. They observed the dynamics of classroom instruction, examined curricular materials, and talked extensively to teachers and principals. Impressed with what they learned, the two administrators returned to the superintendent with the unsurprising recommendation that Knox County begin a middle school program.[24]

Progressive-minded county educators thought that nearby Knoxville city junior high schools were operated like "little high schools" that were not developmentally suitable for youngsters in the upper elementary grades. Mildred Doyle, Mildred Patterson, and Beecher Clapp selected teachers whom they believed were committed not only to the understanding of child and adolescent development but to curricular innovation and the middle school philosophy. The superintendent and her staff also insisted that this transitional phase in students' lives required personalized instructional programs for each child. Teachers wrote and gathered curricular materials organized around the instructional topics of learning skills, art in contemporary living, and personal development. The program proved highly successful. By the time of Superintendent Doyle's defeat in 1976, Knox County had created seven middle schools.[25]

An Extended School Year Plan and a Move to the Right

In the early 1970s, the national educational trends (back-to-basics and "accountability") became more conservative and so did Superintendent Doyle's curriculum projects. Beginning in the 1973–74 school year, several hundred teachers and administrators started working on a large-scale,

long-term curriculum development project to create a standardized curriculum, emphasizing mastery of basic skills, for all grades in all county schools. This idea to rewrite the curriculum was spearheaded by Beecher Clapp rather than Miss Doyle or Patterson. An extended-school-year pilot program instituted at Farragut High School in the 1974–75 school year accompanied the curriculum project.[26]

The logic behind the year-round school plan stemmed directly from social efficiency rhetoric: its purpose was to eliminate wasted time and space by using school buildings for instruction throughout the entire calendar year. School buildings that lay empty for several months each summer bothered Mildred Doyle. She and her staff divided the school year into forty-five-day blocks called "quinmesters." Students and their parents could select any four of the five blocks for actual instruction time and use the fifth for "summer" vacation. In order for the project to work, teachers and administrators had to develop curricula so that students could successfully enter and exit the program according to the quinmester plan, and so that their progress could be formally evaluated at the end of each quinmester.[27]

Knox County's long-term goal was to develop a curriculum guide that would serve system-wide needs, including schools on the quinmester plan. Sam Bratton of the central office helped organize an unusually large committee to tackle this task: "We got a lot of people together that didn't normally get together—teachers, administrators, and consultants working together on that kind of a scale. I mean we had probably 300 people participating in writing curriculum. It was interesting."[28]

Stimulating debates over curricular and instructional philosophies punctuated group meetings, and participants engaged in spirited conversation about the wisdom of breaking with tradition. Groups began work by defining curricular goals for kindergarten through twelfth grade. Following the development of program goals, groups began writing specific objectives for each subject. The groups also had the task of organizing the curriculum into forty-five-day modules to fit the extended-school-year model. The final tasks in the ongoing project were to design and write "curriculum packages or guides for instruction." Implementation of the new system-wide curriculum began in the 1974–75 school year along with a pilot program for the year-round school at Farragut High School.[29]

From the perspective of administrators and teachers, the new curriculum appeared to be successful in practice; however, Superintendent Doyle discontinued the extended-school-year program following its second year. According to Sam Bratton, the year-round program collapsed for eco-

nomic reasons: "We didn't have enough people choose to be different to make it economically feasible. . . . The people that participated in it thought it was great—students, parents, teachers, and principals. Miss Doyle felt it was costing too much." Participation in the program was voluntary, and because its format broke radically with tradition, too few parents volunteered. Most wanted to continue taking family vacations in summer months, and there were not enough students attending school during the summer quinmesters to justify spending the money required to operate the building. Sam Bratton characterized the experiment as one in which "the operation was successful, but the patient died."[30]

Implementation of all content areas in the system-wide curriculum (scheduled for the 1978–79 school year) was incomplete when Mildred Doyle was defeated in 1976. The model, however, had already become recognized by the Tennessee Department of Education as a valuable contribution to the move toward greater accountability. Indeed, the education department, in large part, adopted this basic skills curriculum for use as the official Tennessee State Curriculum in Governor Lamar Alexander's Better Schools Program. Clapp, director of instruction and the mastermind behind the plan, eventually moved to Nashville to supervise operation of the program at the state level as a deputy commissioner of education.[31]

It appears that pervasive conservative national trends moved Mildred Doyle's administration to rewrite the curriculum of Knox County schools to emphasize instruction in basic skills. In the late 1970s and early 1980s, conservative business groups and think tanks criticized the schools for churning out great numbers of high school graduates "who could not spell or write a sentence, and who did not know some basic information in science and history." Powerful voices called for a move toward teaching curricula that focused on the acquisition of basic skills and the increased use of large-scale, standardized assessments for competency. Many states have now instituted such curricula and testing programs. Not only are students targeted for competency testing by advocates of accountability, but teachers must also meet standards of competency, often determined by state departments of education. Critics of the accountability movement argue that "Accountability may turn the schools from humane, spontaneous, creative places that encourage positive self-concepts and success, to cold formal places with measurement procedures and clearly delineated objectives allowing for little spontaneity and creativity."[32]

After Mildred Doyle's thirty years of educational innovation with a commitment to democracy, creativity, and curricular enrichments for students, her efforts to shift to a standardized, basic skills curriculum seem

out of character—regardless of how much control she transferred into the hands of Beecher Clapp. For the Mildred Doyle of the 1940s, '50s, and '60s, school was an exciting place with room in the curriculum and the classroom for creativity and spontaneity. While she always insisted that basic skills were important, she never seemed to see a conflict between their acquisition and the social and emotional needs of children. And throughout her career she maintained that children require a variety of enrichment activities such as music and art. "She believed in enrichment," Patterson insisted. "In fact, she went way beyond state requirements always in Knox County." Some local observers suggest that as Miss Doyle became older she loosened her reins in order to boost the career of Beecher Clapp, grooming him for the superintendency by giving him more responsibility for determining the future direction of the school program. Or perhaps by reflecting national trends, the superintendent, as in the past, simply wanted Knox County to be recognized as an innovative school system. As an example, she supported a "progressive" innovation of the 1970s, open-space classrooms, at the same time that she endorsed basic skills and tracking.[33]

The End of an Era

Authorizing a comprehensive curricular revision that gave much more weight to basic skills than to child development and enrichment was not the only thing Mildred Doyle did that was unusual for her during the 1970s. The superintendent acted in several atypical ways that, according to people who knew her well, influenced her political defeat in 1976.[34]

Several years before her final election, Superintendent Doyle became involved in state and city political contests that were out of character for her. In 1974, she campaigned vigorously for Dr. Nat Winston in the Republican gubernatorial primary. Winston lost the primary bid to Lamar Alexander. The following year, she chaired one of six campaign committees for the Knoxville mayoral campaign of incumbent Mayor Kyle Testerman. Testerman was defeated by Democratic candidate Randy Tyree. According to Judge Howard Bozeman, "There are unwritten [political] rules in East Tennessee and Knox County: Don't get mixed up in party primaries and a county official does not participate in a race for mayor in the City of Knoxville." Mildred Doyle was most certainly aware of such unwritten political rules, but she dared to ignore them. Such activity influenced her defeat because it resulted in a loss of Republican Party support in her last election bid.[35]

While this uncharacteristically flagrant political activity influenced the election's outcome, close friends, relatives, and colleagues generally cite another likely reason for Mildred's defeat. In the late summer of 1975, the seventy-one-year-old Mildred Doyle announced publicly that she planned to retire following the 1975–76 school year when her term expired. She told the *Knoxville Journal* that she planned to use her political background to run for a position on the Knox County Quarterly Court as had her brother, father, and grandfather before her.[36]

Several months later, on 1 December 1975, the Knox County Education Association paid tribute to the legendary educator at a gathering at Doyle High School. Colleagues celebrated the superintendent's successes in office by warmly recalling her numerous accomplishments over the past thirty years. They told stories of memorable encounters with Mildred Doyle and the more (or less) creative colleagues wrote poems in her honor. The highlight of the celebration, however, was the gift of a new gold Cadillac, purchased with teacher contributions to the Mildred Doyle Appreciation Fund. While many thought this gathering in honor of Mildred Doyle was a retirement party, what most Knox Countians did not know was that over the past months the superintendent had been contemplating running for reelection.[37]

To quell rumors that the Cadillac was intended as a retirement gift, the chair of the Knox County Education Association published a letter to the editor of the *Knoxville News-Sentinel* stating that the celebration at Doyle High School had been planned as a birthday party for Miss Doyle and the car was a birthday present—not a retirement gift. Approximately a month later Mildred Doyle announced her plans to run again for superintendent in the Republican primary in May. Friends and colleagues cite her wavering stance on whether to retire or run once more as having contributed to the public perception of a loss of confidence in her decision-making capacities.[38]

According to Sam Bratton, Miss Doyle really wanted to see her assistant, Beecher Clapp, succeed her in the superintendent's office; but she knew that he probably could not get elected in Knox County because "He wasn't a political animal. He was a tremendous educator, very bright, but he was not a politician. He was not a back slapper." Although the highly qualified Clapp was a graduate of Teachers College, Columbia, and a committed veteran educator, Mildred Doyle was apparently convinced that he was not an effective politician. After she announced her forthcoming retirement, she began to escort Clapp to political gatherings to introduce him to Republican leaders. Party leaders agree to support him in the

primary election if that was Mildred's wish, but they confessed that they could not guarantee his success in the general election. Party members repeatedly told the superintendent, "He's too . . . well, he's not the kind of folks that can get down on the level of the common people and talk to 'em." Further, Knox County principals told Mildred that they had no confidence that Clapp could win and asked that she reconsider her decision to retire. She explained that the combination of principals' underconfidence in Clapp "plus the fact that some of the leaders in the party said, 'Now we've got to have a strong ticket, and there's nobody as yet that's emerged and we want you to run.'" was what caused he to decide to run again. Patterson believes that while pressure from her staff contributed to Miss Doyle's decision to run, it ultimately came down to Republican Party loyalty and the fact that "Mildred Doyle just couldn't stand the thought of a Democrat being elected superintendent."[39]

Patterson had uneasy feelings from the beginning that Mildred Doyle could not be reelected and tried to persuade her not to run again. She believed that Mildred's change of heart could be held against her by the voters. Further, rumors circulated that once elected, Mildred planned to step down after several months in office, thus using her power to name her successor to fill the remaining years of her term. According to Patterson, "There were three of us—the music supervisor, a librarian, and I—who did our best to keep her from running. If she had retired, it would have been so much better."[40]

Her good old boy opponent was Democrat Earl Hoffmeister, native Knoxvillian and an assistant principal at Central High School in the Knoxville City Schools. Mildred Doyle gave Hoffmeister his start in education when she hired him for his first teaching position at Powell High School in 1955 when he was in his twenties. In addition to teaching for Knox County, Hoffmeister repaired typewriters for the system for one dollar per machine to make extra money. His campaign theme was that "it was time for a change." He also attacked the open-space classroom idea implemented in several county schools in the early 1970s. He gathered information on his own concerning public perception of open classrooms by talking to community members and asking questions. He stated that students provided him with most of his information about open classrooms. According to the *Knoxville Journal*, Hoffmeister maintained that the open-space concept contributed to a decline in academics and proposed a return to individual classrooms in the open-space schools. A study conducted by evaluators from the University of Tennessee did not support his claims that academic performance had suffered as a result of open-space

classes, and Miss Doyle maintained that no student was forced to attend open-space classes and that parents were given a choice about where their children would be placed. In addition to open-space classrooms, Hoffmeister expressed concern over disciplinary procedures and drug use in schools.[41]

During the campaign, anonymous letters circulated about Mildred Doyle, blatantly attacking her personal character. The letters had been duplicated on a ditto machine. They were poorly written and contained many grammatical errors. The charges, completely irrelevant to her competence as school chief, insinuated that Miss Doyle was homosexual. Earl Hoffmeister claims no connection with the letters and maintains that he ran a clean campaign. Upon learning of the existence of the letters early in the race, he telephoned Mildred Doyle to assure her that he knew nothing of their origin and that he disapproved vehemently of such underhanded tactics. According to Hoffmeister, Miss Doyle expressed her certainty that he was not responsible for circulating the letters. Hoffmeister admitted, "It was a big relief off my mind that she didn't believe I had anything to do with those letters." He described his great respect for Mildred Doyle and her masterful accomplishments as Knox County superintendent, claiming to have run against her only because he felt that it was time for a change in administration—not because he had personal problems with Mildred Doyle's character. He insisted that he "could [not] care less" about Mildred Doyle's private life. He intimated that Miss Doyle's own party may have been responsible for the smear letters.[42]

Did those responsible for circulating the letters have some kind of vendetta against the popular and respected superintendent or did they sense that smear tactics were necessary in order to drastically alter public perception? In either case, this political manipulation suggests that someone definitely wanted to see the superintendency change hands in 1976. And, in the charge of deviance, Mildred Doyle's experience exemplifies the suppression of many women administrators who transgressed traditional gender-role boundaries. Prior to this election, neither Mildred Doyle's few political challengers nor Knox County citizens ever openly attempted to attack her private life. However, while the letters' contents were intended to provoke damaging perceptions, those affiliated with the campaign decided not to address the letters publicly, hoping the political damage would not be enough to defeat her.[43]

In her campaign Mildred Doyle expressed concern with regard to the priority that Hoffmeister could give to the superintendent's office since he operated a construction company in addition to his duties as an educator.

Hoffmeister claimed that his knowledge of construction actually gave him an edge because he could "recognize poor construction and remedies." Further, Miss Doyle attacked Hoffmeister's poor voting record. Apparently he had voted in neither primary nor general elections for the preceding ten years. She also criticized his failure to join state and national educational organizations as well as his poor attendance at school board and principals' meetings. In an earlier article in the *Knoxville Journal*, Miss Doyle claimed the Knox County school system to be one of the nation's best and cited the range of individuals "from preschoolers to adults" whom various school programs served. Further, she described the tremendous growth in student population and achievements in the building program since annexation in 1963.[44]

In the August general election Mildred Doyle was narrowly defeated by Earl Hoffmeister, a defeat that "Miss Tough Guy" would always find difficult to accept. The superintendent later disclosed that she felt that her party turned on her because she "wouldn't turn the school into a political machine" and that Republican leaders had grown jealous of the power she had accumulated over her tenure; she said that she had been "stabbed in the back."[45]

For thirty years, supporters of Mildred Doyle had gathered in the central office for the inevitable victory party following election returns. Even family members from out of town frequently joined the celebrations. On the night of 5 August no celebration occurred. The long tables of party food were left untouched as shock that an era had ended sank in. Tears were shed. Relatives quietly returned to Atlanta. Friends and colleagues somberly expressed their sorrow to the superintendent, who thought this night would never come. Miss Doyle's secretary, Faye Cox, remembered 5 August 1976, as "one of the saddest nights of my life." Patterson summed up Miss Doyle's reaction: "She never did get over it. She really didn't. She had thought, 'They can't get along without me. You know, I have all these people that I am responsible for and have to do for them.' Then they rejected her. She just never did get over that."[46]

Finally, the time had come when voters decided that they wanted a change in the leadership of their schools. Some residents believed that Miss Doyle could have defeated Hoffmeister had she never made the initial decision to retire and then changed her mind. Others, however, felt that it was simply time for a change of the guard. At any rate, Mildred Doyle's public life was not over; it would take new directions.

Notes

1. Mildred Doyle, "Curriculum Development," personal files, 1949, 1; "Superintendent's Report to the Knox County Quarterly Court," Knox County Schools, 9 October 1949 and 4 October 1948, 4; Herbert M. Kliebard, *The Struggle for the American Curriculum, 1893–1958* (New York: Routledge, 1987), 17, 41–58; *Knox County Department of Public Instruction, Tentative Program of Work, Grades 1–12,* 1951–1952, Knox County Schools, 63. An example of the superintendent's support for pedagogical progressivism was her praise of the work of Mrs. Stansberry's fourth grade class at Bearden Elementary for their work on an integrated unit on the Bearden Community.

2. Homer Clonts, "Separation of Good and Poor Pupils Asked," *Knoxville News-Sentinel,* 14 February 1958, 1–2; quoted material taken from Margaret Ford, "Knox School Head Ends First Year in Office," *Knoxville Journal,* 6 September 1947, B1. For a discussion of the class and racial biases of theses practices, see Joel Spring, *The Sorting Machine: National Educational Policy Since 1945,* (New York: David McKay Company, 1976).

3. See Eric Goldman, *The Crucial Decade—and After: America, 1945–1960* (New York: Vintage Books, 1960).

4. Mildred Doyle, "A Good Classroom for Every Child," 1953, personal files, 2, emphasis hers, speech given to students for American Education Week; Mildred Doyle, untitled speech made to student group, personal files, 1953, 2; Mildred Doyle, "Curriculum Development," personal files, 1949, 3–4. During the 1930s, reconstructionists advocated some form of socialism to replace the cruel and dehumanizing effects of private capitalism. They insisted that schools could help spread that ethos, replacing competition with cooperation, thus making the world a better place. For a more thorough discussion see Cremin, *Transformation,* 258–270 and Kliebard, *Struggle for Curriculum,* 183–208.

5. Mildred Doyle, "Educational Horizons," personal files, 1976, 2–3.

6. Mildred Doyle, untitled speech made at a Knox County teachers' meeting, personal files, September 1959; Mildred Doyle, "Knox County School System Plans Its Work," speech to teachers, personal files, 1953, 2. It is not known how the superintendent obtained her information on the poor voting record of Knox County teachers.

7. Mildred Doyle, "Curriculum Development," personal files, 1949; Mildred Patterson, interview by author, 1 March 1995.

8. Mildred Doyle, untitled speech to teachers, personal files, 1949, 1. Her files contain several untitled speeches delivered to teachers during the early 1950s concerning the work of the Planning Committee and the many teacher workshops that occurred as a result; Faye Cox, interview by author, 5 December 1994.

9. Mildred E. Doyle, "Knox County School System Plans Its Work," speech to Tennessee Educational Association, personal files, 1953, 1–6.

10. Ibid., 1.

11. Mildred Patterson, interview by author, 8 June 1994; *Knox County Department of Public Instruction Tentative Program of Work, Grades 1–12, 1951–1952*, Knox County Schools, emphasis hers. Mrs. Patterson provided me with a copy of the "Red Book," stressing that it is probably one of the only surviving copies.

12. Red Book., 20, 24–26; Mildred Doyle, "A Program in Social Arithmetic," (master's thesis, University of Tennessee, 1944), 1, personal files.

13. C. Baker, "Superintendent Doyle," 130–131. Baker cites a statement by Beecher Clapp, former director of instruction, 23 June 1977.

14. Clonts, "Separation," 1–2; Mildred Patterson, interview by author, 9 March 1994; Progressive educators concerned primarily with efficiency advocated similar practices as adopted by Knox County. According to their thinking, schools would run more efficiently if curriculum and instruction matched abilities and interests of students.

15. "Tentative Suggestions for a Revised Primary Program," Knox County Schools, 21 April 1958; Clonts, "Separation," 1–2.

16. Patterson, interview by author, 10 October 1994.

17. "Suggested Plan of Organization for Grades Seven and Eight," Knox County Schools, 21 April 1958; Clonts, "Separation," 2; quoted material taken from Mildred Doyle, "The Knox County Curriculum," personal files, 1949, 1.

18. For a discussion of life-adustment education, see Kliebard, *The Struggle for the American Curriculum*.

19. Joel Spring, *The Sorting Machine: National Education Policy Since 1945* (New York: David McKay, 1976).

20. For discussions of class bias in public schooling, see Spring, *The Sorting Machine*; Samuel Bowles and Herbert Gintis, *Schooling in Capitalist America: Educational Reform and the Contradictions of Economic Life* (New York: Basic Books, 1976); Aaron Cicourel and John Kitsuse, *The Educational Decision Makers* (Indianapolis: Bobbs-Merrill, 1963); Jeannie Oakes, *Keeping Track: How Schools Structure Inequality* (New Haven, CT: Yale University Press, 1985).

21. For examples, see Robert Rosenthal and Lenore Jacobson, *Pygmalion in the Classroom: Teacher Expectation and Pupils' Intellectual Development* (New York: Irvington, 1988); Peter Schmidt, "Debate over Ability Grouping Gains High Profile," *Education Week*, 13 January 1992, 23; Peter Schmidt, "Mass. Leads Mounting Charge against Ability Grouping," *Education Week*, 13 January 1992, 22.

22. Theodore Moss, *Middle School* (Boston: Houghton Mifflin, 1969), 1–41.

23. Samuel Bratton, interview by author, 4 March 1994; Patterson, interview by author, 9 March 1994; "The Middle School—A Rationale," Knox County Schools, January 1968, 1–12.

24. Patterson, interview by author, 9 March 1994.

25. Bratton, interview by author, 4 March 1994; Patterson, interview by author, 9 March 1994; "The Middle School," 6–12.

26. Patterson, interview by author, 8 June 1994.

27. Bratton, interview by author, 4 March 1994; Patterson, interview by author, 8 June 1994.

28. Bratton, interviews by author, 4 March 1994 and 15 March 1994.

29. C. Baker, "Superintendent Doyle," 145.

30. Bratton, interview by author, 15 March 1994.

31. Patterson, interviews by author, 9 March 1994 and 8 June 1994; Terri Weintraub, "'Basic Skills First' Author Workaholic for School Reform," Knoxville Journal, 13 January 1984, A1.

32. Jeanne H. Ballantine, The Sociology of Education: A Systematic Analysis (Englewood Cliffs, NJ: Prentice-Hall, 1993), 383–385.

33. Patterson, interview by author, 8 June 1994.

34. C. Baker, "Superintendent Doyle," 148–149.

35. Ibid., 149.

36. "Doyle Won't Seek Reelection," Knoxville Journal, 7 August 1975, A1. Events described in the following paragraphs were discussed in interviews with Howard Bozeman, Samuel Bratton, Faye Cox, Ruth Doyle Hilton, Earl Hoffmeister, Mildred Patterson, Gordon Sams, and Richard Yoakley.

37. Al Rogers, "Are Doyle 'Retirement' and Rankin Remap Plan Tied to Power Move?" Knoxville News-Sentinel, 4 January, 1976, A1. I tried in vain to locate the poems written in her honor.

38. "They Charge Inaccuracies in Article about Supt. Doyle," Knoxville News-Sentinel, 11 January 1976, B3; "Dr. Doyle Announces Election Bid," Knoxville Journal, 20 February 1976, A1.

39. Bratton, interview by author, 4 March 1994; C. Baker, "Superintendent Doyle," 151; Patterson, interview by author, 1 March 1995.

40. Patterson, interview by author, 9 March 1994.

41. Earl Hoffmeister, interview by author, 1 February 1995; "Open Space Classroom Evaluation Presented," Knoxville Journal, 7 August 1975, A1; "Open Space Classrooms, Discipline Spark County School Race Debate," Knoxville Journal, 26 July 1976, 20.

42. Sue Hicks, interview by author, 13 October 1994; Richard Yoakley, interview by author, 14 October 1994; Faye Cox, interview by author, 5 December 1994; Earl Hoffmeister, interview by author, 1 February 1995. Faye Cox could not bring herself to actually read the letter because she was heartbroken that someone would do that to Miss Doyle.

43. Jackie M. Blount, *Destined to Rule the Schools*, 8, 110; Richard Yoakley, interview by author, 14 October 1994.

44. "Open Space Classrooms, Discipline Spark County School Race Debate," *Knoxville Journal*, 26 July 1976, 20.

45. "Doyle Defeated, Jenkins Wins" *Knoxville Journal*, 6 August 1976, A1; Miss Doyle quoted in Moxley, "Benevolent Dictator: For 30 Years Mildred Doyle Got Things Done as School Chief," *Knoxville Journal*, 4 July 1985, A8. Mildred Patterson described her partner as "Miss Tough Guy," interview by author, 8 June 1994.

46. Cox, interview by author, 5 December 1994; Patterson, interview by author, 9 March 1994.

Chapter 6

Old Habits Die Hard:
Life after the Superintendency

Mildred Doyle devoted fifty-two of her eighty-four years to public education and other public service, and the thirteen years between her election defeat and her death could hardly be termed "retirement" as the gray-haired former superintendent remained in the public eye, preserving the Doyle tradition of civic and political involvement. She continued to influence school policies by serving on committees and service boards throughout her community and state. And her well-known sense of humor and need to entertain at the podium caused her to remain a popular choice for local speaking engagements.

This chapter examines the last years of Mildred Doyle's life. It traces her departure from the central office, her involvement in alternative education programs for troubled youth and unwed mothers and other service projects for her community, public tributes for her service, and, finally, her diagnosis of cancer.[1]

Saying Good-bye to the Central Office

For Mildred Doyle's secretary Faye Cox, the only experience more painful than the thwarted victory party was the next morning's return to the central office, knowing that her days of working closely with the vigorous superintendent who "put her very best into anything that she did" were now numbered. Cox wished that Miss Doyle had never decided to run in that final election, so she "could have gone out in her glory" rather than contending with the pain of political defeat and feelings of rejection. As Mildred Doyle entered the building that day, she stoically hid her shock and sorrow by "keeping a stiff upper lip." The renowned superintendent, considered subconsciously by many to be a permanent fixture in the Knox County Schools, had been given three weeks to vacate her office.[2]

Two weeks following the general election in which Earl Hoffmeister narrowly defeated Mildred Doyle, a *Knoxville News-Sentinel* photograph depicted the elderly superintendent clearing out her office. Cardboard boxes covered the floor behind her desk as she sorted and culled thirty years' worth of memorabilia, documents, and other papers. One of Superintendent Doyle's quirky trademarks was the use of green ink for general note taking about the office and writing rough drafts of speeches. She used green ink to write everything except her official signature. Among the first requests that Miss Doyle made of her clerical staff following her defeat was to remove every pen that contained green ink from the central office. With green pens gathered and boxes packed, she officially departed the superintendent's post on 1 September 1976. Never again was she comfortable returning to the central office despite the fact that Earl Hoffmeister retained all of her staff. He expressed a great deal of outward respect for the venerable educator and suggested that as a novice superintendent, he could have benefited greatly from frequent consultation with her on school matters. The embittered Miss Doyle, however, never made her wealth of educational and political experience available to Hoffmeister.[3]

Mildred Doyle told reporters in 1976 that she had leisure plans to travel "west to Alaska," perhaps even to Europe, and to attend sporting events. Still a lover of baseball, she indicated that she would like to attend a World Series. Further, she added, "I've got my greenhouse and my flowers and maybe now I'll have time for my garden." Because Mildred Patterson retired from the Knox County Schools upon the defeat of her companion, she shared Mildred Doyle's leisure life after the superintendency. They traveled throughout the United States together. Miss Doyle toured the western states as she had planned and was intrigued not only with the landscape, but with romantic notions of cowboy culture. She delighted in visiting the grave sites of notorious outlaws and gunfighters and was amused by the antics of prairie dogs. Doyle and Patterson also spent time at their apartment in Gatlinburg, watching the clear mountain river flow just below their balcony. Back at home on Maplewood Drive, Miss Doyle planted zucchini and tomatoes in her vegetable garden and worked in her greenhouse growing prized orchids. She also continued to keep abreast of sociopolitical events which she and Patterson regularly discussed at length. Patterson's eyes twinkled as she recalled never being bored with the "opinionated" Mildred Doyle around: "We talked about everything. She settled all problems—locally, statewide, nationally. She knew *everything* that was going on!"[4]

When she was not discussing current events or politics, the former athlete often watched professional baseball games on television. She was

particularly interested in the Atlanta Braves but watched the Chicago Cubs "just to hear Harry Caray sing 'Take Me Out to the Ballgame' in the seventh inning." Mildred Doyle even talked Patterson into traveling with her to Florida on several occasions to watch the Atlanta Braves and other professional teams in spring training. On these trips Patterson preferred to stay in the motel, yet she chuckled like a dutiful companion: "I sat through more baseball than I ever wanted to."[5]

The soft-spoken Mildred Patterson preferred music to baseball. Prior to retirement Mildred Patterson had served as longtime director of the Knox County Teachers Chorus, a group that Mildred Doyle, as friend, music lover, and school chief, supported enthusiastically by attending every performance, and by making funds available for them to perform across the state. Patterson remained active with Knoxville music organizations after retirement. She started a choral group called the Singing Seniors (The only requirements for membership were to be a senior citizen and to want to sing). While Mildred Doyle neither sang nor played an instrument, Patterson described her as "an avid consumer" of music, loving classical, jazz, and folk compositions—unlike most of her South Knox County neighbors—anything but country and western.[6]

Besides baseball, gardening, and music, the two women also relaxed at home with their pet cat, Tom, whom they pampered with affection and lavish treats. According to Mildred Doyle's sister Ruth, "They fed it bacon. They fed it watermelon. They fed it everything good." She added, "I used to look at that fat thing and say, 'Kids are starving to death and you are feeding this damn cat.'" Indeed, Tom's feline charm and odd eating habits afforded them a great deal of pleasure and amusement in the years following their retirement, and they were heartbroken at having to put him to sleep when he developed cancer. Despite Mildred Doyle's enjoyment of leisure activities with Patterson and Tom, within several years she began to yearn for the excitement of the public sphere. Because old habits die hard, she soon took on innovative educational projects and engaged in additional community service activities.[7]

The Alternative Center for Learning

In addition to her work with public schools, Mildred Doyle served on the Tennessee Children's Services Commission; she continued her work with this agency until a few years before her death. Through her efforts as both a member and chair of the governor-appointed commission, she worked to create policy and to influence a wide range of Tennessee legislation focusing on the needs and rights of children and youth. Her close

affiliation with the commission led to growing concerns about children who were ill-served or pushed out of schools by public school bureaucracies.

In the late 1970s Mildred Doyle became increasingly concerned about the fate of secondary students who had been suspended or expelled from school. As more teenagers were enrolled in school, discipline problems such as drug use, smoking, and vandalism in schools were on the rise. Hence, the rate of suspensions and expulsions in both Knox County and Knoxville City Schools had climbed, and Miss Doyle knew, from her long experience in administration, that school officials had often "given up" on repeat offenders. The veteran educator insisted that something should be done to enable these students to continue their education in an environment that could help them succeed. She told a reporter in 1981, "You can't just kick them out on the streets. Much concern should be given to these youngsters who will someday be members of our society and made into productive citizens." She understood that students often come to school with a variety of problems that make success in school nearly impossible. She realized that teens cope in different ways, and that behaviors which adults abhor do not necessarily mean that students can't succeed in school. She argued that given a more appropriate learning environment, an alternative to the regular classroom, these students could work out their problems and complete their education. According to colleague Dick Yoakley, "She was an avid gardener, incidentally, so she understood the meaning of preparing an environment where something could grow."[8]

Never a passive person, Miss Doyle took her concerns to Dean William Coffield of the College of Education at the University of Tennessee to see if she could collaborate with the college on her idea to start a school for these youngsters. Coffield expressed interest in Miss Doyle's plan and suggested that she talk with Robert DeLozier, who worked within the dean's office as a field services consultant for the college. Doyle and DeLozier agreed about the reasons why students became discipline problems in the eyes of public school educators, and they considered ways of helping them "turn around." They wanted to prevent students from being repeatedly kicked out of school, or worse, dropping out altogether. By offering alternative intervention strategies, they wanted to challenge the "prevailing attitude that suspending and expelling students from school [would] automatically cause the student to obey rules and regulations and behave better."[9]

With a cadre of central office administrators and principals in both Knox County and Knoxville city school systems supporting their efforts,

they began to develop a structure for an Alternative Center for Learning. Miss Doyle insisted that the center could not be governed by the public schools, because regular school board policies were much too rigid for the alternative structure they envisioned. They decided that the school was to be a nonprofit organization, funded through both public and private sources. DeLozier wrote grants to obtain funding through government agencies and private organizations while Mildred Doyle used her political clout to sway the Knox County Court for financial support. DeLozier remembered Mildred's early appeals to the county court: "Of course the County Court [members] all knew her because she was a politician. I don't know if the program meant so much to the County Court than [did] the fact that *Miss Doyle* was asking for the money." The court agreed to contribute approximately $15,000 per year to the program, and she also obtained some funding from the Knoxville City Commission. She appealed directly to Governor Lamar Alexander for state support, and he eventually adapted the original idea for use in his Better Schools Program several years later, when the legislature required school districts to provide some form of an alternative program for students who had been suspended or expelled. In addition to the governor's support, the public schools agreed to contribute funds equivalent to those a student would receive per year in a regular classroom. DeLozier's initial grant-writing efforts netted over $200,000 for the operation of the school. Through such collaborative efforts, the Alternative Center for Learning was opened in 1980 with DeLozier serving as director. Attendance at the center was voluntary and students were enrolled on a first-come-first-served basis. They remained enrolled for the length of their suspension or, if expelled from public schools, they stayed until they graduated. Not only were students from Knox County welcome at the center, but it admitted students from surrounding counties. The school averaged one new student a day, and it maintained a lengthy waiting list of teens who sought to enroll.[10]

According to the plan devised by Doyle and DeLozier, the central function of the Alternative Center was to get secondary students back into the regular classrooms as soon as possible and eventually to graduate them. The center had four classrooms, one for each grade, nine through twelve; the maximum class size was not to exceed twelve students. Miss Doyle insisted that the Alternative Center provide comprehensive psychological services for its students by assigning counselors to work within each classroom. She wanted to ensure that students had the opportunity to work out personal and family problems that might be the root of behaviors deemed unacceptable by the public schools. Psychological services at the

center provided for students to receive one-on-one counseling twice a week and to attend group sessions once a week. Counselors, social workers, mental health workers, and juvenile court officials worked as a team in order to help students find more effective ways of relating to adult authorities.[11]

Mildred Doyle was in many respects "a kid at heart" and she delighted in young people. As superintendent she frequently visited schools, interacting regularly with students in the halls and on the playgrounds. Her affiliation with the Alternative Center enabled her to continue her contact with the youngsters she loved so much. For the first few years of its existence, Miss Doyle visited the students at the center "every couple of days," and about once a month she brought them boxes of doughnuts. They treated her more as a grandmother than as an authority figure, and they talked seriously with her about their confrontations with school officials. She became "really attached" to several students through the years, particularly ones who were having an especially difficult time. Her encouragement and confidence that these kids would "turn around" often provided the extra push that they needed to envision different futures for themselves. For example, she saw these students overcome drug and alcohol problems that had thwarted their success in school, and she watched them graduate, find meaningful jobs, or, in some cases, attend college. According to DeLozier, many of these youth were headed for juvenile court, and the combination of services offered by the school, local social service agencies, and the special attention of Mildred Doyle helped prevent such a fate. As her health began to deteriorate, she spent less and less time at the school and particularly with individual students, yet she visited until she was physically unable to continue.[12]

While Mildred Doyle advocated the expansion of the social role of public schools to include, for example, health and psychological services for young people, she also realized that the public schools could not cure all social problems. She understood that a high level of "inter-agency cooperation" within the community was needed to balance the responsibility for the fate of children. Through the idea of the Alternative Center, she managed to obtain such cooperation; and, according to colleague Dick Yoakley, the community, through various agencies, began to take more responsibility for young people and problems that they might have with school and family.[13]

DeLozier and Doyle encountered naysayers along the way who expressed skepticism that the efforts of the center could make any significant difference in reducing dropout rates and juvenile delinquency, or in

reducing behavior problems in children after their return to the regular classrooms. High school principals cited a tendency for students to "go backwards" when they returned to their original classroom setting. However, 70 to 80 percent of the students at the center returned successfully to their regular schools and eventually graduated. DeLozier included among his "success cases" students who dropped out of school but found steady jobs and stayed out of trouble with the police. He admitted, however, that the school had "alumni at Brushy Mountain" who did not respond positively to the offerings of the center, got in trouble with the police, and wound up in juvenile court and, eventually, in prison.[14]

Most students enjoyed their experience at the Alternative Center and reported that the caring and the one-on-one attention with faculty contributed to their heightened self-respect and their success in school. DeLozier remembers students who returned to their regular classrooms only to deliberately breach school board policy and get suspended so that they could return to the nurturing environment of the Alternative Center. He believes that approximately 90 percent of students preferred the Alternative Center over the regular classroom.[15]

Mildred Doyle and troubled youths in the region were fortunate in having directors of the alternative school who were interested in healing rather than simply punishing students. John Adams and Jerome "Jerry" Morton, the directors who followed DeLozier, were student-centered psychologists. They worked to provide a pleasant and courteous environment for students and staff alike. Morton taught the staff, and anyone else who would listen, that troubled youth,

> are caring individuals who are more positive than negative. . . . They see themselves as heroic figures surrounded by personal and social injustices. Arguing with them about a specific situation in which their behavior was 'wrong' is fruitless. Even if the adult 'proves' his specific point, the young person can and does bring up other situations in which they were unfairly treated, thereby making a legitimate justification for their inappropriate behavior.[16]

The reaction of most adults, including many teachers and school administrators, to the inappropriate behavior of troubled youth is fear and a desire to punish, to make life for the troublemakers as difficult as possible. In contrast, Morton and his colleagues thought that the better response was to teach students more effective strategies for reacting to the real injustices that they experienced.[17]

With the addition of Rosa Kennedy, a well-known professional artist, art became central to the school's curriculum, and visitors were often

surprised at the talent of the students and the quality of their work. Time spent in art seemed to directly enhance the students' sense of self-esteem, allowed them to communicate without having to be verbal, and improved their academic work.[18]

By most accounts, even those of skeptical high school principals, the Alternative School was remarkably successful. Unfortunately, after the loss of Mildred Doyle's political clout with her death, a newly consolidated metropolitan school system took control of the Alternative School, hired different administrators, and began to change its philosophy to a more traditional, efficiency-based model. The school system required the admission of more students without increasing funding, and the ratio of students to teachers and counselors decreased.[19]

The Alternative Center for Learning provided Mildred Doyle another vehicle through which she could "do what's best for the boys and girls of Knox County," even after she no longer served as superintendent. She once confided to DeLozier that she felt that through her work with the Alternative Center, she in some respects helped youngsters more directly than she did as superintendent of the Knox County Schools. She realized that as superintendent she had so many administrative duties that they took away from her capacity to have direct contact with students.[20]

Helping Pregnant Teens and Unwed Mothers

Mildred Doyle's affiliation with the Alternative Center afforded her additional opportunities to provide help for another group of students who were often ignored, condemned, and pushed out of public schools. Through her connection with the center, she became aware of the efforts of Lyn Overholt, a prominent local youth advocate, who was concerned with high dropout rates among pregnant teenagers and unwed mothers. Overholt had been working to establish a child-care program at Rule High School, an inner city school with a high concentration of unwed mothers and teen pregnancies. Students who had no way to care for their children and simultaneously remain in school were dropping out altogether. Overholt wanted to start a program that provided day care at Rule for the children of teenaged mothers, so the mothers could remain in school.[21]

Overholt's idea was controversial in fundamentalist Knoxville, and conservative school officials and community members were appalled at the thought of accommodating young mothers who bore children out of wedlock. Angry citizens denounced the proposal as permission to engage in premarital sex and as sending a message "telling teenagers to get preg-

nant and bring their child to school." Ever a true believer in the power of schooling, Mildred Doyle was appalled that the moral reactions to teen pregnancy led to a denial of the opportunities that education might bring to young mothers. In her mind, city school officials were disregarding the possibility that a teenager with a child could live a satisfying, productive life and provide adequately for her child if given a chance to complete her education.[22]

While circumspect and conventional in her public utterances on sexual issues, the former superintendent saw personal and social disaster when young mothers lacked education and job skills with which to provide for their children. Because Knoxville school officials refused to allow such a program for unwed mothers within Rule High School itself, the politically savvy Mildred Doyle and leaders of the Alternative Center devised a plan to establish the program while, at the same time, respecting school policy. They rented a portable classroom building and moved it to the Rule High School parking lot, where they instituted a child-care program for the benefit of unwed mothers, their children, and pregnant teens. The program was granted state certification as a childcare center and became eligible for state funds. "We set up a child-care program there and the mothers were required to come take care of their children during their free periods," DeLozier recalled. "We used it as a lab and high school students would come down there and [learn to] take care of the children. The fathers were even required to come down and take care of their children."[23]

A nurse visited the child-care facility once a week and the health department gave all children regular physical examinations. Young mothers learned about child care, from how to change diapers to how to recognize childhood illnesses. Further, the Alternative Center helped finance a van equipped with baby seats to transport young mothers and their children to and from school each day. The program enabled many young mothers who had dropped out to return to school and graduate, and a number of them eventually graduated from the University of Tennessee—a feat almost impossible without such a day-care center.[24]

The Charter E. Doyle Memorial Park

Mildred Doyle understood the importance of recreation for the healthy development of children and for the enjoyment of adults. She devoted much of her life to recreational and competitive athletics as a basketball and softball player before she turned to watching spectator sports on

television in her later years. Early in her superintendency, she approached an aunt about buying the twenty-six-acre cow pasture located across the road from the Doyle Homeplace on Martin Mill Pike, where the superintendent lived at the time with her brother "Pinky" and his family. Mildred possessed great sentimental attachment to the property that was part of the original land grant given to her ancestor John Doyle in 1800. As a youngster Mildred played countless hours of baseball with her siblings in that pasture. Mildred bought the land from her aunt in 1950 and held it until the early 1980s when she devised yet another community service plan.[25]

Parks and recreational facilities were scarce in rural south Knox County, and, in 1983, Dole donated the twenty-six acres to the city and county for use by community residents. Knoxville Mayor Kyle Testerman and County Executive Dwight Kessel gratefully accepted the former superintendent's generous gift and promised to work cooperatively to see that the land was developed according to Miss Doyle's stringent and specific specifications. Always the good politician who knew how to get what she wanted, Mildred told Testerman and Kessel, "I'm glad both of you will be involved in it. The people of South Knoxville have been good to me and my family, and I wanted to return the favor and to preserve the name of my family in this way."[26]

The National Park Service and Knox County and the Knoxville city governments provided matching funds to construct the park, but Miss Doyle oversaw the design. She insisted on a nature trail, a softball field, a paved jogging trail, tennis courts, fitness courts, playground equipment, picnic areas with barbecue grills and tables, several covered pavilions, restrooms, and ample space for parking. Further, she wanted a full-time, live-in caretaker on the premises at all times so that the communities' recreational needs were met within a safe and well-tended environment.[27]

The autumn sun sparkled on the crisp October day as groundbreaking ceremonies were held for the Charter E. Doyle Memorial Park, named for Mildred's civic-minded father who cared about his community and always encouraged his eleven children to enjoy outdoor recreation and who joined his wife and children for Saturday afternoon baseball games on these fields. Accompanying the former superintendent to the groundbreaking ceremony were 250 students from adjoining Moreland Heights Elementary School, which Mildred had attended over seventy years earlier. The youngsters sat cross-legged on the ground, listening attentively as Miss Doyle described the delightful times she shared playing there as a child. She told the children to have as much fun as they could there, "Because

it's for you as well as everyone else in this community." Wearing a construction worker's hard hat, the eighty-year-old ex-superintendent vigorously scooped the first shovelful of dirt, signifying that construction on the park had begun. In addition to the schoolchildren from Moreland Heights, representatives of the extensive Doyle family, enthusiastic community members, and city, county, and state government officials were present at the ceremony.[28]

One of Mildred Doyle's political skills was marshaling community groups to work together for common goals. The Knox County Council of Garden Clubs, the Tennessee Valley Authority's Office of Natural Resources and Economic Development, and the Marine Corps Reserve collaborated on building the nature trail through the park. The Council of Garden Clubs donated over 200 varieties of wildflowers, and they were blooming in profusion along the trail on 10 June 1986, when the trail officially opened with an afternoon tribute to Mildred Doyle. Much pomp and circumstance characterized the ceremony as the U.S. Marine Corps Color Guard was presented and onlookers joined in the Pledge of Allegiance. Miss Doyle first spoke about the devotion to public service of her father and mentor, for whom the park was dedicated, and then, grinning characteristically, she remembered her days as a youngster playing baseball on the land that was once a cow pasture, quipping that she never knew exactly what she was sliding into when she hit second base.[29]

Mildred Doyle loved not only to watch children at play, but to join in the fun. From her time as a teacher and even as principal at Vestal Grammar School, the boisterous educator could often be found on the playground with the students, joining them in informal recreation during lunch period and recess. And she served as coach of both girls' basketball and boys' baseball teams in the upper elementary grades at Vestal. Although long past her playground days in 1986, she was able to use the creation of Doyle Park to ensure that Knox County children would have a place to play freely and safely.[30]

Awards and Honors

Although saddened by her reelection defeat in 1976, in her last years Mildred Doyle was partially compensated by overwhelming expressions of respect, esteem, and even love. Her personal files contain numerous awards, certificates of appreciation, honorary group memberships, and hundreds of letters of praise and gratitude from state and local political figures, educators, and ordinary citizens.

In 1977, the Tennessee State Senate passed Joint Resolution No. 66 "to honor Miss Mildred Eloise Doyle for her outstanding contribution to the field of education in Tennessee." (A copy of the resolution may be found in appendix A.) Governor Ray Blanton approved and signed the resolution on 18 April 1977, the year following Mildred Doyle's political defeat. Perhaps the good old boy politicians were simply honoring one of their own in a routine kind of way, but it seems to be more than a reflection of her political connections. Not only were the legislators who voted to adopt this resolution expressing their own admiration for Miss Doyle, but they were serving as the voice of their constituents in expressing the gratitude of many citizens.[31]

The resolution listed many of her accomplishments, and they are impressive. Throughout the nation, and particularly in the South, managing school systems was in the men's sphere. In Tennessee, the Superintendents' Study Council exemplified the male-establishment network of school administrators; it was a think tank, political league, and social club. Mildred Doyle's success in negotiating gender constructs is exemplified not by her membership but by the fact that she was longtime chair of this almost all-male fraternity.

As the resolution noted, Mildred was active in her professional organizations, including the National Education Association and the Tennessee Education Association. The resolution authors failed to note that, in 1952, she served as the first woman president of the Tennessee Education Association—another gender barrier broken by her "big presence."

The resolution noted that Mildred Doyle was a charter member of the State Textbook Commission. In that capacity she belonged to a group of selected educators who met periodically in Nashville with representatives from textbook companies as they presented their texts for possible adoption. The commission would then select textbooks from which schools throughout Tennessee had to choose. Potentially, membership on the commission could lead to a great deal of power over the control of knowledge that was taught in local school districts throughout the state, and Mildred was not one to squander potential power. She served on the commission for twenty-five years, taking her responsibility quite seriously as she often returned to her office on weekends to read through and evaluate every sample text.[32]

As her honors grew and public and charitable organizations asked her to serve on boards of directors, the former superintendent used her positions to lobby for the well-being of children. Her affiliations included the State Advisory Board on Child Abuse; the National Conference on Juve-

nile Justice; the Tennessee Juvenile Justice Advisory Group; the boards of directors of Maryville College, Knoxville Child and Family Services, Tennessee Volunteers for Children, the Vestal Boys Club; as well as the National Education Association's Educational Finance Committee; the Tennessee State Advisory Council on Vocational Education; and a lifetime affiliation with the National Congress of Parents and Teachers.[33]

In her last years, two honors particularly delighted her—one from the Tennessee General Assembly and the other from Phi Delta Kappa, the honorary education fraternity. On 7 March 1983, at age seventy-nine, Mildred Doyle became the third recipient of the Tennessee Distinguished Service Medal, an award considered the state's highest honor. The Tennessee General Assembly created the Distinguished Service Medal to honor Tennessee citizens who either died as war heroes or who were "considered by the General Assembly to be especially deserving persons." This high honor deeply touched the gruff but sentimental former superintendent. Knox Countians approved the legislature's action enthusiastically. Her personal files contain many letters of congratulations from well-wishing citizens and friends, attesting to her popularity and the love and appreciation given her by thousands of local citizens whom she served for many years.[34]

Three years later, on 30 September 1986, Miss Doyle was again applauded for her service to the public schools. The University of Tennessee chapter of Phi Delta Kappa bestowed upon her its highest honors at a celebration at Doyle High School—"the House that Doyle built." Several hundred friends, family members, and colleagues gathered for the event at which Mildred, though thinner and weaker, still played the stand-up comedian, recalling humorous stories of her days in the public schools and telling the audience that, ironically, as a young girl she had never envisioned a career in education, always vowing adamantly never to become "an old maid schoolteacher." Shortly after her eightieth birthday, University of Tennessee professor Clinton Allison conducted a videotaped oral history interview with Miss Doyle; she recounted aspects of her life as a youngster, an athlete, an educator, a politician, and a servant to her community. The videotaped presentation, condensed from over 100 minutes of conversation with Miss Doyle, was featured as part of the evening's program. At the end of the tape, the old woman arose, walked to the front of the room, faced the audience, grinning, and roared in typical form, "Eat your heart out, Liz Taylor!" The laughing audience gave her a standing ovation.[35]

Diagnosis with Cancer

In 1984 Mildred Doyle became increasingly annoyed by pain in her knees caused by a combination of old basketball injuries and developing arthritis. Because she complained that the pain had spread to her back, her rheumatologist referred her to a bone specialist, who admitted her to Baptist Hospital for a battery of diagnostic tests. Upon completion of the tests, Mildred's doctor telephoned her sister Ruth to advise her that Miss Doyle should probably have someone with her when he revealed the results. Ruth contacted Patterson and they went to Mildred's room to await the news; when the doctor arrived, he told Miss Doyle, "I'm so sorry to have to tell you that you have bone cancer." Patterson recalled that while she and Ruth "expected her to carry on and climb the walls," Miss Doyle simply replied, "Well, okay. Who's playing ball this afternoon?" Mildred's initial cavalier response characterized, at least outwardly, her response to her disease until her death. Much as she never accepted her loss of the superintendency, Miss Doyle, never "accepted the fact that she was going to die," Patterson remembered and "furthermore," she added, "I don't think I did either. It came as a real shock."[36]

To inhibit the cancer's growth, Mildred underwent both chemotherapy and radiation treatments. However, the tough and dauntless Mildred Doyle continued "business as usual" in her final years, continuing her work with the Alternative Center for Learning and planning the creation of Doyle Park for Knox County's youngsters. In the fall of 1988 Mildred became involved in another service mission, this time to help poor and elderly cancer patients who were having transportation problems getting to their therapy sessions. She discovered the problem through her contact with other patients at the Baptist Hospital Outpatient Center and became actively involved in fund-raising efforts to buy vans for cancer patients needing services at the hospital. Not only did the veteran community servant use her highly sharpened skills at raising money, but she gave sizable sums herself. The Baptist Hospital Foundation named the new fund the Mildred E. Doyle Cancer Van Fund; it purchased three vans to transport patients within a 100-mile-radius to the outpatient center at no charge, thus enabling them to continue their treatment programs. Numerous letters from officials of the Baptist Hospital Foundation in Mildred's personal files thank her for her efforts in making the van fund a reality and acknowledge contributions made in her honor by friends and other members of the community. She had served her southern Appalachian neighbors one last time.[37]

Conclusion

Mildred Doyle looked at life as a challenge to further improvement and service, an ethic that required her to look beyond her achievements in guiding the Knox County Schools through decades of educational innovation and growth and to continue using her leadership abilities to do more for others and to expect more of herself. She never stopped devoting her energies to helping others—especially children. Although she would likely laugh to read these words, many of the individuals she helped throughout the years considered Mildred Doyle a saint (even if a very secular one). Sanctification may be hyperbolic, but she gave her entire life to public service. According to friends and colleagues, the school *was* her life; however, she also worked through many other community agencies and committees to serve the citizens of Knox County and Tennessee—literally until her death.

It could be argued that Mildred Doyle is still helping people. She serves as the role model for school people, community servants, and politicians who look to her philosophy and style today to give them guidance. She was largely responsible for modernizing the school system of Knox County—in curricula as well as in buildings. She left the Alternative Center for Learning, the Charter E. Doyle Memorial Park, and the Mildred E. Doyle Cancer Van Fund to serve her community. Although Mildred Doyle made political enemies because she "refused to turn the schools into a political machine," and because her brusqueness occasionally alienated people, she is largely remembered as a giant of a figure—one who was determined, dedicated, and selfless in her devotion to her beloved Knox County and Tennessee.[38]

Notes

1. In her later years Miss Doyle received numerous additional honors and awards for her collective contributions to the community, both before and after the superintendency. Examples may be found in Appendix A.

2. Faye Cox, interview by author, 5 December 1994.

3. Lois Thomas, "Departing Supt. Doyle Feels Funds Pose Biggest School System Obstacle," *Knoxville News-Sentinel*, 29 August 1976, A1; Not only was the superintendent known for her use of green ink, but her signature itself became somewhat of a classic image in itself through the years and was compared by *Knoxville News-Sentinel* writer Sam Venable with the signature of John Hancock on the Declaration of Independence. He wrote upon her death that thousands of former Knox County students "will remember the flowing 'Mildred E. Doyle'—with the 'E.' and the 'Doyle' connected" as they recall their report cards or other school correspondence. See Sam Venable, "Mildred Doyle's Caring Left Touch on the Lives of 'Her' Many Children," *Knoxville News-Sentinel*, 9 May 1989, A6; Faye Cox, interview by author, 5 December 1994; Earl Hoffmeister, interview by author, 1 February 1995.

4. Thomas, "Departing Supt. Doyle," A5; Mildred Patterson, interview by author, 10 October 1994. Patterson enjoyed staying at the apartment more than Doyle because the lack of a yard forced the former superintendent to be more sedentary than she preferred.

5. Cynthia Cummins, "Mildred Doyle—Public Service Is Her Life," *South Knoxville Packet*, 22 June 1987, 2. Aside from watching ballgames on television, Miss Doyle enjoyed programs like *The Andy Griffith Show* and *Bonanza*. The educator's taste in movies leaned toward Westerns—or as Mildred Patterson put it, "blood and thunder." Mildred Patterson, interview by author, 10 October 1994; Robert DeLozier, interview by author, 29 March 1995.

6. Bill Maples, "Choral Society Award: Patterson to Be Honored for Public Service and Creation of Singing Seniors," *Knoxville News-Sentinel*, 23 November 1986, B3; Mildred Patterson, interview by author, 10 October 1994. The Knox County Teachers Chorus was well known across the state and won numerous awards for superior performances in choral competitions. Mildred Doyle was proud of the group's achievements.

7. Ruth Doyle Hilton, interview by author, 25 February 1994; Cynthia Moxley, "Benevolent Dictator: For 30 Years, Mildred Doyle Got Things Done as School Chief," *Knoxville Journal*, 4 July 1985, A1.

8. Mildred Patterson, interview by author, 8 June 1994; "Mildred Doyle to Speak," *Knoxville News-Sentinel*, 22 February 1981, Photocopy, Doyle Family File, McClung Collection, East Tennessee Historical Society, Knoxville, TN. This article indicated that Miss Doyle was to speak on the idea for the Alternative Center

for Learning in an address entitled "An Alternate Opportunity for Young People" at St. John's Episcopal Church. Richard Yoakley, interviews by author, 29 March 1995 and 14 October 1994.

9. Not only did Miss Doyle approach local educators with her idea, but she took opportunities to meet with local PTAs to share her vision and to report the progress of the school after its inception. For example, see Tricia Landen, letter to Mildred Doyle, 16 February 1983, personal files; Robert DeLozier, interview by author, 29 March 1995. DeLozier indicated that many faculty members of the College of Education at the University of Tennessee refused to work with Mildred Doyle because of her strong personality and definite ideas. He explained that these professors preferred not to share the control over projects in which they were involved. Marti Levary, "Troubled Teens Put to the Test at Special School," *Knoxville News-Sentinel*, 10 February 1985, B1.

10. Quote from Robert DeLozier, interview by author, 29 March 1995; Mildred Patterson, interview by author, 8 June 1994; Jane Gibbs DuBose, "Knox School Providing Model for Educating Problem Student," *Knoxville News-Sentinel*, 13 February 1983, B9; Richard Yoakley, interview by author, 14 October 1994; Levary, "Troubled Teens," B1.

11. DeLozier, interview by author, 29 March 1995; Levary, "Troubled Teens," B1.

12. Levary, "Troubled Teens," B1.

13. Richard Yoakley, interview by author, 14 October 1994.

14. DuBose, "Knox County," B9; DeLozier quoted in Levary, "Troubled Teens," B1; DeLozier, interview by author, 29 March 1995; Levary, "Troubled Teens," B1. Brushy Mountain is a Tennessee state penitentiary.

15. DeLozier, interview by author, 29 March 1995.

16. Rosa L. Kennedy and Jerome H. Morton, *A School for Healing: Alternative Strategies for Teaching At-Risk Students* (New York: Peter Lang Publishing, 1999), 173. In this book, Kennedy and Morton tell the story of the Alternative School during their years there.

17. Ibid., 171–178.

18. Ibid., 172.

19. Sue Hicks, interview by author, 13 October 1994; Kennedy and Morton, *School for Healing*ix. According to Hicks, who is Miss Doyle's niece and a teacher at the Alternative Center, "When she died, the funding died with her." At this point the facility was taken over by the Knox County Schools.

20. DeLozier, interview by author, 29 March 1995.

21. Ibid.

22. Ibid.

23. Ibid.

24. The child-care program continues to exist at West High School under the admin-istration of the Knox County Schools.

25. Louise Henigman, "Park's New Nature Trail Has a Long History," *Knoxville Journal*, 11 June 1986, D1.

26. Bill Maples, "Mildred Doyle Gives Land to City, County for Park," *Knoxville News-Sentinel*, 24 January 1984, B1.

27. Roger Harris, "Ready or Not, Doyle Park Will Meet Public," *Knoxville News-Sentinel*, 19 April 1985, B1; Tom Rutledge, "Doyle Nature Trail Opens with Ceremony," *South Knoxville Packet*, 16 June 1986, 3.

28. Ronda Robinson, "Children File in for Doyle Park Groundbreaking," *South Knoxville Packet*, 23 October 1984, 1, 3. When Mildred attended elementary school there, the school was known as Moore's School. The name was later changed to Moreland Heights.

29. Rutledge, "Doyle Nature Trail"; Henigman, "Park's New Trail," D1.

30. Velma McNelly, telephone interview by author, 10 October 1994; Mrs. McNelly, a former student at Vestal School and player on the girls' basketball team, recalls "Coach" Doyle taking them to ballgames in her "beautiful beige Ford roadster." McNelly told of her "hair flying all over" as the girls fought over who would ride in the rumble seat. Mrs. McNelly was particularly fond of Mildred Doyle because her mother had died when she was 12 years old and she explained, "When I needed someone to love me, she was there."

31. Tennessee General Assembly, Senate Joint Resolution No. 66 (13 April 1977). Copy in Mildred Doyles's personal files.

32. Faye Cox, interview by author, 5 December 1994. Cox recalled that occasionally Miss Doyle would show up on Sundays at the office in her pajamas to peruse textbooks for possible adoption. Cox would meet Miss Doyle at the office to help her keep the texts in order and make sure her name was stamped in green ink on the inside covers of each book.

33. "Mildred Doyle Continues Family Tradition of Service," *Spectrum*, August 1981, 3. "Services Tuesday for Longtime Knox Educator Mildred Doyle," *Knoxville Journal*, 8 May 1989, A1; "Former TEA President Mildred Doyle Dies," *TEA News*, June 1989, 5; "Mildred Doyle Joins MC Board," *Knoxville News-Senti-nel*, 6 July 1972, photocopy, Doyle Family File, McClung Collection; certificates attesting to service located in Mildred Doyle's personal files.

34. Quoted material taken from "Doyle Wins State's Top Honor for 50 Years' Educa-tion Work," *Knoxville Journal*, 8 March 1983, photocopy, Doyle Family File, McClung Collection; "Mildred Doyle Given Medal," *Knoxville News-Sentinel*, 8 March 1983, photocopy, Doyle Family File, McClung Collection.

35. Kaye Franklin Veal, "Mildred Doyle Saluted for Service to Schools," *Knoxville News-Sentinel*, 1 October 1986, A16.

36. Mildred Patterson, interview by author, 1 March 1995.

37. Leon Stafford, "Doyle Helped Others until the End: Former Superintendent Active in Fund Raising for Cancer Van Patients," *Knoxville News-Sentinel*, 9 May 1989, B1; F. Graham Lee, letter to Mildred Doyle, 3 October 1988, personal files.

38. Miss Doyle quoted in Moxley, "Benevolent Dictator," A1; Stafford, "Doyle Helped Others," B1; Venable, "Mildred Doyle's Caring," A6; Roger Ricker, "Former Schools Chief Doyle Remembered as Dedicated, Unselfish," *Knoxville Journal*, 9 May 1989, A4; "Mildred Doyle, Political Pioneer for GOP Women," *Knoxville Journal*, 8 May 1989, 6A.

Chapter 7

Conclusion:
Mildred Doyle in Perspective

The major themes that interest feminist scholars may be found in Mildred Doyle's public life as a politician and school superintendent and in her private life as companion to Mildred Patterson. Her biography illustrates the ways that one powerful, ambitious woman broke through the gender constructions of her time, and how she used her power and authority differently from male counterparts. It exemplifies how homophobia can punish women who don't exhibit stereotypical feminine characteristics, and it enhances our understanding of the meaning of committed relationships among women who share their lives with each other.

In order to assess the contributions of Mildred Doyle's experience to our understanding of these themes, her biography is placed in the context of other studies of early and mid-century exceptional American women. Three sources have been helpful in providing such a context. Jackie Blount's informative study of the history of women school superintendents, *Destined to Rule the Schools: Women and the Superintendency, 1873–1995*, was invaluable. Two group biographies stimulated questions about the ways that Mildred Doyle's upbringing, personality, and experiences were similar or, in some cases, remarkably different from other women who first challenged and then lived outside the traditional women's spheres of their time. In *Composing a Life*, Mary Catherine Bateson provides an engrossing, well-written study of five quite different but extraordinary women; two (including herself) were college administrators, and the biographies provided helpful examples of women's ways of leading and nurturing. Patricia Ann Palmieri's *In Adamless Eden: The Community of Women Faculty at Wellesley* welcomes readers into a world that would have been very alien to Mildred Doyle. The upper-middle-class, academic women in the "protected" environment of Wellesley College and the southern Appalachian "rough and tumble" politician seem to have little in com-

mon; yet we may glimpse Mildred and Charter Doyle in Palmieri's discussion of the girls who would become Wellesley women and their fathers, and the study was particularly helpful in adding to understandings of "romantic friendships."[1]

Exploration of common themes may tell us much about a group of people, in this case, extraordinary political and educational women leaders, but the generalization may hide the individuals who were shaping and changing their worlds. Maxine Greene writes of the need for both contours and identities, for general themes and interpretations that explain the particular, but also for close examination of individuals who acted or were acted upon. As important as the generalizations are, we also need the individuals who may well be anomalies; we must be careful not to file "the burred edges, the *interesting* burred edges, from a subject in order to fit him smoothly to the shape of other characters of his [or her] 'type,' to slip him like a greased key into the lock of received expectation." Mildred Doyle broke through gender barriers and lived an extraordinary life for a woman in her time and place, yet, at the same time, she only partially went beyond the boundaries of her southern Appalachian culture. It is in such ambiguities and anomalies that biography provides understanding and interest.[2]

The biographer, like the novelist or the historian, is a storyteller, "an artist under oath," concerned not only with the facts but also with the aesthetics of construction. Biographers' responsibilities lie in interpreting the facts of a life as they understand them. Their own past experiences and subjective autobiographical reality inevitably influence them. In digging through the maze of newspaper accounts, letters, speeches, photographs, and memories of survivors, in trying to understand a subject's motives and psychological makeup, biographers find themselves affected and channeled not only by who they are, but also by the people and artifacts the subject of their story happens to have left behind.[3] Biographer Doris Kearns makes the point: "[In] the end, if we are honest with ourselves, the best we can offer is a partial rendering, a subjective portrait of the subject from a particular angle of vision shaped as much by our own biography—our attitudes, perceptions, and feelings toward the subject—as by the raw materials themselves."[4]

This story is but a partial rendering, one interpretation of the many that are possible, given the particular facts of Mildred Doyle's life coupled with a biographer's perspective. A different picture of Mildred would have emerged from this story had I believed, for example, that women had no place in positions of educational leadership, or in historical narratives, for that matter. Or, had I found that Mildred Doyle's actions as an educator

contradicted her words as a politician, she would appear an entirely different person to my readers. Her words and actions, however, remained remarkably consistent for her three decades in office, except for a turn to the right close to the end of her superintendency. Further, a very different rendering could have occurred had Miss Doyle failed to obtain the strong support of local newspapers and voters. Moreover, during her long career, had the superintendent created more public enemies who were willing to reveal themselves, I might have told still another story.[5]

A Contribution to the History of Women

Mildred Doyle's story adds to an expanding literature on women's history and serves to reduce a regional bias with an account of her atypical life as a southern politician and educator. It is no secret that academic histories have largely excluded women—even after the women's movement gained momentum. The general pattern persists that histories, including educational histories, usually portray white males as the "movers and shakers." The experience of the white male tends to hold the spotlight because most historical narratives center on the public experience of dominant groups—that is, the dynamics of the economic sphere of paid work, the leadership of institutions, the control of governmental affairs, or tales of "heroic" military exploits. Our society has perpetuated such patterns that promote gender inequality because they "ascribe to men alone the right to offer ideas for public discussion and the ability to run societal institutions."[6]

Written histories typically ignore the private sphere—the domestic aspects of life and work where women have been major players, doing the crucial work of sustaining the human race throughout time. The stories of women, like Mildred Doyle, who courageously chose to challenge patriarchal hegemony by entering male-dominated spheres of politics and educational administration, as examples, have been largely omitted in historical scholarship, as have the stories of women who have worked in the domestic sphere. As a way to remedy such silences, feminist researcher Shulamit Reinharz contends: "Biographical work has always been an important part of the women's movement because it draws women out of obscurity, repairs the historical record, and provides an opportunity for the woman reader and writer to identify with the subject."[7]

Breaking Gender Constructs

Mildred Doyle grew up in the period of suffragists and flappers, a time when the place of women in society was becoming more problematic.

The older Victorian ideal of womanhood was becoming passé, and throughout the Western world (even slowly in Appalachia) women were enlarging their tradition sphere, and for middle-class women, particularly, the domestic sphere was expanding to include commitments to education and social reform. But social change always comes with a built-in backlash, and traditionalists accused powerful, educated women who didn't play conventional roles as wives and mothers of subverting the social order, even of "race suicide" because they failed to keep pace in child bearing with paupers and "lesser races." Sometimes the backlash became more pernicious, and women were accused not only of neglecting their womanly responsibilities, but worse, "of deviance."[8]

While Mildred Doyle is hardly unknown to Tennesseans, I needed to tell her story to a larger audience in order to provide a case study, in one time and place, for those seeking to understand the variety of roles that women have played historically, the gender barriers that they have broken, and the cultural norms that they have disregarded in their efforts to lead freer, more atypical lives. I invite persons interested in gender studies to reflect upon the ways in which Mildred Doyle's life as one woman has affected the social (re)construction of gender in her community and, further, to witness the possibilities that occur when one is willing to transgress dangerous boundaries. Her story illuminates and applauds the determination and courage of a woman who achieved leadership positions still thought improper for southern women of her day.

I wish to emphasize the humanness of Mildred Doyle, while taking nothing away from her contributions to public schools and community service or from the fact that she exhibited courage to live life as she saw fit. Her story illustrates a life lived largely by instinct and one that thrived on challenge and a remarkable mix of unconventionality and conventionality. Most of all, I see it as a story of self-actualization in which Mildred Doyle expanded roles considered appropriate for women in order to live a life that made sense to her. The theme of "instinctiveness" that runs through the life of Mildred Doyle has direct bearing on how she conducted her life. She constructed her *self* according to who she wanted to be, relying on her instincts rather than artificial social criteria when charting her course. Mildred Doyle's parents encouraged her to be the best she could be at whatever she attempted, never discouraging her from any activity because of her gender. Her father and mentor, Charter Doyle, nurtured Mildred's instinctive self-confidence that served her well in her adult life when she crossed gender lines as superintendent of schools and became an active figure in local politics.

Feminist scholars have analyzed the relationships between powerful women who challenge gender constructs and their fathers. Bateson found that powerful fathers may provide an image of achievement for their daughters to emulate, but they may equally send a "message that achievement is not for girls." Palmieri examined the relationship that Wellesley professors had with their fathers, and it is interesting to compare her findings with Charter Doyle's mentoring of Mildred. Like Doyle, the Wellesley fathers were prominent persons; but, unlike him, they were well educated, were often intellectuals, disliked competition, tended to lead private rather than public lives, and were not particularly interested in their careers, thus having time to nurture their daughters. Their intellectual and moral ideas were often mirrored in their academic daughters. The gregarious politician Mildred Doyle mirrored the personality of her father, who was quite different from the introspective Wellesley fathers. In both cases the fathers exerted a powerful influence on their daughters, directing their education (in its broadest meaning), giving them strong emotional support, and helping them to believe in their own potential. And in both cases they were "career brokers" as well. The Wellesley fathers intervened to secure academic positions for their daughters as Charter Doyle used his political influence to further the public school career of Mildred. But again there were also differences, some Wellesley professors worried that they would not or could not live up to their fathers' expectations and were emotionally unprepared to attempt to rival their fathers' careers. Mildred left little evidence of these types of doubts.[9]

The childhoods of the Northeast, privileged, upper-middle-class girls who would become Wellesley professors and Mildred's rural Tennessee upbringing are in many ways strikingly different, but these daughters shared a nurturing that encouraged them to be assertive and inquisitive and allowed them a "sense of naughtiness." Even as children they resented any differential treatment between themselves and their brothers. When she was a girl, Mary Alice, one of the "Wellesley women," objected to her parents that it was unfair that her brothers could go barefoot in the summer and she couldn't. Mildred would have thought, "The hell with this," and taken off her shoes.[10]

Mildred did not deliberately set out to challenge the hegemony of rigid gender constructs that place males at the forefront of educational leadership and politics. She simply decided, as did many extraordinary women of her generation, that rules that didn't make any sense were made to be broken. One of the women in Bateson's study recalled, "I developed the idea very early that if there were rules that didn't make sense, you had to

think carefully about how you broke them. If you got caught, well, OK, you got caught, but that was not a reason to stop thinking."[11]

Mildred's concern was child advocacy, not necessarily the expansion of roles for women. According to family members, close friends, and even Mildred herself, she was oblivious to the fact that *she* might encounter opposition based on gender when she decided to enter educational administration. Her instincts told her that through a leadership position she could be of further service to children, so she decided to become principal of Vestal Elementary School, despite opposition from the Vestal PTA and the scarcity of women principals in southern Appalachia. Further, her inherited family interest in politics, coupled with her commitment to better schools for young people, instinctively propelled her to run for the superintendency. Through both administrative positions, especially the latter, Mildred Doyle served as a role model for women to follow in educational leadership and politics.[12]

Not only did instincts determine her decision to leave the classroom for leadership positions, but they told her that she could succeed in the world of politics. After all, her father and grandfather before her were powerful local politicians, and it appears not to have crossed her mind, until after she had made the decision to run for the superintendency, that some citizens may have been more prepared for a native son rather than a native daughter. She not only overcame traditional southern Appalachian resistance to "political women," she became one of the most successful Tennessee politicians of her generation.

From the moment she announced her intention to seek the post in 1946 until she was finally defeated after thirty successful years, the dauntless Doyle heard and ignored repeated warnings from naysayers who said that the Knox County superintendency was a man's responsibility. "It was not in her head" that the voters would not elect her. The name Mildred Doyle carries with it an uncanny aura of respect in the Knox County community because she paid no attention to sexist attempts at intimidation, followed her instincts, and transformed scattered one- and two-room rural schools with rudimentary curricula into a modern system with dozens of new facilities and progressive curricular innovations. As is typical of successful women leaders, she gave her staff credit for her success, but local citizens remember the salty Miss Doyle as the driving force. A former student wrote at the time of her death: "In an era when female educators remained quietly in the classroom, Miss Doyle commanded the office of superintendent as none before her or ever since." She instinctively interrupted the patriarchal pattern of males in educational administration, look-

ing for inclusion, attachment, and sense of community, and subsequently gained extraordinary respect as a leader.[13]

Although there was much about her day-to-day work that was women-centered, Mildred did not think of herself as a feminist. She didn't frame issues as feminist scholars would. She, like most other school administrators, was not an intellectual. She did not engage in gender analysis, terms like feminist pedagogy had little meaning for her, and she avoided gender considerations when possible.

Mildred Doyle's Administrative Style

By the time Mildred became Knox County school superintendent, men had reconstructed the superintendency into a male-defined and male-occupied profession. Those who controlled this position had distanced themselves from women teachers by modeling the office on hierarchical institutions such "as the military and industry where roles, status, power, and authority were defined with position." From their downtown offices, close to other powerful men, they could focus on controlling teachers, often treating them "like abstract enemies, embattled opponents who need to be reminded where power resides."[14]

Women, such as Mildred, who entered this male-dominated profession faced a baffling quandary. If they operated as successful leaders and supervisors using male models, they were accused of being masculine—an abnormal, perhaps even perverted, way for a woman to be, and certainly not the sort of people that should be working with schoolchildren. If they, however, approached their duties in women-centered ways, they were dismissed "as weak and ineffectual." Feminist scholars debate the value of women entering male domains if they simply adopt traditional masculine ways of leading and supervising and leave the office much as they found it. "We celebrate," Bateson observes, the success of such women "with a certain ambivalence." The challenge, she admonishes, is to change the office into something different by affirming women's ways of working and nurturing.[15]

Again, Mildred does not fit smoothly into a male or a female model. She exhibited many of the characteristics of male administrators, including some of their worst traits. Her hot temper and strong language sometimes intimidated and alienated people, and she bordered on the paternalistic by occasionally admonishing parents for their child-rearing practices that she considered harmful to children. Sometimes, potential allies, including some professors at the University of Tennessee, found her diffi-

cult to work with because of her strong-willed personality. She clearly enjoyed control and demanded to know the details about everything taking place in *her* school system, particularly in the central office. Finally, she did not distance herself far from the prejudices of her place and time, and some of her words and actions contained sexist (and racist) overtones which are always potentially harmful.[16]

Nel Noddings and other feminist scholars place nurturing at the center of women's ways of transforming professional practice; women administrators tend to seek power or authority less for personal fulfillment than as a means of healing, caring, or helping others to grow. In discussing the women in her group biography, Bateson observes that "they have learned modes of effectiveness that make them caretakers and homemakers beyond their own families, creating environments for growth or learning, healing or moving toward creative fulfillment." A male model would consider this caretaking as coddling, inefficient, or perhaps a waste of time. "Slowing down for caretaking is obviously a losing strategy in the short run," Bateson agrees, "but a winning strategy in the long run." Reflecting on her experience as a college dean, she emphasizes the importance of nurturing and caring for professors so that they in turn can support and nurture the growth of their students.[17]

Nurturing was fundamental in Mildred Doyle's administrative style. She did not have a mother's responsibilities to her own children, but, as Bateson points out in her sketch of women education administrators, "being a mommy" was essential to success. And it was *almost* always with affection that Knox County teachers called Mildred "Granny." Of course, calling the formidable-looking superintendent Granny in her presence would have been unthinkable. Almost any of the teachers who were in the Knox County system have a story to tell about her caring, which was often hidden to avoid damaging her "tough guy" image. The editor of this book gets to tell his: Nearly twenty-five years ago, my wife, Claudia, a first-year, untenured librarian, had just taken a job in a middle school library when our twelve-year-old daughter was diagnosed with juvenile diabetes. Distraught, through proper bureaucratic channels she asked for a leave of absence to care for the frightened child. The leave was granted, and an unexpected, kind note of concern from the superintendent followed. When Claudia was ready to return to work, all of the school librarian positions were filled, but a place for her was found in the materials center until a library position became available. Many years later, without further contact, the short, bulky former superintendent appeared one day in Claudia's school; she said that she was visiting Doyle High School nearby and just

wanted to see how things were going at Bonny Kate School. "And how," she asked, "is your daughter doing?"[18]

Mildred Doyle used her charismatic political power to work for students and teachers in the Knox County Schools rather than to bolster her political career for personal gain. She chose deliberately to remain in local public education rather than to pursue the typical male career politician's desire to climb from local to state to national levels. Her connections and influence reached such proportions that, despite barriers that her gender might have posed, she almost certainly could have attained a seat in the Tennessee General Assembly, and likely a seat in the United States Congress, had she elected to leave her post as superintendent.[19]

Mildred clearly enjoyed her power and notoriety. Many times she waltzed past open-mouthed secretaries to appear unannounced before various Tennessee governors in order to hold an urgent conversation concerning an educational matter; yet her craving for power had its limits. Her paramount concern was to enable children by providing them with the education that she believed they had a right to receive. While Mildred Doyle was both fascinated and successful with politics, she loved children—their education was her career.

Females probably have more of a male-female blended view than males because they have been enculturated into a patriarchal society; certainly that was true of Mildred Doyle. She renegotiated a place for herself as a woman who commanded power and respect within the male-dominated spheres of educational leadership and the patriarchal political elite that she understood so well, and, at the same time, she used her power to care for and nurture those for whom she had responsibility.

Relationship with Mildred Patterson

Another way in which Mildred followed instincts and ignored gender conventions was her choice not to marry but to share a home with her long-term companion, Mildred Patterson. Their relationship led to whispers, gossip, and finally charges, by opponents in her last campaign for superintendent, that they were lesbians. The type of strong emotional bonding (often referred to as romantic friendships and sometimes as Boston marriages) such as that of the two Mildreds was quite acceptable among unmarried women in previous generations. Historian Lillian Faderman describes the advantages of such relationships: "They afforded a woman companionship, nurturance, a communion of kindred spirits, romance (and undoubtedly, in some but not all such relationships, sex)—all the

advantages of having a 'significant other' in one's life and none of the burdens that were concomitant with heterosexuality."[20]

These relationships also afforded strong, able women freedom from women's traditional home responsibilities so that they could pursue their careers. Palmieri found such relationships "commonplace" among the professors and administrators at Wellesley College. Many of the professors maintained close, emotional, interdependent friendships from youth to old age; they shared work, homes, vacations, money, in short, their lives.[21] In a similar relationship, the first woman school superintendent of a large city school system (who was also the first woman president of the National Education Association), Ella Flagg Young of Chicago, lived and traveled with one of her former teachers and, later, her personal secretary, Laura Brayton, who inherited Young's considerable fortune in 1918. Blount observes that

> The public viewed Young as an upstanding, pure, selfless, and dedicated educator. . . . [However] prominent women educators living a similar lifestyle only a generation later would likely have been severely criticized. In a climate of suspected deviance, though, single women faced the challenge of carefully managing their images, living in the shadow of suspicion, altering their personal lives, or leaving the profession.[22]

Mildred Doyle's relationship with Patterson shared many of the characteristics ascribed to the "romantic friendship" of a previous era. It also resembled an ideal heterosexual marriage in that it was characterized by love, honesty, trust, security, patience, companionship, and integrity. Perhaps the most important feature of their relationship was that their mutual influence brought out the best in each other, a model affinity for anyone seeking a husband, wife, companion, or partner.

By the time that Mildred became superintendent, Freud and the sexologists had turned these accepted (and often respected) romantic friendships from relationships generally considered innocent into morbid and deviant couplings that were often labeled lesbian. As research by pioneer sexologists such as Katharine Bement Davis in the 1920s and Alfred Kinsey in the 1940s and 1950s informed the public that homosexuality among both males and females was more prevalent than they had known, it was considered more dangerous to society, particularly to the young. During the Big Red Scare of the 1950s, homosexuality was often considered a source of political subversion as well as sexual perversion, and the search to find, expose, and fire them "extended to all segments of the population as the FBI, the Post Office, local police forces, [schools] and

other agencies conducted investigations to identify and turn them in."
Thousands lost their jobs.[23]

Although for generations female teachers had been required to remain single, spinster teachers were increasingly viewed as potential lesbians who could subvert the natural gender qualities of their students: boys might become effeminate and girls masculine. In 1947, Ferdinand Lundberg and Marynia Farnham argued "that all spinsters be barred by law from having anything to do with the teaching of children." And educational sociologist Willard Waller, arguing that homosexuality was certainly contagious, insisted that teaching candidates had to be carefully screened for "such personality traits as carriage, mannerisms, voice, speech, etc."[24]

The campaign to convince citizens that homosexuals were undesirable teachers was successful. A 1970 National Institute of Mental Health poll found that 77 percent of citizens were opposed to allowing homosexuals to teach. And teachers were sometimes dismissed because they were rumored to be gay or because they were insufficiently "masculine" or "feminine." The prejudice continues; Jackie Blount discussed the Appalachian public school in which she taught: "a number of male and female teachers who seemed even vaguely outside conventional heterosexuality were refused promotion, transferred against their will, demoted, or punished for unrelated reasons."[25]

According to Blount, this sexually stigmatizing of women who didn't meet stereotypical feminine characteristics was part of the reason for the drop in the percentage of women superintendents in mid-twentieth century. Women who wanted school superintendencies and other high administrative posts "could be viewed as masculine, aggressive, ambitious, and inappropriate." Some critics were concerned that administrative positions would make women masculine: "By the very act of working, something has happened to her. . . . [S]he has become, in important psychological elements, a man."[26]

Able women were put in the preposterous position of avoiding hostility by concealing their leadership abilities under a veil of traditional femininity. Women accentuated their femininity by crafting a soft, "womanly" appearance, maintaining a submissive countenance, pretending to have active heterosexual relationships, and sometimes marrying for the sake of appearance. They avoided curricular areas (such as high school physical education or coaching) that would raise eyebrows, and some resisted efforts toward advancement into male domains.[27]

By not attempting to conceal her ambitious, aggressive personality, by not pretending to be "ladylike," and by living as she pleased with some-

one whom she loved and trusted, Mildred Doyle risked the insinuations of a homophobic society. She never apologized to anyone for the way she conducted herself at work or at home. According to Patterson, Miss Doyle's public persona was for "all to see." She rarely, if ever, discussed any fears and insecurities—*that* was the private side of Mildred Doyle no one ever really knew. The robust superintendent lived and worked in ways that made sense to her, enabling her to lead a life she found worthy and rewarding.[28]

In her work on women relationships at mid-century, Lelia Rupp gives us some guidance on thinking about relationship such as that of the two Mildreds: "We need to distinguish between women who identify as lesbians and/or who are part of a lesbian culture . . . and a broader category of women-committed women who would not identify themselves as lesbians but whose primary commitment in emotional and practical terms was to other women." In other words, lesbian is a term that should be reserved for those who claim it for themselves. Mildred Doyle's niece Sue Hicks who knew her very well may have been accurate when she characterized her aunt as "asexual." Regardless, not only do we not know the exact nature of the relationship between Mildred Doyle and Mildred Patterson, we have no need to know in order to appreciate their loving relationship—or for any other reason.[29]

Mildred Doyle's story demonstrates that, even in a conservative society, if persons resist allowing social conventions to constrain them and insist on becoming self-actualized by living their lives as they choose, myriad life possibilities arise. Her life exemplifies what can happen when a woman does not fall prey to limitations perpetuated by artificial gender constructs and societal expectations for women. Moreover, in the process of striving to live an authentic life herself, she contributed greatly to the lives of others, including a quarter million children and youth who passed through the schools during her superintendency. She gave them an example of courage to follow their own instincts in constructing their lives.

Miss Doyle used the words "hangin' in tough" in response to a query about her health during her last weeks of life. She *could* have used those words to describe her life almost anytime during her eighty-four years. Instinctively, she hung in tough on the basketball court, on the softball field, and in her negotiation of gender constructs during her work in educational administration and politics. As is characteristic of women everywhere, Mildred Doyle was both tough and nurturing. Because she loved the schools and her community in much the same way that her Appalachian ancestors loved their land, she never grew tired of giving. For Mildred Doyle, hangin' in tough was simply a part of who she was.[30]

Notes

1. Jackie M. Blount, *Destined to Rule the Schools: Women and the Superinten-dency, 1873–1995* (Albany: State University of New York Press, 1998); Mary Catherine Bateson, *Composing a Life* (New York: Plume/Penguin, 1990); Patricia Ann Palmieri, *In Adamless Eden: The Community of Women Faculty at Wellesley* (New Haven: Yale University Press, 1995).

2. Maxine Greene, "Identities and Contours: An Approach to Educational History," *Educational Researcher* 2 (1973): 5–10; Geoffrey Wolff, "Minor Lives," in *Tell-ing Lives: The Biographer's Art*, ed. Marc Pachter (Washington, DC: New Re-public Books, 1979), 62.

3. Leon Edel, "The Figure under the Carpet," in *Telling Lives: The Biographer's Art*, ed. Marc Pachter (Washington, DC: New Republic Books, 1979), 17–34; Desmond MacCarthy, quoted in Victoria Glendinning, "Lies and Silences," in *The Troubled Face of Biography*, ed. Eric Homberger and John Charmley (New York: St. Martin's, 1988), 54.

4. Doris Kearns, "Angles of Vision," in *Telling Lives: The Biographer's Art*, ed. Marc Pachter (Washington, DC: New Republic Books, 1979), 91.

5. I became initially interested in Miss Doyle largely because of her unusual achieve-ments in the face of impossible odds based on social perceptions of gender pro-priety. I admired the courage of such a woman and thus became emotionally engaged in writing her life. I see this connection as an asset rather than a liability because I share biographer Leon Edel's belief that it is an emotional engagement with a subject that creates the burning desire needed to write that subject's life. See Leon Edel, *Biography as an Art: Selected Criticisms, 1560–1960*, ed. James L. Clifford (New York: Oxford University Press, 1962), 226–239.

6. Patricia A. Schmuck, "Women School Employees in the United States," in *Women Educators: Employees of Schools in Western Countries*, ed. Patricia A. Schmuck (Albany: SUNY Press, 1987), 90–91; Joan Burstyn, "Historical Perspectives on Women in Educational Leadership," in *Women in Educational Leadership*, ed. Sari Knopp Biklen and Marilyn B. Brannigan (Lexington, MA: D C. Heath and Co., 1980), 66. I make no apologies for the somewhat celebrationist tone of the work because I appreciate the gains she made for herself as a woman in the very resistant male-dominated worlds of educational leadership and politics.

7. Shulamit Reinharz, *Feminist Methods in Social Research* (New York: Oxford University Press, 1992), 126.

8. Palmieri, *In Adamless Eden*, 151; Bateson, *Composing a Life*, 28; Blount, *Destined to Rule the Schools*, 91–92.

9. Bateson, *Composing a Life*, 39; Palmieri, *In Adamless Eden*, 62–66.

10. Palmieri, *In Adamless Eden,* 70–71.

11. Bateson, *Composing a Life,* 25.

12. Mildred Patterson, interviews by author, 9 March 1994 and 8 June 1994; Sue Hicks, interview by author, 13 October 1995; Carmen Carter, "'Elect Woman' Session Includes Mildred Doyle," *Knoxville News-Sentinel,* 26 April 1985, photocopy, personal files.

13. Sue Hicks, interview by author, 13 October 1994; Sam Venable, "Mildred Doyle's Caring Left Touch on the Lives of 'Her' Many Children," *Knoxville News-Sentinel,* 9 May 1989, A6. For contrasts between male Johns Hopkins University and female Wellesley College on isolation versus community, see Palmieri, *In Adamless Eden,* 168.

14. Blount, *Destined to Rule the Schools,* 7, 47, 166.

15. Ibid., 9; Bateson, *Composing a Life,* 62, 233.

16. Biographer Victoria Glendinning, however, maintains that "a sense of history should stop both writer and reader from condemning a single individual, when a social climate, or history itself, is both the culprit and the victim." See Glendinning, "Lies and Silences," 59.

17. Nel Noddings, "Feminist Critiques in the Professions," 16 *Review of Research in Education* (Washington DC: American Educational Research Association, 1990); Bateson, *Composing a Life,* 158, 234–235.

18. Bateson, *Composing a Life,* 141.

19. Biographer Doris Kearns writes of the particular problems that the biographer encounters when writing about political figures and deciphering the potential ambiguity of their words. See Kearns, "Angles of Vision," 97–98.

20. Lillian Faderman, *Odd Girls and Twilight Lovers: A History of Lesbian Life in Twentieth-Century America* (New York: Columbia University Press, 1990), quoted in Blount, *Destined to Rule the Schools,* 101.

21. Palmieri, *In Adamless Eden,* 137–142.

22. Blount, *Destined to Rule the Schools,* 101.

23. Faderman, *Odd Girls*; Palmieri, *In Adamless Eden,* 137, 222, 263; Blount, *Destined to Rule the Schools,* 101, 106.

24. Blount, *Destined to Rule the Schools,* 95, 99; Ferdinand Lundberg and Marynia Farnham, *Modern Woman: The Lost Sex* (New York: Harper & Brothers, 1947), quoted in Blount, *Destined to Rule the Schools,* 103; Willard Waller, *The Sociology of Teaching* (New York: John Wiley and Sons, 1932), quoted in Blount, *Destined to Rule the Schools,* 100.

25. Blount, *Destined to Rule the Schools,* 107, 155.

26. Ibid., 92, 95–95.

27. Ibid., 107–108.

28. Mildred Patterson, interview by author, 1 March 1995.

29. Lelia Rupp, "'Imagine My Surprise': Women's Relationships in Mid-Twentieth Century America," in *Hidden from History: Reclaiming the Gay and Lesbian Past*, ed. Martin Duberman, Martha Vicinus, and George Chauncey Jr. (New York: Meridian, 1990), quoted in Palmieri, *In Adamless Eden*, 138; Sue Hicks, interview by author, 13 October 1994.

30. Rev. Robert Temple, "Funeral Service of Mildred E. Doyle," 9 May 1989, Ruth Doyle Hilton's personal files.

Appendix A

Tennessee State Senate
Joint Resolution No. 66

To honor Miss Mildred Eloise Doyle for her outstanding contribution to the field of education in Tennessee.

WHEREAS, Mildred Eloise Doyle has shown a remarkable dedication to the furtherance of education, having served for over 50 years in various capacities in the education profession; and

WHEREAS, She demonstrated this dedication by serving as elementary school teacher and principal while continuing her academic career through 20 years of summer school and thereby acquiring a Bachelor of Arts and a Master of Science Degree from The University of Tennessee; and

WHEREAS, Miss Doyle was the first woman to be elected superintendent of Knox County Schools, and held this position for 31 illustrious years; and

WHEREAS, Within this capacity, remarkable strides were made in the provision of quality education to the children of Knox County including the creation of three comprehensive high schools which have offered innovative structures, curriculum and teaching techniques; and

WHEREAS, Educators throughout the nation have toured the Knox County educational facilities in order to observe the exemplary programs established under Miss Doyle's leadership; and

WHEREAS, She has participated vigorously and tirelessly in civic and community organizations in an effort to keep the public abreast of developments in education; and

WHEREAS, Miss Doyle has been the recipient of numerous professional awards and honors including an honorary doctorate from Maryville College, life membership in the National Education Association, Tennes-

see Educational Association, and the Tennessee Congress of Parents and Teachers as well as the title of the "Outstanding Woman Athlete of the Last Fifty Years in Tennessee"; and

WHEREAS, She has had a significant impact on the development of educational programs throughout the State of Tennessee as a president of the Tennessee Education Association, as Chairman [sic] of the Superintendents Study Council from 1948 to 1973 and as a charter member of the State Textbook Commission from 1951 to the present; and

WHEREAS, She received national recognition as a member of the White House Conference on Children and Youth; and

WHEREAS, Throughout her years of service to the Knox County Community, Miss Doyle has continued to demonstrate her concern and interest for the welfare of others and maintained a keen interest in the continuing development of educational innovations; and

WHEREAS, It is fitting and proper that such outstanding service be lauded; now, therefore,

BE IT RESOLVED BY THE SENATE OF THE NINETIETH GENERAL ASSEMBLY OF THE STATE OF TENNESSEE, THE HOUSE OF REPRESENTATIVES CONCURRING, that Miss Mildred Eloise Doyle be honored for her contributions in the field of education.

BE IT FURTHER RESOLVED, That a copy of this resolution be sent to Miss Doyle.

Appendix B

Mildred Doyle's Eulogy

Miss Doyle's physical presence is no longer with us. Each of us who knew her will have to interpret her meaning in our individual lives, and this is what I believe she would have us do if we choose to honor her memory. Let me attempt to share with you some of her meaning to me:

She was my friend, my colleague, my guide, and my teacher. She fulfilled these roles in word and deed.

She was a visionary. She dared to dream, but her dreams were only the beginnings of many wonderful visions which she committed to action. Her visions were about the betterment of the lives of children. She championed the causes of children all her life. She was at her best and greatest when pleading the cause of a child or children whether the plea was to a parent or to the Governor of this State. She had the ability to look into the heart of any child and immediately win its affection and awaken its potentiality.

She saw the child in all of us. She won our hearts, and she made us become more than we were.

And so she taught me the difference between *common* power and *real* power. She taught me that common power and glory are but illusions and temporary at best. She taught me that real power and glory come from a personal commitment to and a resolution of something of value.

She taught me that our most precious resource is our young people and that if we serve them well, our purpose and mission will be fulfilled and our future will remain secure.

She was compassionate and understanding of the young; She was kind and gentle to the aged; She was generous and benevolent to the poor and the less-able; She was tolerant of those who did not understand.

I think she knew that at sometime in our lives all of us were *all* of these.

Richard Yoakley

Selected Bibliography

Books and Dissertations

Allison, Clinton B. *Teachers for the South: Pedagogy and Educationists in the University of Tennessee, 1844–1995.* New York: Peter Lang, 1998.

Baker, Carol E. "Superintendent Mildred E. Doyle: Educational Leader, Politician, Woman." Ed.D. diss., University of Tennessee, 1977.

Baker, William J. *Sports in the Western World.* Urbana: University of Illinois Press, 1982.

Ballantine, Jeanne H. *The Sociology of Education: A Systematic Analysis.* Englewood Cliffs, NJ: Prentice-Hall, 1993.

Bateson, Mary Catherine. *Composing a Life.* New York: Plume/Penguin, 1990.

Bennett, Kathleen P. "Wrenched from the Earth: Appalachian Women in Conflict." In *Curriculum as Social Psychoanalysis: The Significance of Place,* ed. Joe L. Kincheloe and William F. Pinar. Albany, NY: SUNY Press, 1991.

Bertaux, Daniel, ed. *Biography and Society: The Life History Approach in the Social Sciences.* Beverly Hills, CA: Sage, 1981.

Biklen, Sari, and Marilyn Brannigan, eds. *Women and Educational Leadership.* Lexington, MA: D. C. Heath and Co., 1980.

Blount, Jackie M. *Destined to Rule the Schools: Women and the Superintendency, 1873–1995.* Albany: State University of New York Press, 1998.

Bowen, Catherine Drinker. *Biography: The Craft and the Calling*. Boston: Little, Brown and Company, 1969.

Bowles, Samuel, and Herbert Gintis. *Schooling in Capitalist America: Educational Reform and the Contradictions of Economic Life*. New York: Basic Books, 1976.

Burstyn, Joan. "Historical Perspectives on Women in Educational Leadership." In *Women in Educational Leadership*, ed. Sari Knopp Biklen and Marilyn B. Brannigan. Lexington, MA: D.C. Heath and Co., 1980.

Campbell, Jack K. "Inside Lives: The Quality of Biography." In *Qualitative Research in Education: Focus and Methods*, ed. Robert Sherman and Rodman Webb. London: Almer Press, 1990.

Cicourel, Aaron, and John Kitsuse. *The Educational Decision Makers*. Indianapolis: Bobbs-Merrill, 1963.

Clifford, Geraldine Joncich. "The Life Story: Biographic Study." In *Historical Inquiry in Education: A Research Agenda*, ed. John Hardin Best. Washington, DC: American Educational Research Association, 1983.

Clifford, James L. *From Puzzles to Portraits! Problems of a Literary Biographer*. Chapel Hill, NC: University of North Carolina Press, 1970.

———, ed. *Biography as an Art: Selected Criticism, 1560–1960*. New York: Oxford University Press, 1962.

Cremin, Lawrence. *The Transformation of the School: Progressivism in American Education, 1876–1957*. New York: Random House, 1961.

Deaderick, Lucille, ed. *Heart of the Valley: A History of Knoxville, Tennessee*. Knoxville: East Tennessee Historical Society, 1976.

Dewey, John. *Democracy in Education*. New York: Macmillan Co., 1916.

Edel, Leon. "The Figure under the Carpet." In *Telling Lives: The Biographer's Art*, ed. Marc Pachter. Washington, DC: New Republic Books, 1979.

Faderman, Lillian. *Odd Girls and Twilight Lovers: A History of Lesbian Life in Twentieth-Century America*. New York: Columbia University Press, 1990.

Glendinning, Victoria. "Lies and Silences." In *The Troubled Face of Biography*, ed. Eric Homberger and John Charmley. New York: St. Martin's, 1988.

Goldman, Eric. *The Crucial Decade—and After: America, 1945–1960*. New York: Vintage Books, 1960.

Heilbrun, Carolyn G. *Writing a Woman's Life*. New York: Ballantine Books, 1988.

Kearns, Doris. "Angles of Vision." In *Telling Lives: The Biographer's Art*, ed. Marc Pachter. Washington, DC: New Republic Books, 1979.

Kendall, Paul Murray. *The Art of Biography*. New York: W. W. Norton, 1965.

Kennedy, Rosa L., and Jerome H. Morton. *A School for Healing: Alternative Strategies for Teaching At-Risk Students*. New York: Peter Lang Publishing, 1999.

Kliebard, Herbert M. *The Struggle for the American Curriculum, 1893–1958*. New York: Routledge, 1987.

Mandell, Gail Porter. *Life into Art: Conversations with Seven Contemporary Biographers*. Fayetteville: University of Arkansas Press, 1991.

Moss, Theodore. *Middle School*. Boston: Houghton Mifflin, 1969.

Nadel, Ira Bruce. *Biography: Fiction, Fact, and Form*. London: Macmillan Press Ltd., 1984.

Noddings, Nel. "Feminist Critiques in the Professions." In *Review of Research in Education*. 16. Washington, DC: American Educational Research Association, 1990.

Oakes, Jeannie. *Keeping Track: How Schools Structure Inequality*. New Haven, CT: Yale University Press, 1985.

Oates, Stephen B. *Biography as High Adventure: Life-Writers Speak on Their Art*. Amherst, MA: University of Massachusetts Press, 1986.

Ortiz, Flora, and Catherine Marshall. "Women in Educational Administration." In *The Handbook of Research on Educational Administration*, ed. N. Boyan. New York: Longman, 1988.

Palmieri, Patricia Ann. *In Adamless Eden: The Community of Women Faculty at Wellesley College*. New Haven: Yale University Press, 1995.

Reinharz, Shulamit. *Feminist Methods in Social Research*. New York: Oxford University Press, 1992.

Rosenthal, Robert, and Lenore Jacobson. *Pygmalion in the Classroom: Teacher Expectation and Pupils' Intellectual Development*. New York: Irvington, 1988.

Rupp, Lelia. "'Imagine My Surprise': Women's Relationships in Mid-Twentieth Century America." In *Hidden from History: Reclaiming the Gay and Lesbian Past*, ed. Martin Duberman, Martha Vicinus, and George Chauncey Jr. New York: Meridian, 1990.

Schmuck, Patricia A. "Women School Employees in the United States." In *Women Educators: Employees of Schools in Western Countries*, ed. Patricia A. Schmuck. Albany: SUNY Press, 1987.

Seller, Maxine Schwartz, ed. *Women Educators in the United States, 1820–1993: A Bio-Bibliographical Sourcebook*. Westport, CT: Greenwood Press, 1994.

Shakeshaft, Charol. *Women in Educational Administration*. 2nd ed. Newbury Park, CA: Corwyn Press, 1989.

———. "Women in Educational Management in the United States. In *Women in Education Management*, ed. Janet Ouston. Harlow, UK: Longman, 1993.

Spring, Joel. *The American School, 1642–1990*. White Plains, NY: Longman, 1990.

Tyack, David. *The One Best System: A History of American Urban Education*. Cambridge, MA: Harvard University Press, 1974.

Tyack, David, and Elisabeth Hansot. *Learning Together: A History of Coeducation in American Schools*. New York: Sage, 1990.

———. *Managers of Virtue: Public School Leadership in America, 1820–1980*. New York: Basic Books, 1982.

Wolff, Geoffrey. "Minor Lives," In *Telling Lives: The Biographer's Art*, ed. Marc Pachter. Washington, DC: New Republic Books, 1979.

Journals

Apple, Michael. "Teaching and 'Women's Work': A Comparative Historical and Ideological Analysis." *Teachers College Record* 86 (1985): 455–473.

Birrell, Susan, and Diana Richter. "Is a Diamond Forever? Feminist Transformations of Sport." *Women's Studies International Forum* 10 (1987): 395–409.

Greene, Maxine. "Identities and Contours: An Approach to Educational History." *Educational Researcher* 2 (1973): 5–10.

McMurry, Linda. "George Washington Carver and the Challenges of Biography." *Vitae Scholasticae* 2 (1983): 1–17.

Perko, Michael. "Biography and the Rebirth of Wonder." *Vitae Scholasticae* 4 (1985): 2–15.

Reed, Ronald. "Biography, Gossip and Other Forms of Scholarship." *Vitae Scholasticae* 6 (1987): 205–211.

Shore, Miles F. "Biography in the 1980's." *Journal of Interdisciplinary History* 12 (1981): 89–113.

Smith, Joan K. "Metabiographics: A Future for Educational Life-Writing." *Vitae Scholasticae* 6 (1987): 1–14.

Strober, Myra, and David Tyack. "Why Do Women Teach and Men Manage? A Report on Research on Schools." *Signs* 5 (1980): 494–503.

Theberge, Nancy. "Toward a Feminist Alternative to Sport as a Male Preserve." *Quest* 37 (1986): 193–202.

Young-Breuhl, Elizabeth. "The Writing of Biography." *Partisan Review* 50 (1983): 413–427.

Index

A

Ability grouping, xii, 70, 71, 74–77
Accountability movement, 80
African American, 60–64
Alexander, Lamar, 9, 35–36, 45–46,
 80, 81, 95
Allison, Clinton B., ix, 13, 15, 28, 29,
 30, 31, 46, 65, 66, 67, 103,
 131
Alternative Center for Learning, 93–
 98, 104, 105, 106
Anderson School, 24
Ashe, Victor, 1
Athletics, 19–23, 33, 99
Austin High School, 60, 63

B

Back-to-basics, 78
Bailey, Hop, 51, 59, 62
Baker, Carol E., 13, 14, 15, 28, 30,
 31, 45, 46, 47, 65, 66, 87,
 88, 131
Baker, Howard, Sr., 6, 9, 35–36, 46
Baker, William J., 28, 131
Baptist Hospital Foundation, 104
Bateson, Mary Catherine, xv, xvi, 111,
 115–116, 117, 118, 123,
 124, 131
Bearden Elementary School, 62, 86
Bearden High School, 62
Bellamy, James, 39
Biklen, Sari Knopp, 13, 30, 123, 131,
 132

Birrell, Susan, 28, 135
Blount, Jackie M., xi, xiv, xvi, 3, 13,
 14, 30, 46, 89, 111, 120,
 121, 123, 124, 131
Bozeman, Howard C., 45, 47, 54, 57,
 60–61, 66, 67, 81, 88
Brannigan, Marilyn B., 13, 123, 131,
 132
Bratton, Samuel, 8, 14, 28, 29, 38,
 40, 44, 46, 47, 49, 65, 66,
 68, 79–80, 82, 88
Brown v. Board of Education, xii,
 60, 63
Burnett, T. J., 20, 29
Burstyn, Joan, 123, 132
Byrd, Ben, 29, 30

C

Catcher in the Rye, 52
Central High School, 55, 83
Charter E. Doyle Memorial Park, 99–
 101, 105
Clapp, Beecher, 78, 79, 80, 81, 82–
 83, 87
Clonts, Homer, 45, 65, 86, 87
Coffield, William, 94
Competency testing, 76, 80
Cox, Faye, 6, 7, 13, 14, 15, 43, 47,
 52, 65, 85, 86, 88, 89, 91,
 106, 108
Cremin, Lawrence A., 65, 86, 132
Curriculum, xii, 4, 7, 39–40, 50, 53,
 78–81, 86, 87, 97, 131, 133

Mildred Doyle's curriculum philosophy, 69–72

Curriculum reform, 72–77

D

Dante Special Education Center, 58

Davis, Katharine Bement, 120

DeLozier, Robert, 94– 98, 106, 107

Democrat Party, 12, 36, 38, 45, 81, 83

Desegregation, xi, xii, 49, 60–64, 67

Dewey, John, 69, 74, 132

Doyle, Bert, 19, 34

Doyle, Charter, 15, 18, 20, 24, 27, 28, 34–35, 45, 112, 114–115

Doyle, Illia Burnett, 18

Doyle, Jacob, 34

Doyle, John, 18, 33, 100

Doyle, Otto, "Pinky," xiv, 18, 28, 42, 100

E

Edel, Leon, 123, 132

Extended school year, 78, 79

F

Faderman, Lillian, 119, 124, 132

Farnham, Marynia, 121, 124

Farragut High School, 39, 47, 59, 79

Flenniken, Fred, 36

Freud, Sigmund, 120

G

Garland, Judy, 11, 41

Gibbs High School, 55

Glendinning, Victoria, 123, 124, 133

Greene, Maxine, 112, 123, 135

H

Hansot, Elisabeth, 13, 23, 30, 46, 47, 134

Hess, Martha, 29, 47

Hicks, Sue, 11, 13, 14, 15, 22, 28, 37, 42, 46, 47, 68, 89, 107, 122, 124, 125

Hilton, Ruth Doyle, 13, 14, 15, 28, 29, 30, 47, 88, 106, 125

Hoffmeister, Earl, 46, 83–85, 88, 89, 92, 106

Holt, Andrew (Andy), 59

J

Jennings, John, Jr., 26

K

Kearns, Doris, 112, 123, 124, 133

Kennedy, Rosa L., 97, 107, 133

Kessel, Dwight, 100

King, Ebb, 26, 31

Kinsey, Alfred, 120

Kliebard, Herbert M., 86, 87, 133

Knox County Board of Education, 6, 24, 26–27, 30, 31, 33, 37, 43, 46, 49, 51–53, 55–56, 59, 60, 62, 63, 67, 85, 97

Knox County Court, 6, 8–9, 10, 12, 13, 14,15, 24, 26, 33–34, 43, 45, 49, 51, 54–57, 59, 65, 66, 67, 82, 86, 95

Knox County Education Association, 82

Knox County Principal's Conference, 53–54

Knox County school conditions, 4, 13, 50, 55, 66

Knox County teachers, 23, 53, 72–73, 77, 86, 118

Knoxville City Council, 57

Knoxville City Schools, 57, 62, 63, 83, 94

Knoxville Journal, 12, 13, 14, 23, 28, 29, 30, 31, 45, 46, 47, 66, 67, 68, 82, 83, 85, 86, 88, 89, 106, 108, 109

Knoxville News-Sentinel, 12,13,14, 28, 29, 30, 31, 42, 45, 46, 47, 65, 67, 82, 86, 88, 92,106,107,108,109,124

Knoxville Sports Hall of Fame, 23, 30

L

Lee, Hermione, xi, xvi

Lesbian (homosexual), 12, 84, 119–122

Levary, Marti, 107
Life-Adjustment Curriculum, 75
Lundberg, Ferdinand, 121, 124
Lyon, Leland, 27

M
Marshall, Catherine, 46, 47, 133
Maryville College, 21–22, 23, 24, 29,
 67, 103
Mays, A. W., 26
McNelly, Velma, 108
McWherter, Ned, 36
Merkin, Daphne, xi, xvi
Middle school, 59, 77–78
Mildred E. Doyle Cancer Van Fund,
 13, 104, 105, 109
Minnelli, Liza, 41
Moore's School, 20–21, 108
Moreland Heights Elementary School,
 100–101, 108
Morris, Betsy, 29, 31, 45, 47, 65
Morton, Jerome H., 46, 97, 107, 133
Moss, Theodore, 87, 133
Moxley, Cynthia, 14, 15, 28, 30, 31,
 45, 66, 67, 89, 106, 109

N
National Education Association, 102,
 103, 120
Noddings, Nel, 118, 124, 133

O
Oak Ridge National Laboratories, 51
Oakes, Jeannie, 87, 133
Open-space classroom, 83
Ortiz, Flora, 46, 47, 133
Overholt, Lynn, 98

P
Palmieri, Patricia Ann, xv, xvi, 111,
 115, 120, 123, 124, 125,
 134
Parent Teacher Association (PTA), 26–
 27, 55, 58, 107, 116
Patterson, Mildred, xi, xii, xiii, xiv, xv,
 1–3, 7, 8, 11, 13, 14, 15,
 20, 24, 28, 29, 30, 38–39,
 40–43, 45, 46, 47, 52, 55,
 56, 57–58, 59, 62, 63, 65,
 66, 67, 68, 72, 73, 78, 79,
 81, 83, 85, 86, 87, 88, 89,
 92–93, 104, 106, 107, 109,
 111, 119–120, 122, 124,
 125
Phi Delta Kappa, 103
Plessy v. Ferguson, 60
Powell High School, 83
Presley, Elvis, 41, 47
Progressivism, 49, 50, 60, 65, 132
 Pedagogical progressivism, xii, 74,
 81, 86

R
Red Book (Knox County Department
 of Public Instruction
 Tentative Program of Work,
 Grades 1–12, 1951–1952),
 74, 87
Reinharz, Shulamit, 113, 134
Republican Party, 12, 24, 33, 34, 36,
 45, 70, 81, 82–83, 85
Richter, Diana, 28, 135
Romantic friendships, xv, 112, 119–
 120
Rule High School, 98–99
Rupp, Lelia, 122, 125, 134

S
Sams, Gordon, 14, 28, 45, 47, 88
Sasser, James, 36
Schmuck, Patricia A., 123, 134
school building programs, 55–59
Shakeshaft, Charol, 38, 46, 47, 134
Social efficiency, 50, 70–71, 79
Social reconstructionists, 65, 70
Sorting. See ability grouping
Spring, Joel, 67, 76, 86, 87, 134
State Textbook Commission, 35, 102
Strober, Myra, 13, 30, 46, 135
Sullivan, Ed, 41
Superintendents' Study Council, 102

T
Teachers College, Columbia, 82

Temple, Robert, 2, 13, 125
Tennessee Better Schools Program,
 45, 80, 95
Tennessee Children's Services
 Commission, 35, 45, 93
Tennessee Education Association, 102,
 108
Tennessee General Assembly (Tennes-
 see legislature), 73, 103, 119
Tennessee State Board of Education, 73
Tennessee State Department of
 Education, 30, 58, 61, 80
Tennessee Valley Authority (TVA), 51,
 101
Testerman, Kyle, 81, 100
Theberge, Nancy, 28, 135
Thomas, Lois, 14, 46, 106
Title IX, 19, 29
Tracking, See ability grouping
Tyack, David B., xii, xvi, 13, 23, 25,
 30, 46, 47, 65, 134, 135
Tyree, Randy, 81

U
University of Tennessee College of
 Education, ix, 6, 10, 56, 94,
 107

V
Veal, Kaye Franklin, 13, 14, 15, 108
Venable, Sam, 106, 109, 124
Vestal, 18, 27, 28
Vestal School, 11, 24, 25–27, 30, 101,
 108
Vestal Lumber Company, 18, 35
Vestal Parent Teacher Association, 26–
 27, 116

W
Waller, Willard, 121, 124
Wellesley College, xv, xvi, 111–112,
 115, 120, 124, 134
Williams, Ted, 43
Winston, Nat, 81
Women's ways of administering, xii,
 7–12, 37–40, 52, 72, 78,
 111, 115–119

Y
Yarborough, Willard, 45
Yoakley, Richard, 47, 68, 88, 89, 94,
 96, 107, 129
Young High School, 21, 29

History of Schools and Schooling

THIS SERIES EXPLORES THE HISTORY OF SCHOOLS AND SCHOOLING in the United States and other countries. Books in this series examine the historical development of schools and educational processes, with special emphasis on issues of educational policy, curriculum and pedagogy, as well as issues relating to race, class, gender, and ethnicity. Special emphasis will be placed on the lessons to be learned from the past for contemporary educational reform and policy. Although the series will publish books related to education in the broadest societal and cultural context, it especially seeks books on the history of specific schools and on the lives of educational leaders and school founders.

For additional information about this series or for the submission of manuscripts, please contact the general editors:

Alan R. Sadovnik
118 Harvey Hall
School of Education
Adelphi University
Garden City, NY 11530

Susan F. Semel
Dept. of Curriculum and Teaching
243 Gallon Wing
Hofstra University
Hempstead, NY 11550

To order other books in this series, please contact our Customer Service Department:

800-770-LANG (within the U.S.)
212-647-7706 (outside the U.S.)
212-647-7707 FAX

Or browse online by series at:
www.peterlang.com